DRINKING WITH STRANGERS

BY BUTCH WALKER

Drinking with Strangers

(with Matt Diehl)

DRINKING
WITH
STRANGERS

Music Lessons from a Teenage Bullet Belt

Butch Walker
with Matt Diehl

wm

WILLIAM MORROW
An Imprint of HarperCollins*Publishers*

FIRST EDITION

Designed by Lisa Stokes

Library of Congress Cataloging-in-Publication Data has been applied for.

ISBN 978-0-06-178731-7

11 12 13 14 15 OV/RRD 10 9 8 7 6 5 4 3 2 1

To my father and idol, Willard "Butch" Eugene Walker, and my loving, patient, and talented mother, Ruby Melissa Walker. I turned out all right . . .

CONTENTS

If you are reading this foreword, please put this book down *now* if you think it will be anything like that Mötley Crüe book. Put it down if you are expecting me to tell you I slept with Lindsay Lohan, or if you think it will contain any of the following:

1. Heroin use
2. Fucking the dog in front of Grandma
3. Satanism
4. Orgies with small people
5. Constant use of the word "fuck" (example 2 exempt)

I know . . . That's all the good stuff, especially since the bar for gratuitous shock value has been raised so high in modern literature these days. Nope. I am a *bore*, but I do think you will find some of my journeys enlightening and entertaining, or maybe just worth picking up for five minutes while pooping in the morning. Either way, I am gonna tell you the whole truth and nothing but the truth, so help me . . . Wait—so help me who?

P.S. The names and identifying characteristics of some of the places and individuals featured throughout this book have been changed because I don't wanna come across as a total dick . . .

DRINKING WITH STRANGERS
Notes from an Expert

Ironic. This book is going to be called "drinking with strangers." I just rode my bike down to a local beach bar to proofread the final edit of this book, sat down at the bar, and this is how the next hour of my life went:

Two guys to the left of me, in their mid-forties, and three girls to the right. The girls are cute: they're maybe in college or work at a hospital together (I haven't been able to distinguish the two types from each other). The guys to my left are perfect, sloppy, textbook "What the hell have I become"s. They won't leave me alone. For the next hour, I will be accosted with the subjects of "hair metal," "the Internet," and their past sex lives. All the while, for what seems like an eternity, John Cougar Mellencamp's "Lonely Ol' Night" is playing on the speaker in the background.

At this point in my life, I can't help but think this is some kind of joke, what with the ironic history I have had with all of the visual suspects at hand . . . And audible. I played this song by "the Coug" when I was not even old enough to drink, but old enough to masturbate every day after school to Nina Blackwood on MTV. The two guys at the bar keep talking about how I couldn't relate to what they

were talking about because I am too young (they are two years older than me), and that the music they grew up on had so much more substance than nowadays—except for Gaga. They love Lady Gaga.

At least they bought me two Cadillac margaritas, and l left without having to give my life story or them asking for some sort of business card. Just know that after you read the rest of this book, you will understand this scene a lot better. Now, if you will excuse me, I have to pry my helmet from underneath the seat of the nurse/pledge leader next to me . . .

THAT'S THE WAY YOU DO IT

A Young Metalhead Comes of Age

The music business is a Crüel and shallow money trench, a
long plastic hallway where thieves and pimps run free, and
good men die like dogs. There's also a negative side.
—*Traditional folk wisdom (often attributed, incorrectly,*
to Hunter S. Thompson)

The record business is fucked—it's kinda funny
It'll separate a boy from a man
You can buy every copy of your record with your money
But you'd be your only fan . . .
—*Butch Walker, "Song for the Metalheads"*

Screw or be screwed—in the music industry, those aren't mutually
exclusive concepts: it is possible to do both simultaneously. The
term "rock and roll" actually comes from a euphemism for screwing,
and with good reason. From the beginning, the music held such a
sexual allure, Ed Sullivan felt it necessary to censor Elvis Presley's hips
on national television. Since those early days, musicians have also
been getting screwed out of their earnings by managers, record com-
pany dudes, greasy promotions men, ponytailed, burned-out, non-

musical disc jockeys, alleged songwriters with nicknames like "the Doctor," and so on. Yes, screwing and popular music prove inextricably intertwined—although, for me, it was a bunch of grown men wearing makeup and platform boots that put me on the path to losing my innocence, fiscal and otherwise, to rock and roll. When my ears lost their rock-and-roll virginity, it led to me actually losing it as a whole, which led to me getting screwed (several times) in the music business. As a wise philosopher with a seven-inch tongue rumored to be surgically enhanced with cow parts once wrote, "The first step of the cure is a kiss." Or, in my case, KISS . . .

In Christianity, they call the period before spiritual enlightenment "Before Christ" (or BC). For me, that period is known as "Before KISS" (or BK). Today, I am considered a decent success in the music business (well, when it actually was a functioning business): you may not know my name, but chances are if you even occasionally listen to the radio in your car, you've probably heard a song I've produced, or written, or maybe even played cowbell on. As a producer and songwriter, I've worked on songs for the likes of Pink, Avril Lavigne, Weezer, Katy Perry, Dashboard Confessional, Fall Out Boy, and—please don't hold it against me, I can explain, really—Lindsay Lohan (okay, that wasn't a hit, but it makes for a hell of a footnote). In 2005, *Rolling Stone* even named me "Producer of the Year," graciously overlooking the whole Lohan thing. As a performer, I'm often derided as a one-hit wonder thanks to "Freak of the Week," the ubiquitous-on-the-radio-for-a-minute single from my old band Marvelous 3, which is typically lumped in with the other "number bands" populating the second wave of the '90s alternative rock, like Eve 6 (number band), 3 Doors Down (Southern rock number band), and yes, Horseshit 6 (asshole by numbers). I've even had a long-standing solo career as a "mid-level artist," which among music professionals can be considered both an insult and a compliment simultaneously: basically, if you're a mid-level artist,

you've obviously got some talent, but you're both too smart and too stupid to sell out effectively.

In the music biz, I've seen it all, from playing stages in the lowliest dive bars to taking meetings in the lowliest corporate boardrooms to being in the first rock band to ever tour Communist China, bringing late-period hair metal to confused locals surrounded by Red Army militia in rural sports arenas. It's been one hell of a colorful ride, and I owe it all to my mother, father, sisters, cousins, wife, Peter Criss, Ace Frehley, Gene Simmons, and Paul Stanley.

When I was a child, it would take me some time to discover the healing qualities of my future career path in hard rock and heavy metal. Indeed, metal would prove the catalyst, the spermal conduit, to the social diseases, problems, and relationship woes that bratty little teenage snot punks get themselves into. But even "BK," I was still very much into music, even as a little kid. I grew up a white boy, in a white family, with very white taste in music. My parents came from beer-drinking, sometimes embarrassingly loud, working-class folk from the backwoods of Tater Hill, Georgia. Rome, Georgia, however, is the city I was born in on November 14, 1969, and I was raised there until I was one year old. Then we moved to Columbus, Georgia, where my dad worked for Southern Bell (pre-AT&T, y'all) until I was five or six. Then we settled in Cartersville for the rest of my youth. In our house, we didn't listen to blues or jazz music, say, or anything that cultured. Growing up in small-town Georgia in the '70s, I heard more of the epitome of whatever bad music was on the radio at the time, like, oh . . . maybe Leo Sayer.

My dad ran an antiques dealership on the side, so all the furniture in the house was old, which I hated: cast-iron bed frames, turn-of-the-century quilts, and tiny old crank telephones were everywhere. As such, the family stereo was a big, antique flip-top Victrola record

player that must have weighed nine hundred pounds—*very* ergo-nomic. It had settings for 33, 45, and 78 rpm, along with a built-in radio. On that dusty, crackling machine, I would listen to my mom's records—Creedence Clearwater Revival, Barry White, Grand Funk Railroad, Neil Diamond, and whatever else was lying around.

I always went first for the albums with the coolest-looking covers, the ones that intrigued me with their artwork (something that doesn't happen too often in the current iTunes era). Mom had a live Creedence album that had photos of the band playing in concert, which looked so high-energy and amazing to me as a little kid. Grand Funk, mean-while, had a record called *Survival,* where they all dressed up like cavemen on the cover: it was so retarded, but to me, I was like, "Look, long hair, loincloths, and afros! These guys are *crazy!*" The way they looked, standing in a cave holding clubs and bones, they could've come from an import black metal album from today, but they were, in fact, the cheesiest '70s band ever.

The visuals were crucial for a dyslexic kid like me—not that any-body knew what dyslexia was back then. I remember figuring out who the Beatles were for the first time because my cousin Molly had the 45 rpm single of "I Want to Hold Your Hand." I found the green Apple logo on the label visually striking; when I listened to the song, though, it made me realize that music was not just about the album covers. The Beatles were like the original boy band, and I just wore that single out because the power of their melodies hit me so hard. All their great amazing chords, the way John and Paul harmonized—they just freaked me out so hard that I went into full-on Beatlemania mode.

And then there was my first Elvis experience—Presley, that is; Costello would come later, and provide perhaps an even stupider tattoo choice (that's a story for another chapter). That's actually hard to believe, considering the Presley ink on my arm. It comes from the cover of an Elvis record from my mom's collection, *Aloha from Hawaii via Satellite:* I got that tat while on tour ten years ago, to remind myself why I got into

music. Admittedly, it's probably not the best Elvis album to choose skin art from. Of course, I got an image of the fat, pill-popping, drug-addled, suicidal, fall-asleep-on-the-toilet Elvis permanently etched into my flesh; then again, I have no regrets about it—really, the first memory I have of rock and roll is the cover of that record. It was a double album: I would just sit and stare at the pictures and think, "Oh my God, this guy is *really sweating*." In the cover photo—set in outer space, naturally—a satellite projects onto the moon's surface an image of "The King" sporting a white sequined jumpsuit and that infamous crazy hair get-up. *Aloha!* When I was a little kid, that visual burned into my tiny brain. I just did not see people walking around the streets of Columbus, Georgia, looking like that. To me, he looked like a space alien; soon enough, I would look like one, too. I remember listening constantly to this Elvis record. He was the first person I have ever heard on record with a *growl*—you know, "You ain't nothin' but a hound dog!" It was like the metal voices I would hear years later: it just sounded so angry that I immediately was fascinated with it and loved it.

Elvis was the perfect gateway drug, however, to lead me to my next obsession: KISS. Talk about space aliens. When KISS hit, it was all over for me: they borrowed the melodies of the Beatles—Gene Simmons, KISS's own "God of Thunder," is an avowed Fab Four freak—but they had visuals and a heaviness like nothing I'd ever seen or heard. Even to my third-grade sensibility, their stage show and costumes made the circus seem totally lame. In fact, I saw KISS in concert before I ever even went to the circus.

For my induction into the KISS Army, I have my cousins Zack and Nick to thank. They were from my mom's side of the family, and lived in Columbia, South Carolina. They were both very talented—like, *stupidly* talented: good-looking, smart, funny, and popular at school. In fact, they were such attractive kids, they even modeled for

the local department store. I was the exact opposite of that: dorky, antisocial, and kind of chubby. I did not have "it," and they always did. I lived for visiting Zack and Nick, and for them visiting us, because I just thought they were the coolest guys. Almost none of my friends my age in Cartersville were into music, which I was into excessively. In Cartersville, it was all about gun racks, pickup trucks, deer hunting, farming, quarterbacks, and meth heads—sometimes all at once. There, it was not socially (or religiously) acceptable for a kid to play a guitar and listen to rock music as much as I did. That's where Zack and Nick came in.

It's not that I could relate to them: I wanted to *be* them. They were only two and four years older than me, but they played guitars and drums and sang, too. They even had a band, called Aries: Nick, who was the younger brother, played bass, and Zack played drums and sang. They played concerts at their school, for which my aunt made them stage costumes: satin one-piece jumpsuits with bellbottoms and sequins all over them.

With a little portable recorder, my grandmother made a tape of Aries' performance at their sixth-grade talent show. I would just listen to it religiously, freaking out: I could not believe these superstars were my cousins! I knew there was hope, because these guys were close to my age, but just shredded. In sixth grade, Zack was ripping it, and remains one of the best drummers on the planet: he would later go on to be the singer and drummer for the legendary metal band Savatage—he's still doing the metal to this day.

Zack and Nick were so cool they actually gave me an inferiority complex. At the same time, they were totally generous and gracious, giving me my first guitar lessons. The first song they taught me was "Rock'n Me" by Steve Miller Band, and the first chord I ever learned was the D-chord. I have come to use it so many times since, that when I shake people's hands, they feel my fingers in the formation of a D-chord in their palm. Even as kids, they could really play. Instead of

playing along with the record player and lip-synching, like I did then (and like pretty much most pop stars do today), Zack and Nick actually played their instruments, doing covers of whatever was popular at the time: stuff like "Brick House" by the Commodores and "God of Thunder" by a band I'd never heard of, called KISS.

Naturally, it was Zack and Nick who turned me on to KISS for the first time. One day, we were hanging out at their house going through all their albums, and they pulled out *Love Gun* by KISS. "This band is the shit!" they told me excitedly. I was quick to agree: *Love Gun* was the first KISS album I ever heard, but then I went back and got all of them. The cover of *Love Gun* just bewitched my eight-year-old mind: the cover was full of scantily clad, half-naked women lying at KISS's feet, in a harem. It was the best thing I had ever seen.

I paid so much attention to the details in KISS's imagery: at school, I would draw their logo on everything and everybody. I could replicate every lizard scale on Gene's dragon boots, and perfected the teeth at the bottom in perfect verisimilitude. My whole world revolved around KISS: I had KISS bedsheets, the worthless KISS AM transistor radio, the action figures, all the comic books that were supposedly inked with their actual blood. I can't tell you how many times I watched their movie *KISS Meets the Phantom of the Park,* which might actually be the worst film ever made—well, until Mariah Carey made *Glitter.* I found two friends in my third-grade class, Andy Smith and Kelly Wade, who shared my KISS connection. They agreed with me that *Hotter Than Hell* was clearly KISS's best album—the title track is still one of the sexiest KISS songs ever. We would perform concerts together, making guitars out of cardboard and drums out of Lego tubs covered in aluminum foil, using Lincoln Logs for drumsticks. We'd set up in the classroom and mime along to *KISS Alive!* on the school's record player, playing air guitar and lip-synching even the obnoxious

between-song patter: *"How many people here like the taste of alcohol? I know it's getting so hot outside, you need something to cool off. I know some of you out there like to drink tequila. But when you're down in the dumps and you need something to bring you up, there's only one thing that's going to do it for you . . . 'COLD GIN'!"*

It must have been a hilarious sight, and it was probably incredibly weird for our homeroom teacher. Andy, Kelly, and I, however, were absolutely convinced of one thing: we were going to *make it* as rock stars. You see, the weird thing is, when we did these little "concerts" in our classroom, one thing would always ring true: afterwards, everyone there treated us differently the rest of the day. The teacher was always nicer and would let a lot of things slide, and our classmates (especially the girls) were much more accommodating to us. "You can have the rest of my egg salad." "You can go in front of me in the bathroom line." This was the common thread that would lead me to believe that when you are famous, people will go out of their way to make you happy because you can do something that *they can't*.

Being into KISS required a certain commitment that our local community did not share. Young boys wearing copious makeup just wasn't something you saw every day in Cartersville, which is what my dad, Big Butch Sr., always used to say. Big Butch was a man's man who wore a cowboy hat, listened to George Jones and Kenny Rogers in his pickup truck, and was always the loudest, drunkest, and funniest guy at neighborhood parties; I'm sure he was convinced I was going to be gay or transsexual when I grew up. When I was four, I would wear a tutu and dance on the coffee table with a fake guitar to Elvis records. Joining up with the KISS Army took my questionable sexuality to a new pinnacle, though: now, after school, I would get into my sister's makeup collection and try to copy Ace's "Spaceman" look on myself. If my dad was sitting there having beers with all his buddies watching

Dukes of Hazzard, I just knew I was going to get in trouble looking like that. As for my mother, a saint who doesn't drink and plays piano for the church to this day, I can only imagine what she thought of *Hotter Than Hell:* she would regularly bust into my room upon hearing some risqué lyric blasting through the wall, demanding, "Do you know what they are saying?" I would always reply "No," which was true. I was *eight years old!* I had no idea what they were singing about—it just sounded badass.

I kept dressing up like KISS, especially when I heard they were coming to Atlanta. I really have to toast my parents for letting me talk them into taking me when I was just eight years old to a KISS concert. I begged for it—it was my birthday and Christmas gift all rolled into one. The show was set for December 30, 1977, at the Omni Coliseum, and was completely sold out: this was the high point of KISS's career—the *Love Gun* tour. That was the *big, big* tour, with the lit staircases, the risers that came up and moved back and forth, and Gene literally flying up into the scaffolding during "God of Thunder." Going to that concert changed everything. The whole experience freaked me out—my parents, too. Everybody was dressed up as their favorite KISS character. I smelled pot for the first time. I saw older kids in cool clothes. Everybody in the crowd was drinking: my dad was threatening to kill this twenty-year-old in Gene Simmons makeup who kept spilling beer on his brand-new leather jacket. KISS was a learning experience for us all. At this concert, my dad was as uncomfortable and paranoid as a whore in church. The whole time, people were passing joints down over my mother and my sisters and me, the youngest of three. Everyone was loving it, and of course I loved it. I loved it all.

I remember the opening band, Piper, had to play with the house lights on because KISS wanted to be the only band that played in total darkness. Ironically, Piper's lead singer, Billy Squier, would later go on to a successful solo career. I thought Piper was amazing, even with

the lights on; this was, after all, the first band I had ever seen live! I couldn't get over how exciting it was. For years, onstage I would throw guitars to my tech: that practice came from watching Billy Squier do that with Piper that night. He would throw his guitar fifty feet, then get another one thrown to him from fifty feet, catch it, and immediately start playing. I was like, "Man, that guy *is* rock and roll!" Did I just lose cool points? Probably.

Who cares—when KISS came on, they blew my doors off. I saw Ace Frehley make his Les Paul explode and fly up into the rafters and disappear, as 25,000 stoners went nuts. And the blood was obviously *frightening*. Paul Stanley, the effeminate, glammy pretty boy, was just shameless, and he made it okay to be that way: he came out smashing his guitar, clearly taking a tip from The Who—who, of course, I knew nothing about. I didn't know who The Who were, I hadn't heard of the Rolling Stones yet, I didn't know any of these bands. For me, KISS was like *Fisher-Price: My First Rock Band*. At the time, I didn't realize that Peter Criss was a sloppy drummer; all I knew was, I was mesmerized by the drum solo with the two cats on the riser that rose up thirteen stories as he played twenty-seven toms and eighteen cymbals (more than I had on my Lego drums), and the fact that he could play them all at once—well, that made him the best drummer in the world. Seeing that spectacle, I thought, "*This* is what I have to do!" After that, I hounded my parents for a drum set. Somehow I talked them into it . . .

Cut to the next Christmas morning, when I was surprised with a white five-piece Reuther drum kit. They were set up all weird (like in the music store window that sells lofty gear or the way that a parent with no drum background knowledge would), but it didn't matter—the memory will be in my head forever: walking down the stairs and seeing *drums* in front of the Christmas tree. I still think it was the most

beautiful sight I have ever seen. A white drum set just seemed so rock and roll to me, and I had never owned anything that was rock and roll until then. Of course, it was later deemed a mistake by my parents to have given me those drums: all they would hear every night, from after school until bedtime, was me banging on them in my bedroom. Finally they were like, "Forget it, Butch, put them out in the shed— anywhere outside the house! We cannot hear this anymore."

The drums brought out the natural performer in me, which I genetically attribute to my mother, a truly gifted singer and pianist (my father, on the other hand, always would say he "can't even play the radio good"). My talents especially bloomed at our school talent shows. At my first appearance, I played along to the 45 single for Eddie Rabbitt's "Drivin' My Life Away"—both the A and B sides— and just *nailed* it. I got so good, I started playing with older musicians. By 1980, when I was eleven, I was asked to play in an Elvis Presley tribute band—and all the members were in their thirties. I was only in that band for all of two weeks, however, because the singer's daughter was hot, and I got the hots for her, which made her daddy/Elvis uncomfortable. This hound dog got kicked to the curb, naturally, but I was ready to move on from drums anyway. I was starting to learn how to play guitar in earnest: I just couldn't stand sitting behind everybody at that point. "I don't wanna sit in the back behind the drums," I thought. "I wanna stand up at the *front*."

The big turning point that took me from drums to guitar happened when this little band called Van Halen came along. I realized what shitty musicians KISS were when I heard early Van Halen classics like "Runnin' with the Devil" and "Eruption" for the first time: they were amazing players, especially Eddie Van Halen's guitar playing, but they played with a weird, almost punk rock attitude that I loved. I learned about Van Halen from a guy named Phil Orton, who was my sister Dana's on-again/off-again boyfriend since elementary school. Phil was the neighborhood cool kid in Cartersville. I liked

him, but he was a passive hesher dude to everyone else, with dark circles under his eyes and a stoner bi-level mullet. I probably bugged him because I was a young brat, but I would go over to his house every day and hang out in an attempt to absorb his cool factor. He had the coolest stuff. I'd never seen a life-size poster before Phil, and he had every life-size poster on his bedroom wall: these huge images of Blue Öyster Cult, Rush, Van Halen, and the Police were his wallpaper. He got them from Record & Tape World, the record store in downtown Cartersville where I would buy KISS records and everything else that looked anarchic and cool. That moment when Phil Orton introduced me to Van Halen, Blue Öyster Cult, Rush, and the life-size poster represented yet another paradigm shift. Van Halen was *in;* KISS was now *out.* The way it happened was, Phil did me a solid. "I'll tell you what," he said to me one day as I was ogling Judas Priest's *Unleashed in the East* gatefold album sleeve in his man-cave, "I'll trade you—temporarily—*Kiss Alive II* for the first Van Halen record." I agreed to this Faustian bargain, took *Van Halen* home, and promptly had my tiny mind blown from the very first note.

To me, Van Halen's music sounded like a robot was playing guitar: I was like, "That is not humanly possible. What *is* this?" I was so mesmerized and mystified by this album, I just wore the vinyl out. I immediately needed to find out everything about Van Halen. This was pre-MTV, pre-video, pre-porn, pre-everything: I couldn't just turn on the Google tube and see this band. I had to look at pictures; I couldn't even see this band play live. Eventually I did find some concert footage of them somewhere, and I was like, "Oh my God, this is amazing! The singer is out of control! What's going on here?" KISS seemed lame compared to Van Halen onstage. I realized that KISS's reliance on lights and fire and everything else was used to distract from the fact that they were kind of whatever as performers. It's like the line in *Role Models* where Seann William Scott is talking to the little black kid checking out his KISS pinball machine: the kid says, "I

didn't know Jewish guys could sing rock music," to which Scott retorts, "Oh, they can't—that's why they wore makeup." This epiphany pushed me to really become an incredible musician: I wanted— no, *had* to—learn to shred like Eddie Van Halen.

Phil Orton had a family friend and guitar genius named—no shit— Huey Lewis; even weirder, Phil's uncle played guitar in a local New Wave band called the Neuz! Strictly coincidence: unlike the other Huey Lewis, who wrote "I Want a New Drug," this one actually sold them and took them and had a prison record—but he was also a mean guitar shredder who could play every note and lick on the first Van Halen album! I would freak out watching Huey jam at shoddy summer gigs at the pool park, which prompted me to start taking guitar lessons. I didn't want to just learn "Oh! Susanna" and "She'll Be Coming 'Round the Mountain" from the Mel Bay songbook, though; who wants to learn that shit when you're listening to metal and rock? I wanted to start shredding as soon as possible. To that end, I found a teacher who wanted to be Eddie Van Halen more than Eddie Van Halen did. Chris Fowler was a strict Jehovah's Witness, but he could also religiously deliver every Eddie solo note for note; he even had all his guitars (cars, toasters, and probably shoes as well) pinstriped in the Van Halen style. I took lessons from Chris once a week: he taught me all the little tricks with the whammy bar and stuff, and I became a good little wanker.

THE LES PAUL GUITAR

I remember my first encounter with it. It embodied everything I could ever want in a girl (eventually). Sexy curves, solid body (screams a lot when you touch it). *A Les Paul.* I remember when my parents took me to see KISS when I was eight years old and I couldn't wait to see what color Les Paul Ace Frehley was going to play. I had studied

the album covers, *Creem* magazine spreads, the posters in my room, and noticed how he only ever alternated between a cherry sunburst Custom model and a tobacco sunburst Standard model. Both seemed so expensive, so fragile . . . and so . . . *bitchin'*—the way it hung low on a strap and made *anyone* look rock and roll with it. Hell, even when my mom took me to a Toys for Tots radio station Christmas concert when I was eleven years old, and I saw such greats as Exile, Little River Band, Paul Davis, and Eddie Money play, even the guitars playing knobs that were backing these guys up *all* had Les Pauls. When I saw Mick Jones from the Clash playing one . . . well, that was all she wrote. I *knew* it was the coolest guitar in the world.

I would drive down to Atlanta to the local music stores, just to paw at all the amazing Les Pauls they had on display. Music store dudes hated me. I was *that* guy that came in and asked to play the sunburst Les Paul behind the glass, through the loudest amp, and play my funny metal squeals all day on it. But don't worry, guitar-seller guy. I'm gonna own one of these one day. I am gonna have money from playing music and be famous and shit . . . "Sure you are, kid . . . sure you are."

Ironically, to this day, I have strayed on and off Les Pauls for live show use, due to the luxury of choice throughout the years, but in the studio *it is the only guitar for rock.* My prized one to this day is a tobacco Standard that was given to me as a gift by my friend Alecia Moore (Pink) after a fire took all my guitars (and everything else . . . more on that later). It is a beauty and I will never part with it. I used it to write and record everything for the longest time after the fire. Les Paul, the man and the guitar . . . I salute you for carving out a little piece of my soul into your guitars for me. . .

By that time, I was already playing with all these bands around town. I got into a group full of guys that were all from the Atlanta suburbs, which seemed really cool to me because they weren't just hicks from Cartersville. We were called Standing Room Only (SRO). Our bass player, Tommy, came up with the name; later in life, I heard he went on to drug rehab, divorced his wife, and then married his rehab counselor. The cool kid in the band was twenty-five years old: he was a mediocre guitar player and a marginal singer, but I thought he was hip. He knew this keyboard player, a total rocker chick from Atlanta named Laura. Laura was still in high school, three years older than me, and the person to whom I would lose my virginity. She was my first-ever real love—my first major rock crush. When she walked in the room with tight leopard-print jeans on, *big* crazy bleach-streaked, Aqua Net hair, and heavy eye makeup, I took one look at her and lost it. I was like, "Oh my God, I've found my very own Pat Benatar—my own Lita Ford." No girls like this ever existed in Cartersville. Only on MTV . . .

We became serious lovers midway through sophomore year. Many years later, I'd write a song about Laura: "Lost my virginity to a girl in my band/She was three years older—she made me a man." Before Laura, I hadn't had much luck with the ladies. I was not a player back then; in fact, I got *no play* at all. Girls in my high school were not attracted to me: I wasn't a jock or a redneck, so I was definitely not cool to them. So, to be fifteen years old and be able to take down a senior—a *senior!*—who wore leopard jeans and looked like Pat Benatar? Cameron Crowe couldn't have scripted my loss of innocence any better.

The deed took place in our band's practice room, which happened to be in my mom and dad's antique store behind our house. I'll never forget it: Dire Straits' "Money for Nothing" was playing on my little radio when I had my first-ever orgasm inside of a woman. I was so damn nervous. I was worried I wasn't doing it right. Just as my little

vessel was about to actually meet the mother ship, Laura looked up at me and said, "That's the way you do it"—right in time with Mark Knopfler's famous line from the song coming out of the radio. It was so sexy and awesome and awkward: I was scared to death, but it was the most incredible five-minute experience of my life. After that happened, it was *on*. Laura had unleashed a complete gushing river of sexual libido and physical ability in me that I never knew was humanly possible.

Eventually, Laura and I ditched Standing Room Only and started a new group with some friends of hers from her school; in keeping with our pattern of wildly unoriginal band names, we christened ourselves the Scene. We were really into pop, playing hits from the likes of Journey, Huey Lewis, the Babys, and Blondie; one of our signature numbers was "Voices Carry" by 'Til Tuesday, which Laura sang and played synthesizer on. The Scene would play shows wherever we could, from a home for the mentally disabled to a school for the deaf, which was an interesting gig. All the time, though, we had our eyes on a bigger prize: we wanted to be the house band at the Six Flags amusement park.

Six Flags was a crucial part of my musical upbringing, as well as the first place where I would experience the arbitrary, Crüel, exploitative nature of the music industry. For years throughout my childhood, my biggest thrill was getting to go to Six Flags every summer, but I didn't go to ride the roller coasters: I went to see the house rock band. They always had an outdoor shed with a rock band playing covers, three sets a day, and I would just sit there, mesmerized, watching all three sets. These were real people, with real instruments, playing songs I knew from the radio, which blew my mind. We simply did not have anything like that in my little town.

By my junior year, after playing tons of crappy gigs, the Scene was ready to move up in the rock-and-roll food chain, and Six Flags was our Everest. After all, we'd become a really good cover band, but we

were still too young to play bars in Atlanta. We figured our best option was to try out for Six Flags; at that time, nothing sounded better than spending the summer getting paid to play "Hit Me with Your Best Shot" and "What I Like About You" in the great outdoors to a captive audience of maybe forty people. To that end, we rehearsed like mad for the "battle of the bands"–style tryouts, building up a

thirty-song repertoire of nonstop summer hits. Little did I know that, despite our best efforts, the odds were already stacked against us.

At this point, the band that had been the reigning kings of Six Flags was a group from Marietta, Georgia, called Rare Breed. Rare Breed was the premier local cover band of the day: the members were really good-looking young dudes, suburban rich kids that looked like they could have been in Huey Lewis and the News (them again), which admittedly isn't saying much now. But at the time, they looked like a real band, with perfect flashy clothes and really good bi-level haircuts; half of the band members were brothers, which upped the cute factor even more (like, Hanson and Jonas Brothers–level cute). Rare Breed's problem was that they were really bad; in fact, they were horrible. I never understood why they were so popular and got the Six Flags gig year after year. They did have a large female following, which I attributed to their looks, but that wasn't enough to explain why they considered themselves massive rock stars. Rare Breed were truly delusional regarding their rock-star status (especially the bassist . . . I don't remember his name). I remember seeing him at a concert for Stryper (a glammy, Christian metal band): he was out in the audience with his arms crossed, criticizing Stryper's bassist, thinking he was better. I was like, "You guys are a fucking *cover* band. Stryper might make ridiculous Christian heavy metal, but at least they are a real band. I hope you get pelted in the head tonight by the New Testament." Yes, Rare Breed were as lame as they were legendary in their own minds, and we were sure the Scene was good enough to snatch the Six Flags crown from them.

We were confident going into the auditions to determine if we would become the next Six Flags cover band. I was sure it was our time: after all, Rare Breed had already been the Six Flags house band for three years straight. "How can they keep getting this gig?" I wondered; surely they couldn't keep beating the odds—especially as there were fifty other bands auditioning that year. But when we played,

dare I say it, we kicked their asses. The judges narrowed it down to just us and, you guessed it, Rare Breed. We were *in*. I knew it. We were going to do this, and I could not believe that we'd finally made it—that we'd come this far. Therefore, I was shocked when it was announced that, yet again, Rare Breed would be the Six Flags band all summer long. I found out later Rare Breed had had the whole thing set for years: allegedly, the brothers' dad was one of the chairmen of Six Flags or something. *That* was the reason why this shitty band that was all looks/no hooks kept getting the cool gig, year after year. Welcome to your first taste of the music industry, Grasshopper. This scenario would repeat itself again, and again, and again, throughout my career.

Losing the Six Flags gig broke up the band, but it also fueled me to really step up my game. When the Scene dissolved, Laura and I tried staying together for a bit; ultimately and sadly, I think I'd moved on from her, musically and romantically. I felt the pull of my hard-rockin' roots: I didn't want to play second fiddle to synthesizers and limit myself to a steady diet of Top 40 hits—my fingers couldn't make the chords for "The Power of Love" by Huey Lewis one more time. No, I wanted to rock, and rock hard; I wanted to *shred*. I was steeped in metal, hair metal, glam, all of it, and there was no turning back. After Van Halen came AC/DC, then Judas Priest, then Iron Maiden—and, of course, Mötley Crüe. I was obsessed with the Crüe at that time, especially their *Too Fast for Love* album. Mötley Crüe was the ultimate sleazy, do-not-give-a-damn, excessively rowdy band—and, incredibly, they still kinda are. If only I had a time machine to go back and tell my teenage self that I would someday end up at a weird and dark Encino Hills mansion with Nikki Sixx while avoiding coked-out *Playboy* models and going on helicopter joyrides with Tommy Lee in between writing songs together . . . I still don't believe it.

As hard rock became a bigger part of me, I started transforming into the shape of a rock guy. I grew my hair out, and by the time I'd turned sixteen, I'd become this phenomenal shredding guitar player. I was fanatical for all the freakish speed-demon virtuosos of technique. I was into Yngwie Malmsteen; still, of course, into Eddie Van Halen; I adored Steve Vai, even the stuff he did with Frank Zappa; Neil Schon from Journey; Santana, without a doubt. In particular, I was a junkie for this small subgenre of all the early shred-metal gurus—George Lynch of Dokken, Paul Gilbert of Racer X (and later Mr. Big), Chris Impellitteri, and a bunch of other guys with long Italian last names and big hair who could shred. You had to play insanely fast and technical or you wouldn't even hold my attention. I had a real need for speed: I would even go to guitar clinics to learn how to play faster. I needed to get off, musically and otherwise.

I found I craved metal's guitar-driven assault all the time, but also I loved that metal was dark, confrontationally anti-religion, and above all *dirty*—that it was about sex, not love. These were all things I wanted to explore. I was getting a little bored, living a double life. "Goddamn it, I need to go for it," I kept telling myself, trying to build up the courage. I needed a new band that would be willing to not just go for the brass ring, but wear it as an earring and maybe hang a big pink feather off it, too.

Before I would fully embrace the metal god, however, I had to endure a very brief encounter with the Christian one. In the middle of my junior year, I did not know if I was on the right path with my love for Satan's music, and my questioning was amplified via my peers who were Christians. Growing up in the Bible Belt, I was surrounded by Christianity: I even was forced to go to church on Sundays, which is something I still resent to this day. I will never force that on my kids—if they want to learn about religion, it'll have to be due to their

own prerogative. Today I detest organized religion, but being young and impressionable, I went through a very brief post-adolescent phase of Christian rock in that moment. I had a Christian friend from school, who liked rock music; I didn't have my license yet, so he'd drive us down to Atlanta to see Mylon LeFevre and Broken Heart play concerts at Mt. Paran Church. We'd see all these Christian versions of punk, metal, and rock bands. While passing around the bread offerings and drinking grape juice from a goblet, eventually I got asked to join a touring Christian hard-rock group called L.O.U.D., which stood for—get this—"love over universal destruction." I was excited—rockin' for God would be my ticket *out*.

I had two years at high school left, but I was sixteen—old enough to legally quit. I did not give a shit about school. By the time I was a sophomore, I really had no desire to go to class: I knew what I was going to do in my life—I was going to *rock*. I definitely wasn't going to college, that's for sure. I figured joining L.O.U.D. could be my ace in the hole with my churchgoing parents to allow me to quit early. I thought, "Well, I can quit school, but I'll be on the road with a Christian band, so they'll know at the very least that my morals won't be all messed up." The idea did not resonate well with my dad, however. Butch Sr. possessed real leadership skill, especially for someone who had pulled himself up from nothing to some semblance of success: he's a proud twenty-six-year employee of AT&T, and I used to love to visit him at work in Atlanta at the Southern Bell building in Little Five Points (the very same neighborhood that would become the hub of Atlanta's music scene, and where I would reside as rocker, resident, and barfly for over a decade). However, as a kid, Big Butch was not much of a student, and I believe that shame hung over him: he didn't want the same thing to happen to his kids. I remember finding his report cards from his childhood, hidden in his closet next to the guns and his secret stash of *Playboy* centerfolds from the '50s and '60s that I would love to look at. Dad's report cards had no vowels in them: they

were straight consonants, all Cs, Ds, and Fs. And right when I was considering going on the road with L.O.U.D., we were going through a big generational disconnect centering on my own academic career (or lack thereof).

It all came to a head during a very emotional argument one day after I came home from school. At that point, my father was experiencing what I thought to be a midlife crisis. His mother had just passed away, so he had no parents anymore, and he was in a melancholic, often drunken-like state. I, meanwhile, was a little punk who thought he knew everything because he was playing nightclubs every night. That day, Dad sat me down and told me in no uncertain terms that he wanted me to graduate from high school. Even though he had never done well in school, he didn't want me to end up as a quitter, and he certainly didn't want me to end up uneducated, with no prospects. He asked me to at least finish high school, and if I did that, he would morally support me wholeheartedly in whatever I did. I remember it to this day because of the tears in his eyes: I never saw my dad cry that much. "I'll never tell you you can't do something," he told me. "I'll never stop you from doing anything. You can go play six nights a week, and do whatever you want, if you'll just promise to graduate. Please, please, just don't quit." I saw how much it meant to him—his face just screamed, "Don't fuck up"—so I agreed. Many years later, I would write a song about that conversation on "Song for the Metalheads," a track that appeared on my 2008 album, *Sycamore Meadows:* "If it's one thing my father said when he was younger/To a kid with a mullet that looked like his son/To want and to try is the difference why/Some people will walk, and some run."

I have a lot to be thankful to my dad for from that moment: not only did I finish high school, but he saved me from a career in Christian rock. I quickly returned to my dream of forming my ultimate metal band. My first metal group was started with a couple of stoner kids from Marietta: we called ourselves Nytemare. Yes, that's right—N-Y-T-E-M-A-R-E. It

was my first experience with choosing heavy metal names: like choosing a porn name, it has to be just right. It's no different than that scene in *Boogie Nights* when Dirk Diggler discovers his name while smoking pot in a hot tub with Jack Horner in an Encino backyard: "I want a name that just lights up when you hear it—where you can see it in lights." While it is by no means an exact science, one can get started by, say, replacing any instance of the letter "i" with a "y." Similarly, "z" can, and often should, be substituted for the letter "s": Naughty Toyz, for example, just seems so much *heavier* than Naughty Toys. Try it sometime . . . This foolproof process turned William Bailey of Lafayette, Indiana, into Axl Rose of Guns N' Roses; it has also worked wonders in modern hip-hop (which essentially is the same blueprint for hair metal of the '80s). For Nytemare's individual stage monikers, we simply adopted our first and last names from two different metalhead heroes. For my metal alias, I became "Robbin Frehley." At the time, Robbin Crosby from Ratt was my favorite guitarist, and I liked Ace Frehley, too, so therefore "Robbin Frehley" was born, albeit for a short time (I can't believe I am telling you this shit).

At first, we were like a gang: we'd go down to Six Flags covered in bandanas from head to toe, dangling earrings, smoking pot, cigarettes, or whatever we could get, and make fun of wimpy-ass bands like Rare Breed. Nytemare, alas, wouldn't last long. Ken, the other guitar player, thought he was the dick and balls, but was really just a dick with no balls—a loudmouth, cocky, snotty little hesher dude from a white-trash neighborhood in Kennesaw, Georgia. At first, Ken seemed like a real bad boy to me, but it soon became clear he was just a shit talker and a terrible guitar player. I was a much better guitarist, so I was soon on my way to bigger, better, and heavier things.

Accordingly, I found my next partners in rock via my continued pursuit of shreditude. My musical chops had actually received a steroid boost a few years earlier, when I was forced to switch guitar teachers. Chris, hearing the call of Jehovah, eventually stopped giving

lessons, so I started up with another guy in Rome, Georgia, which was thirty minutes away. At the time I couldn't yet legally drive, and my mom wouldn't be out of work yet, but my teacher, Jerry King, would come and pick me up after school, even though he taught something like fifty students a week. Jerry was so passionate and crazy: he was a former Bay Area hippie who'd gone to music school at Berkeley. I idolized him. Jerry taught me how to do everything—music theory, chords, jazz; he even taught me about the music business, giving me a book on how to make a living as a musician. He saw I was very serious about making it, especially for my age. I got so good, he basically retired me after three years of taking lessons from him. In the beginning, Jerry would put together jazz guitar ensembles with ten of his best students and a drummer: we'd go out and do these concerts, playing complicated chart arrangements and medleys of old '70s Santana songs, the Allman Brothers—things that I didn't know about until he introduced them to me. The elite from Jerry's stable would put on shows at the Rome City Auditorium every year; then, for the second half of the concert, he would let any of us that had our own bands play twenty-minute sets. That was even more important to us—we would get to play a concert for all the kids in Rome! The Scene dominated Jerry's Rome revues, along with another band called Oasis. No, not that Oasis: there were no feuding Gallagher brothers in '80s-era rural Georgia. This Oasis was clearly the Scene's only real competition in town, though, and its members shared my mojo for metal.

Oasis had Jimmy Shilestett on guitar and Doug "Slug" Mitchell on drums, and I became really close friends with them immediately. Like me, they loved Mötley Crüe, Ozzy, Priest—all that. I started hanging out with them more than I did with my girlfriend, or anybody else, really: I'd missed out on having a brother growing up, or any friends that were into the same things, so these guys were my connection. I ended up hanging out constantly with those guys in the parking lot at

the Krystal Burger, eating fast food and listening to metal cassettes in our mini-trucks all night long.

We really bonded, though, when we'd camp out for concert tickets at Turtle Records and Tapes. Back in the day before the Internet and online ticket scalpers, you had to camp out in line the night before to get good floor seats for concerts: tickets would go on sale at eight A.M., and if you were not already in line hours before, you knew you were going to get stuck in the nosebleeds. Camping out for tickets begat its own subculture, which was amazing—sort of like the documentary *Heavy Metal Parking Lot,* but instead of congregating at the actual concert, we'd hang and party in the ticket line in front of the record store. All the effort often proved worth it: I camped out for Mötley Crüe tickets during the *Shout at the Devil* era. They were opening for Ozzy on the Ultimate Sin Tour, and on their second song, Vince Neil kicked a security guy in the head and went to jail. That was the best concert ever to me.

Jimmy, Slug, and I would go to those concerts together and mingle with all our fellow metalheads at this record store called Strawberries in the Riverbend Mall; we'd just go to the back room, set up shop for hours, and get schooled on music. Not only was I mesmerized by the girl who worked behind the register, but Strawberries got all the best import records on vinyl: Raven, Celtic Frost, Venom, Possessed (whose guitar player would go on to be in Primus), Mercyful Fate, Tygers of Pan Tang (which is where John Sykes, formerly of Thin Lizzy and later of Whitesnake, ended up). I would never hook up with Suzie, the girl who worked the Strawberries register: while I adored her leopard-print trench coat and jet-black Joan Jett haircut, Suzie became more like my wise big sister. She was older, and all her conquests were in touring metal bands. I was mesmerized by Susie's knowledge and her inner-circle status inside the local Rome metal scene. She really took me under her wing, so I trusted her judgment when she introduced me to Chuck.

Of course, I already knew who Chuck was—you couldn't miss him: he would walk into Strawberries looking like a rock star, which he sort of, in his own local mind, was. Chuck and this guy Drew Martin played in a regionally popular heavy metal cover band: they were touring all the time, even outside of Georgia, and I was impressed that they had their own PA system and homemade light show. I thought they were *big time,* so I was stunned when they asked me to audition for them. One day Chuck came up to me and said, "We heard from Suzie that you're a hotshot guitar player. You should come down and rehearse with us." All the while I'm thinking, "Wow! This is it! My big chance, finally!" We jammed and decided to start a whole new band we called Badd Boyz. Bad, indeed: I would later find out this guy wasn't who I thought he was. Lemme tell ya, it was a hell of a way to spend my high school years. I thought I was in heaven. I would think with amazement, "Wow—I am going to high school during the day, and I have this secret life at night!"

To this day, I still love Drew Martin. He was like a big brother as well, but very fatherly and stern. Brash and confident, he could sing David Lee Roth better than, well, David Lee Roth. Chuck, I don't like him so much. I would ultimately find out what a shitty and horrible person he was, but not until after he'd been my mentor and best friend for a good long while. He was the guy who took me under his wing, showed me the ropes, and introduced me to all of the glorious demons—in particular, all the girls with STDs and drug habits. In Chuck and Drew, I had truly found my tribe. Chuck played bass and sang: he had a high voice, so he could sing a lot of crazy metal songs like "Mean Streak" by Y&T and all these covers that I always wanted to do. For our first rehearsal, I brought along Slug from Oasis to play drums (the original drummer left to play in a Holiday Inn circuit cover lounge band), and we had instant musical chemistry. The first song we played together was "Bark at the Moon" by Ozzy Osbourne, and Chuck and Drew just lost their minds at how good we were. Slug

was my age, but he was a shredder on drums, and me, I could play all the Jake E. Lee solos note for note. Once we started jamming, they were like, "Oh, you guys are more than hired." Looking back, I think Chuck saw us as his meal ticket. He had the hair and the image and everything, but was a very average talent compared to Slug and me, and we were ten years younger and prettier to boot.

Badd Boyz rehearsals took place at the local Fraternal Order of Police lodge in Rome, Georgia. Now, how did a band full of deviant, under-age-beer-drinking, chick-mongering slacker metal dudes practice at such a place—and free of charge, I might add, with twenty-four-hour access and our own key? The only expectation was that we had to be the backup band for Kenneth Kines, the local chief of police, every year at the annual policemen's Christmas ball. Chief Kines fancied himself an expert Elvis impersonator, so he'd slick back his hair, dress up in rhinestones and boots, and we'd play covers of "Hound Dog" and "Heartbreak Hotel" all night. By the way, he called the band—I couldn't make this up—"Kenneth Kines and the Fourskins." Being in with the local police certainly held advantages for a young rock-and-roll dirtbag. I just remember many times driving around Rome after three A.M., a little buzzed and stoned after playing a show, and I'd see the blue lights of a police car coming up behind me. Instead of busting me, though, the cops would pull up next to my mini-truck, say, "Is that all you got, pussy?" and then hit the gas hard. We'd end up drag-racing down Highway 411.

It was a hell of a ride, my life at that moment. My parents, my teachers, my friends from school—they did not know about all this. I was breaking all the rules: we even had secret mattresses stashed down in the basement of the Fraternal Order of Police lodge, where I got turned into a man by the crazy girls who would hang out with us. Chuck knew all the really hot girls into hard rock. With their big

hair-spray hair and animal-print miniskirts, they resembled the red-neck-lite version of the chicks in Hollywood filling the Sunset Strip, like the ones that we'd see on MTV in Mötley Crüe videos. Soon enough, I'd be experiencing the real thing.

We started playing at this place we'll call "Bo's Chicken Shack," which had no ceiling left after our first week gigging there: all this asbestos was hanging down because our homemade pyrotechnics had burned out the tiles (thank God we didn't burn the club down like Great White did in Rhode Island in 2003). Bo's was a dump, whose owner was a good, jovial man with a taste for the rock-and-roll party lifestyle. I knew that the band was earning money, but I was too young and stupid to pay much attention. My mind was elsewhere, anyway—I was usually in the corner, wasted on free drinks and getting dry-humped by a girl with the Kennesaw Claw for hair (Kennesaw being a popular Atlanta suburb full of these girls with upward-hair-sprayed, claw-like bangs) before having to go to high school three hours later.

This was my life, six nights a week. By our second summer with Badd Boyz as Bo's house band, Slug and I had our own keys to the club, which was insane, because I was only sixteen years old and Slug was just a year older; it became *the* place to hang—our own private man-cave of sin. We could drive there any night after hours and get all the beer we wanted. We had a mattress under the drum riser, too, where we'd take girls after the bar closed (I know, gross . . . I'm sorry, Mom!).

We were starting to draw larger audiences so well that every time we played, we could pack out Bo's. We were the only reason that place stayed open: it was always dead on the nights we didn't play. Then it would be packed to the gills—every person in Rome, Georgia, would be there, out of their minds on cocaine, meth, and alcohol. Badd Boyz were playing three sets a night, and I was making great money for a teenager—it sure beat working at Kentucky Fried Chicken.

By now, I was beginning to suspect that something was wrong, but Chuck managed the band's finances, which gradually became an issue between us. Realizing something was deeply fishy with Badd Boyz, Slug and I secretly decided to move on. We started talking quietly to Slug's former bandmates in Oasis about creating a new super group. We were already friends, and whenever we saw each other, we were like, "Yeah, man, we should get together and *jam* sometime!" The plan was to covertly unite the best of the best from Rome's music scene to create the greatest metal cover band ever (?). Indeed, this band would prove to be my ticket to the famed Sunset Strip and its bacchanalian orgy of metallic pleasure. Little did I know we'd be the hometown heroes for a long time after we signed the proverbial Big Major-Label Record Deal.

Under everyone's noses, we formed this new super group, which we named Byte the Bullet. Chuck smelled a rat, so he cut ranks and disappeared. Before he skipped town, though, he took all the money from a couple weeks' worth of Badd Boyz shows and stole all of the band's equipment. We had a school bus that we converted into a tour bus, which the band owned collectively, bought with our gig money; that left with him, along with everything in it. We owned everything in our little empire of a traveling road show: we had a professional truss light show, full PA system, all the amps and guitars I used—and Chuck just took off with all of it. He was never to be seen or heard from again. I wanted to kill him, yes of course; I was so pissed, I cried like a seventeen-year-old. Right then and there, I realized that the music business will fuck with you no matter what: that those guys who were your friends, bandmates, gang members, fellow musketeers, whatever—they can and often will screw you at the drop of a guitar pick. After that, I made sure I was always the leader; I always took matters into my own hands and did every deal, settling up everything myself from that point forward. In that way, Chuck was great for me: he gave me my independence.

<center>★ ★ ★</center>

After suffering this loss, I was determined to succeed with Byte the Bullet. First, however, we had to undergo a purification ritual, shed our former identities, and take on new metal names—well, most of us. "Butch Walker" and the name of Byte's bassist, Jayce Fincher, were deemed sufficiently tough-sounding; Slug, however, became "Mitch McLee," while Jimmy became "Jesse Harte." Jesse was the rhythm guitar player in Oasis, but then I discovered that he had a crazy-pitched voice—an undiscovered high-range metal squeal that even he didn't know existed. Plus, he was really cute, in good shape, with a baby-faced Leif Garrett look and bleached-blond hair. I was like, "Oh, this is perfect! You are my guy. You are my Vince Neil." I did not want to be Vince Neil; I wanted to be a serious shredder like Jake E. Lee. So Jesse dropped the guitar and became the front man from that day forward, and that is when we became Byte the Bullet. That name just sounded "rock." Of course, we had to misspell it. There was no other option—blond lead singer plus misspelled band name was the only way forward, give or take an umlaut over the vowels. I know we had umlauts somewhere, but I cannot remember where I put them. Has anybody seen my umlauts?

Getting started was tough, as Chuck had split with all my gear. We decided we didn't need fancy lights or a PA system; we would dazzle people with our musicianship alone. Once I got a used Ibanez guitar on layaway at the music store that I worked at, it was on. At first, however, we had trouble getting gigs, because Chuck burned so many people in the music scene. But soon enough we took over as the reigning kings of Bo's Chicken Shack, which was funny, as we were all still way too young to even get in there. But we didn't fit in with our age group, either. I would get up to go to high school half-asleep after playing a gig the night before, eyeliner still running down my face. Seeing me, the cheerleaders would always say, "Oh, how is your *little* band doing? That is so cute! You play in a *little* band. Maybe you can play our prom this year or something!" They

would be so condescending, thinking their lives were so goddamn amazing and exciting, while mine was so pathetic and trivial; I was like, "You have no idea what I did last night." My parents reiterated that as long as I maintained a C average and graduated, then I could do whatever I wanted; if I received any failing grades on my report cards, however, then I was done. I made sure I got a B average just to prove that I could do it, but I was ready to get out of there as quickly as I could. I had a few close calls, though. In my senior year, I'd signed up for Diversified Co-op Training, where, if you weren't going to take college prep, you would get class credit instead for working a job. Best of all, doing DCT, I got to leave school at lunchtime. My DCT teacher, Mr. Pinkard, was an asshole, though. He loved to fail people, obsessively checking up on students with surprise visits where they worked, because there was nothing he loved more than busting your balls. Alas, there was no way I could tell him, "I'm working in Atlanta playing clubs six nights a week"; that would never fly. Instead, I taught guitar lessons at the local music store, Strings and Things. The store was a real revelation for me. The last time there was a music store in Cartersville, it was run by a drunk who gave me two guitar lessons (both out of the aforementioned Mel Bay book), after which I quit due to being bored out of my skull. Strings and Things was more progressive. When I found out they were looking for a guitar teacher (thank you, Chris Fowler, for calling me and tipping me off on this), I immediately called the store and the guy invited me down to "try out" for the position. Keep in mind that, in Cartersville, I would have the random yokel come in and pawn off a vintage guitar for a Bible hymn book and in the same breath get told, "Look at you with your long hair—I bet you play the Devil's music." I would swiftly reply, "Is the Jesus painting above your bed the one with short hair?" After that, they would quickly leave and probably cry and masturbate on the way home. The owner of Strings and Things, Ashley Schubert, would

become one of my best friends, and also my dad's best friend and drinking buddy. Ashley was the coolest: we'd have beers every day, and he cut me a lot of slack. I'd teach guitar lessons three days a week, then cut out early and drive to Atlanta to play clubs with my band until two in the morning. If I needed to skip out and get some sleep, he would cover for me whenever Mr. Pinkard would come by to check on me. "Butch is in the back room teaching—you can't interrupt his lesson," Ashley would tell him, when actually I'd be home in bed, hungover. Without Ashley covering my back, I would've never graduated high school and gotten to pursue my holy grail of rock liberation. I think, in a way, he was good for my relationship with my father. We became closer due to the shared respect that we had for Ashley. My dad and Ashley started coming to my shows together: they were theoretically "checking in on me," but also just having a beer and a laugh at what I was doing and getting away with. When Big Butch and Ashley were there, I remember the club "regulars," shady characters in their own right, would come to me and ask, "Hey, are them guys *narcs*?"

By this time, I had become a legend in my own mind. Byte the Bullet got a pretty good local following, and pretty soon we got too big for our spandex pants—definitely too big for Rome, Georgia. We constantly debated whether we were going to stay in town or try our luck somewhere else. It was probably time to leave—all the boyfriends of the girls we were screwing wanted to kill us: "Please put down that pocketknife, sir, and I kindly won't touch Kimberly Jo again."

That was reason enough to get out of there—that, and I wanted to show up my old bass player, Chuck. I'm a Scorpio to the fullest: I *love* revenge. I do not forgive at all. And I knew, paraphrasing the cliché, that success was the best "fuck you" I could give him. I wanted to prove to Chuck that he was the loser in this equation; in fact, I wanted to smear that fact in his fat face. I wanted so badly to succeed without him. And against all odds, later that year, 1990, we did. (Often I won-

der about Chuck nowadays—if he is dead or in jail, or maybe working a factory job with seven kids. I don't know: he never came out of the woodwork like so many others, so I will never know. I actually hope he is okay . . .)

I was seventeen years old. I'd graduated high school, just like I'd promised my parents I would. I wasn't going to college, I knew that: I was going to the finishing school of rock and roll—Los Angeles. If you were a hair metal band, that's where you had to be. Our mission was to become the biggest band on the Sunset Strip and get signed to a huge, major-label record deal. Within a year, unbelievably, we would accomplish these goals, and so many more I hadn't even thought of. Rock-and-roll mega-stardom would finally be within my grasp . . . And just as quickly would slip out of it. As the band prepared our move to L.A., I pledged I was going to make it in the music industry without getting screwed. By now, I'd been done over and ripped off so often, I knew I would never let it happen again.

Of course it did.

FOXY GUYS AND TAINTED ANGELS

*Adventures in the Department of Alcohol &
Restaurants, Sunset Strip Division*

There's a disgruntled metalhead playing guitar
For a pop singer up on the screen
With his guitar held high and his head held low
He just wants a chance to be seen.
—*Butch Walker, "Closer to the Truth and Farther from the Sky"*

Heaven can wait—we're only watching the skies
Hoping for the best but expecting the worst.
—*Alphaville, "Forever Young"*

Get your money for nothin'
Get your chicks for free . . .
—*Dire Straits, "Money for Nothing"*

In the late '80s, there was no four blocks like the Sunset Strip any-
where else in America—anywhere in the *world*. For an aspiring
hard-rock superstar, this fabled Mecca of metal was heaven, the Gar-
den of Eden, and Hooters all rolled into one. Sure, in Rome, Georgia,

we had our own little redneck version of the decadent, Max's Kansas City '70s scene; the Strip, though, made it look like *High School Musical*. I would soon discover this for myself as I joined the flock of boot-shod youth drawn to the distinctively acrid cloud of Aqua Net emanating above the western edge of Los Angeles.

For Byte the Bullet to become successful, we didn't have any choice *but* to move to L.A. Our dream was to be more than just a cover band, which was all you could be in Georgia at that time. Ironically, the minute we left for California, a vital music scene started percolating in Atlanta, so go figure. But for the most part, if you wanted to rock, you were shit outta luck: a lot of the regional jangly alternative bands like R.E.M. and Guadalcanal Diary were getting deals and acclaim, but not bands like *us*. There were two or three original rock bands in Atlanta—Georgia Satellites had come out of there, and Drivin' N' Cryin' were an amazing local band that went national—but they were all guys who were in their thirties, while we were still in our teens. I secretly loved all that music, but we wanted to be heavy metal icons like Mötley Crüe and Guns N' Roses: the first Guns N' Roses album was so huge at that time, and the Strip was the petri dish that GN'R's bacteria famously festered in, so we needed to go where they'd broken out from. We played butt rock, so we had to go where the butts were. No ifs, ands, or . . . Never mind.

Half of my motivation to move to California stemmed from my desire to follow the path of Kenny Cresswell, one of the idols of my so-called '80s life. At the time, Kenny was one of my favorite musicians and people in the world—still is, in fact: he would play drums on my first two solo albums, and go on to great success as the founder of the South's biggest backline-support company, Avatar Events Group. But when I met Kenny in the late '80s, he was *the guy* on Atlanta's metal scene: he was a few years older than me, and the flashy drummer in a band called Panda. Yeah, I know—Panda: the science of heavy

Hair Today/Back later Today

(Childhood Metal band names I
remembered... that sound familiar today)

Oasis
PANDA
The Scene
Nytemare
BADD BOYZ
Roulette

metal names back then was as good as it gets! Ladies and gentlemen . . .
please won't you make some fuckin' noise for . . . *Panda.*

Anyways, before they moved to L.A., Panda was really tearing it
up locally, and as a result they had every good-looking girl in Atlanta.
Naturally, we looked up to them. They were all good-looking, with
super badass clothes and long blond hair: basically, they all looked like
Fabio, which seems ridiculous now, but back then that's just what it
took. They even had a band poster—a *real* poster—like the kind you
bought at Spencer's Gifts or Turtles Records and Tapes. We thought
Byte the Bullet just couldn't compete with the likes of Panda: here we
were, this disheveled, *Bad News Bears* version of a rock band, made up
of eighteen-year-old zit-faces wearing even worse versions of the
already bad clothes and bad hair Panda had. And we had no poster . . .
No poster!

I would go see Panda every weekend at clubs like Jumbo's, where the bouncer, J. T. Buttbuster, would sneak me in because I was underage; usually I couldn't get into bars unless my band was playing. The cocktail waitresses there loved me; I am sure I tried to hook up with all of them. When I was young, I had the tolerance of a pit bull, so they would give me free drinks until I was wasted, and then they would walk me to my mini-truck before I exited the heavy metal parking lot, every night. Despite the benefits, I was truly there to see Panda. What really resonated with me was the fact that Panda could sell out Jumbo's playing not covers but originals—that was something we didn't see in Atlanta. Panda so had it going on, they even had their own stage pyro! We saw that and . . . "Jesus!" Kenny and Panda ended up moving out to L.A., because they felt they'd just completely tapped out Atlanta, girls and otherwise. They were our heroes for making that leap.

Kenny was my informant, my mentor in all the strange customs of the Hollywood metal scene, and we communicated via Panda's "band hotline." In the golden daze of the '80s, band hotlines were the closest thing we had to a MySpace page; they were the only means of checking voice messages and connecting with fans. It was the most OG social networking ever. Every band on the Strip had a 1-800 number with a rambling five-minute message: "Hey, we're Tyger—that's Tyger with a 'y'—and we're playing the Whisky tonight! Yo, if you're a chick and you need tickets and know how to cook, just leave your name and number! And if you're a dude—hang up now!" It's funny—having a band hotline now is big news again. You know, you can now call, say, Katy Perry, hear a recorded message from her, and then leave a message, too. It's also a way the record company profiles, traces, and interacts with an artist's fans, so they can text you announcements about concerts, upcoming releases, and so on. It was such a weird scene, but it reflects what's going on right now to a T. Same shit, different haircut, and less phone tracing . . .

Before I moved out to L.A., I would call and leave messages on the Panda hotline as often as I could. I would sneak phone calls to Kenny from our home landline, which was a big deal—back then, calling long-distance cost a lot of money. Every maybe three or four phone calls I would make to him, he would actually answer. He probably was so sick of having a seventeen-year-old badgering him to death about what's going on in Hollywood: "Hey, Kenny! We're moving out there and do you have any ideas of a good place to stay and live and blah, blah, blah, tattoos, blah, rent, Mötley Crüe, blah, blah . . ." Kenny did not have to help us; the scene was so cutthroat and fierce—certainly Panda didn't want anybody else coming out there and muddying up the waters of competition. And there was *so much* competition: Kenny told me there were fifteen bands on every street corner at all times of the day, dressed to kill and ready to do whatever they had to do to make it. He said you had to be really crazy or tenacious, and preferably both, to make it. That actually made me feel better about going to California—I knew I had those qualifications down pat.

We were sure Panda were going to be huge, anyway, and we'd just ride their white-leather coattails to a record deal. I was utterly convinced Panda would immediately get signed once they hit the L.A. scene, because they were *that great:* they had the best logo, the best hair, and they actually had recorded a full album of their own songs, which I listened to over and over on vinyl. It sounded really pro and amazing. Back then, nobody made good-sounding albums as an unsigned band, because the available technology was so bad. We didn't have GarageBand on our laptops—we didn't have *laptops.* The only people with computers at all were people like Matthew Broderick in *War Games.* These days, it's not so hard: a kid can press play on a built-in track already in GarageBand and say it's their own song; switch a couple of beats around, and all of a sudden that song is on the freakin' *radio.* I'm telling you, from my experience as a producer, I can

smell GarageBand on the radio. I know the loops and all the stock shit that these people are using, which is fine. There's some exciting music that comes from it every now and again. But in the pre-GarageBand era, demos often just sounded really bad and amateur, and independent albums were rarely good unless you had the help of an A-list producer, a pro studio to record in, and great songwriting. Panda didn't have an A-list producer, but they had the next best thing— someone who would become an A-list producer. An unknown engineer named Brendan O'Brien, who was a good friend of Kenny Cresswell's, produced Panda's album. Brendan's since gone on to produce total nobodies like, you know, Pearl Jam, Stone Temple Pilots, Neil Young, Rage Against the Machine, Bruce Springsteen, and AC/DC. Yeah, never heard of 'em, either.

Brendan O'Brien was one of the best things to happen to Panda. Back then, you really couldn't make a professional-sounding recording at home: you needed really great equipment, which could only be found in huge, elaborate studios that cost $2,000 a day to book out. For a band like Byte the Bullet, that wasn't even a reality. While we fantasized about breaking out of the cover-band ghetto, we didn't let the fact that we barely had any original songs and no recording experience hold us back. I would sit in the old corn mill in the backyard by the creek, tracking our band into a four-track cassette recorder. Making those hissy tapes was my first taste of the art of producing, way before the digital magic of Pro Tools and GarageBand: just me running cables, learning how to mic up amps and drums by recording my band out of necessity. I would teach our singer to sing scales, producing before I was ever a producer. Despite my lack of studio skills, we managed to get together a shitty demo of the five original songs we'd written. We were writing inexperienced, seventeen-year-olds-with-stars-in-their-eyes' versions of Aerosmith's "Dude (Looks Like a Lady)" or Bon Jovi's "Bad Medicine." Given that those songs were pretty schlocky already . . . Well, you can imagine what they sounded

like. One was called "One More Day in the City," while another was called "Party Time"—you know, just all the worst clichés that we could possibly come up with. Armed with this impressive repertoire, we decided to conquer Los Angeles. We had high hopes, but little did we know that within a year, we'd be writing a major-label album with the guy who *actually wrote* "Dude (Looks Like a Lady)". . .

Before I left Atlanta, I heard every cautionary tale possible from every long-haired dude who went out to L.A. to "make it" and lasted all of two months—and sometimes just two weeks. All of them told me the same thing: "Dude, don't waste your time going out there. You'll never make it. There's too much competition. There are just too many good bands out there." They would tell me that because they had failed: they were scared to see somebody else go out there and succeed when they didn't. Naturally, that kind of adversity just fueled my fire even more. I was like, "I'm not going to sit in Cartersville, Georgia, the rest of my life." I think it was Gibby Haynes of the Butthole Surfers who put it best in one of my favorite quotes: "I don't regret things I have done. I only regret things I *haven't* done." I agree with that (even though he may have been referencing narcotics and not life in general): you can't blame yourself for trying, and I was going to try. No one could convince me otherwise—I couldn't get to the Strip fast enough.

I graduated from high school in June 1988 and left for Los Angeles the very next day. I'd been counting the days until this moment. At graduation, I high-fived my principal as he handed me my diploma: school wasn't just out for summer—it was out *forever* (as prophetically sung by Alice Cooper). But as my dad drove me to the airport the following morning, it was tough. That day, everything felt pretty weird: we were all very scared—none of us had ever lived away from home before. As my father pulled the car up to Delta's passenger-unloading

zone, I remember hesitating. This was real: suddenly I had to live as an adult, and really I was still just a boy underneath all that eyeliner and mascara.

"I don't know if I want to go, Dad," I told him. He wasn't hearing it. "No, you're going now," he said solemnly. "This is what you've decided to not go to college for. You're packed; it's done." Inside, I loved it that Dad was pushing me to do this: this is a guy who went off to the navy and was stationed in Midway when I was a little boy, so I knew he'd grown a lot to let me follow my dream. But I had no trust fund, no allowance; the most I could expect from my folks was an occasional care package filled with ramen noodles. They couldn't afford to send me out there with money, and I wouldn't have wanted them to. I'd already saved up all my gigging cash—about $1,500; that and a guitar were all I brought with me. I remember being on the plane, listening to a mix tape my sister had made me. It had all these songs with the symbolism and theme of going and getting what you want in life. "Forever Young" was on there, and it made me cry like a baby. I was already nervous. What I'd chosen to do with my life didn't have the comfortably predictable track of going to college; back then, it was a lot harder to live on your own without an education. Indeed, there wasn't much difference between the School of Hard Rock and the School of Hard Knocks. Tough as it was, soon enough we'd discover we'd actually arrived in Paradise City. Little did we know, as our redneck butts settled into those economy-class seats at the back of the plane, that our band would not only become a huge band on "the Strip"—we'd also be signed to a major-label record deal within ten months. Careful what you wish for . . .

Getting off that plane and seeing that first palm tree was pretty unbelievable: we were *free,* and we were *freaking out.* We were so excited we couldn't stop screaming, "Oh my God, we're in L.A.!" at the top of our lungs, which were about to get challenged like they'd never been before. At that time, sensible auto-emission regulations

hadn't yet kicked in, and car-crazed Southern California had the worst air quality imaginable. It was so smog-ridden in the late '80s, a seemingly permanent haze loomed over the whole city of L.A.; some days that haze was as purple as Hendrix would've wanted it, some days it was orange, but, regardless, it was always there, as dependable as the morning sun. It wasn't like in the movies, which depicted L.A. as this crystal-clear, gorgeously infinite landscape whenever a shot panned across the city from the Hollywood Hills. Still, we couldn't believe how beautiful it was; to us, Georgia had nothing like this. California was 80 degrees and sunny every day: there was no humidity, rain, snow, none of that. And bathing in that sunshine were girls, girls, girls—everywhere we stepped, there were hot girls. You never forget the first time you meet women who are so sophisticated, so gorgeous, and so . . . *easy.* Robert Downey Jr.'s character said it best in the movie *Kiss Kiss Bang Bang:* "L.A. is like as if New York City got picked up and shook westward, but only the smart girls knew to hang on." In Los Angeles, all the most beautiful women in the world were converging at once—it was just like the heavy metal videos where you see all the small-town girls getting off the buses with stars in their eyes. On the Sunset Strip, the cliché and the reality were the same. And the funny thing was, we just were too young and naïve to care. This all sounds ridiculous now, coming from me, a forty-one-year-old family man. But at seventeen, it was incredible. It was *awesome.*

And it was *terrifying.* We were certain that our arrival in Hollywood was going to resemble the "Welcome to the Jungle" video, shot for shot, and it pretty much did. We went straight from the airport and checked into the cheapest, skeeziest motel we could find. There were several of us—of course, we had to come out as a unit and make a statement, so our roadies moved out with us, too—and we all lived together in a one-bedroom, non-air-conditioned shithole with Astroturf for a carpet. We'd budgeted fifteen bucks a week for groceries,

every penny of which was spent on five-for-a-dollar generic-brand macaroni and cheese. When I arrived in L.A., I was pudgy from Mom's Southern food, but after three months, the emaciated rock-and-roll look came naturally to me. I lost forty pounds: call it the "hair metal diet." Trust me, it works much quicker than Atkins, especially when people factor in the "booger sugar" supplements. Once I was skinny enough, I found the actual tailors who made Guns N' Roses' stage wear and spent my life savings on a pair of bad leather pants; I even tracked down the store where I could buy the same boots that Axl Rose wore. Pretty soon I would be hanging out with girls Slash slept with, too. It was gross and amazing.

Our motel was right at the corner of Hollywood and Highland. Today that intersection is home to a huge shopping mall and *The Jimmy Kimmel Show,* but back then it was positively frightening to live there. This was still very much the era of the Crips and Bloods gangs battling over turf in that neighborhood, and east of Vine it got even scarier. Regardless of any danger, on those Hollywood streets you saw every long-haired musician who ever picked up a Gibson Flying V: we had found our tribe. That first night, as we checked into our shitty little motel, I figured I'd better call Kenny and let him know we'd arrived; after all, he was pretty much the only guy I knew in L.A. I went to a pay phone and called the Panda band hotline, and, surprisingly, Kenny himself picked up. He was psyched to hear from me and ready to show me the ropes. "Butch, you guys have to meet us on the Sunset Strip," Kenny said. "That's where we go every night. If you're in a band, that's where you have to go to network, promote your shows, and pimp your shit."

Living at Hollywood and Highland, we were pretty far from the Strip. Well, it was pretty far if you didn't have a car, which our broke asses definitely did not. Instead, we started walking the several miles to our agreed-upon meeting point with Kenny; this was no mean feat in cheap cowboy boots and skintight acid-washed jeans. But, us being

semi-cute guys with semi-long hair and wearing semi-cool clothes, eventually a Ford Pinto pulled up filled with four bleached-blond girls going to—you guessed it—the Sunset Strip. We didn't know these girls, never met 'em before, but it didn't matter: we were all making out with them by the time we got to Gazzarri's, or the Whisky A Go-Go, or the Roxy, or The Rainbow—wherever it was we were going in that four-block radius where all hell broke loose every night. There was no shortage of "go to" girls, ones who would go with guys to the upper deck of the parking garage and give them a blow job— and then take down everyone else in the band, too, no problem. It was like the whole '60s "free love" concept had been given a bad dye job, a backstage pass, a case of gonorrhea, and a corner booth next to Lemmy at The Rainbow. This is how we learned Hair Metal Lesson #1: The girls have the cars, in which they like to drive musicians around. Soon we'd learn they had apartments, and food, too.

Kenny's guidance in such matters was as golden as the bleached hair everyone seemed to have back then. In the pre-Google era, there was no way to learn about these strange rituals of hair metal in L.A. if you came from where we did; you just had to go out there and dis- cover them on your own, and often you found out the hard way. They were not covering the Sunset Strip scene even on television—even though hair metal and sleaze rock had caught on in the mainstream, it was still considered a subculture to the pop masses. There was *Head- bangers Ball,* sure, but MTV wasn't showing footage of the local Hol- lywood scene—then again, the raunch of it all would've never gotten past the network's Standards and Practices Department. Suffice to say, to right-off-the-bus Southern boys like us, our minds were blown, among other things.

Indeed, by the time we finally met up with Kenny, we found our- selves smack-dab in the middle of a heavy metal Mardi Gras that hap- pened every single night, with thousands of girls in short skirts with teased-up bad hair hanging out with thousands of guys in bands in

short skirts with teased-up bad hair. Outside every club, there'd be a buzz every time a celebrity made an appearance: "I heard that *Axl* is inside!" or "I just saw David Lee Roth walk in *right now*!" Everyone was drinking whiskey, passing bottles, smoking pot, and doing cocaine, the music blasting a hole in the smoggy air every time the door opened at Gazzarri's. It was at that moment Kenny bestowed Hair Metal Rule #2 upon me: on entering the Strip, immediately go to this corner liquor store called Gil Turner's, which, amazingly, is still there. It's pretty much responsible for turning Eddie Van Halen into the notorious drunk that he is/was; as proof, the wall behind the counter was filled with eight-by-ten photos of all the famous rock icons that were regular customers. According to Kenny, the thing to do was to go to Gil Turner's and buy a tallboy Bud or a cheap bottle of vodka, put it in a brown bag, and nurse it all night long like an IV drip as you walked around. This was not something I had gotten to do in Georgia.

Pretty soon all our days and nights were spent on the Strip. We'd be just out there observing (well, as much as you can observe while drunk), wearing, you know, leather pants and no shirts, our hair all teased up, handing out the flyers we spent all afternoon making at a print shop to any girl who happened to walk past. Every band was out there handing out gig flyers plastered with their cute skinny faces to try and sell these girls tickets, which was part of a perfect scam known as "pay to play."

This was a whole other thing we experienced moving out there. With "pay to play," if a band wanted to be booked, it had to sell tickets to make a cash guarantee to the club owner; if you didn't sell all your tickets by the show day's sound check, you owed the club the difference or you couldn't play. Therefore, you had to convince some girl who just got handed fifteen other flyers that she's already thrown in the trash that your band was ten bucks more special than that other band with the same haircuts and leather chaps. Basically, each club would have five bands a night playing thirty-minute sets each; the

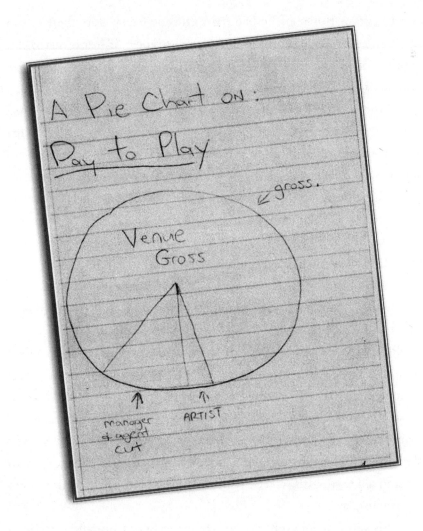

clubs were raking in the cash, because they would give each group a hundred tickets or more, and you'd have to sell every one of them.

Wanna hear one of my favorite jokes? Okay: What does a stripper do with her asshole before going to work? Drops him off at band practice.

Where were we? Oh, yeah: while the "pay to play" policy definitely exploited fame-hungry musicians, it also provided a brutally Darwinian system that separated the have-talents from the have-nots. It really was corrupt, and eventually the system kind of ate itself, but it was also

a good way to show who was really the shit (relatively), or at least who was the most motivated to make it. Once we got to L.A., it wasn't hard to tell which bands had financial backing—the ones that had the coolest gear, or stage costumes, or a professional-sounding demo made in a "real" studio with a "real" producer. That support could have come from a stripper girlfriend, or a drug dealer, or a rich parent. It could have been any of the above; sometimes even a drug-dealing stripper with a kid. But if a band didn't have talent, didn't have charisma, didn't have good songs (again, a relative concept in the '80s)—well, they simply couldn't survive. If you got someone to take a chance on a band they'd never heard, you had one chance to make them want to buy a ticket again. You might get lucky and sell a hundred tickets, but if your band didn't blow those people away, you'd play to empty houses from then on; if you weren't good, they wouldn't come back to see you the second time. Our shows got more and more packed every time.

"Pay to play" was way before hip-hop hit on the guerrilla marketing tactics of street promotion: it was such a hassle selling your shit, and selling yourself, every single night on the Strip, but it guaranteed you were sure to run into some characters. After all, everybody had to have some lunatic gimmick to get some attention and stand out from the crowd. As such, I remember one band, Zoom, whose gimmick *and* talent certainly proved memorable. Zoom was always out there on the Sunset Strip, and they were hard to miss: they had the requisite big bleached metal hair, sure, but they distinguished themselves by wearing nothing but bath towels and roller skates. Zoom's flyers always had a stick of gum on them, too. Good way to meet chicks, right? Zoom were destined for big things, but not in hair metal: the guitar player in Zoom went on to become Rivers Cuomo from Weezer. Rivers and I laugh about all this today. I recently produced and cowrote on one of Weezer's latest albums, and Rivers is now my neighbor, too. When I went over to his house for the first time to write with him, I saw he had these photos of metal icons all

over the wall, like K. K. Downing from Judas Priest. I was like, "Yeah dude, I was in the Sunset Strip scene, too," and we reminisced. Thinking back on Zoom, it kind of makes sense that Weezer is the band that they turned out to be.

While Zoom's towels and roller skates were way cool, we figured our gimmick was no gimmick: our shtick was that we could really play and sing. We definitely were not that cool; we were just talented (again with the relative thing). We developed this modus operandi after we checked out a few of the more popular bands on the Strip soon after we got to California, when we realized our standards were higher than those of most of the bands we were up against. If you've seen the great metal documentary *The Decline of Western Civilization Part Two* (which you should), you saw a scene full of bands with high hopes, big dreams, and no talent, which made for high tragedy (emphasis on "high"); those groups represented the majority of what you heard in clubs on the Sunset Strip. We were shocked—we thought we'd made a wrong turn on the way out there: these bands were selling out clubs, and they were *terrible*. The girls didn't care—cute lead singers were all they cared about—but the music was poorly played. It reminds me of some emo bands now; it's all about a haircut and how many T-shirt designs you have. Hell, we couldn't afford merch, so that wasn't even a question. We never sold it. Never made a single T-shirt. But we had the haircuts, and we could sing, each one of us, in four-part harmony.

Back then, when you went to see Bon Jovi, Mötley Crüe, Aerosmith, KISS, Journey, whoever—any of those big corporate rock bands—it sounded like God and his backup singers coming out of the speakers, and it was: they were usually playing to about fifteen thousand backing tracks (everything comes around: today all the emo bands are playing to tape, too—well, digital "tape"). We had no idea half of that shit was prerecorded: we just thought that was how bands were supposed to sound! I was on the mission for our band to stand

out and be great without a gimmick, without backing tapes. We got so good, so tight, we got a rave press write-up on our first gig, and that's what really got the ball rolling.

Our breakthrough happened on a night at the Whisky called "The Monday Night No Bozo's Jam." No Bozo's Jam was a great showcase for new bands: you didn't have to pay to play, but you had to have enough buzz to somehow get booked. Each band got twenty minutes to do their thing. We sent our demo tape in, and the booker, Rich—who has since become a huge concert promoter—liked it enough to give us a slot. We were lucky: the night we played No Bozo's, this band called Love/Hate were doing a special guest appearance. Love/Hate were a big deal at the time: they had just signed a major-label deal with Columbia Records and even had a hit—with a video on MTV!—with a song called "Why Do You Think They Call It Dope?" With Love/Hate on the bill, that meant all the hair metal tastemakers would be there (as if taste had anything to do with said genre). That meant the pressure was on us to really crush.

Love/Hate went on at midnight, and we went on right afterwards in what was known as the "clean-up slot" following the headliner: we got up there fast, because we knew people would start leaving right away. If memory serves me, we opened our show with "Rock and Roll Band" by Boston, which was chosen specifically to dazzle, as it is so technically difficult; with all its vocal overdubs, guitar layers, and changes that were manufactured in the studio, even Boston couldn't play it live without backing tapes. But we did it all, with the four of us singing harmonies all the way through, all the falsetto shit, jamming on the epic guitar solos, all that. Of course, we changed the first line, making it "We were just another band out of Georgia" to fit our experience. After that opener, we blasted through our five originals, which were awful, of course, but we played the shit out of them. When the local music paper, *Rock City News,* came out a week later, they gave us a glowing review, writing us up as "the tightest band on

the Sunset Strip." Byte the Bullet had arrived. After three or four more shows like that, we didn't have to play the "pay to play" game anymore. By that point, not only were we headlining Gazzarri's ourselves, but they would also actually pay us, too.

We were now in with the Hollywood Strip mafia, people like Ron Jeremy and Sam Kinison, and it was all due to Bill Gazzarri giving Byte the Bullet his blessing. Bill Gazzarri was the Don of the Sunset Strip, and a walking caricature: he was known as the "Godfather of Rock and Roll," and he dressed like it, with his white fedora, mob-style suits, omnipresent cigar, and raspy tough-guy voice. He owned his namesake club, Gazzarri's, which was the hottest club on the Strip for decades. To make clear just who was responsible for the party, he even had a giant mural of his face painted on the side of the building. Gazzarri's was the place where all the stars seemed to pass through on their way to the big time. Famously, Bill was the guy who wouldn't let Jim Morrison in because he had no shoes on. Of course, he would later give The Doors the house-band gig at Gazzarri's; Van Halen also held that honor when they first started. Thanks to Bill's cosign, The Doors got their record deal, as did Ratt, Mötley Crüe . . . and Byte the Bullet. If Bill deemed a band worthy, he called them "foxy guys." When Bill said about a group, "They are foxy guys," their chances of making it skyrocketed. He would say that because for Bill, his business depended on getting the hottest girls to come to the club: the chicks, after all, wanted to party with the foxy guys. And once he'd discovered us, we became his new pet band. Every show we did, Bill would come up onstage, an eighteen-year-old girl under each arm, and introduce us. He would always say the same thing: "You are going to love these foxy guys." It was so weird and creepy—and awesome. To have Bill Gazzarri introduce your band was a big deal. He'd never introduce bands; the only other band I heard of that he'd do that for

was Van Halen. We got a lot of respect on Sunset Strip after that. A *lot*.

After we were anointed "foxy guys," Hollywood opened up to us. Bill was good friends with Sam Kinison, who was a megastar comedian at the time. Kinison had done a controversial music video "Wild Thing," with Jessica Hahn, who at the time was the Kim Kardashian of her day due to her involvement in the sex scandal that brought down evangelist Jim Bakker. Sam would come and see us play all the time, which was a hoot, because he was literally *nuts*. We would always dedicate our last song of the night to Bill, which was a ramped-up heavy rock version of "New York, New York." One night, during "New York, New York," Sam jumped onstage and went crazy; he'd brought, like, fifty dancers up with him, and poured beer down my throat as I was playing.

It was such a weird, surreal time. This was back when I was friends with real pimps, before it was fashionable in L.A. to wear a shirt by Ed Hardy that bore the phrase. Barney, who ran the door at Gazzarri's, was pimpin' hos—not metaphorically, but literally. There were even porn flicks being shot in the basement of Gazzarri's all the time. We even got asked to be the band in a porn film one time—a Ron Jeremy production, naturally. I was psyched. "This is a big break for us!" I ignorantly told my band. Our singer, however, talked us out of it, which was odd for him. We couldn't believe that all this was happening to us. It was a decadent scene, but we were so young and gullible, we had no idea that it was all, like, one big coke deal going on around us. We were famous on the Strip, which is only four blocks long, and that was it. But it was a great feeling.

After six or seven months, we were one of the biggest-drawing bands on the Sunset Strip (again, relative to only a four-block radius). On any given night, we could easily get the five hundred people needed to sell out Gazzarri's. Soon enough, our shows were crawling with managers and A&R guys who wanted to sign us. A&R, by the way, stands for "artist and repertoire": theoretically, an A&R guy

works as a scout for the record company, looking for bands to sign. However, I would come to learn that A&R actually stood for "alcohol and restaurants." At this point, we clearly needed a manager. Bill Gazzarri pointed us to a guy named Jerry Landers, whom we called "Pop." Pop was an older guy who'd worked in the Secret Service for Jimmy Carter: he didn't really have anything going on, but he talked a good game, worked hard, and we just really needed someone to help us navigate the feeding frenzy of record labels we found ourselves in. Pop introduced us to this guy Bob Cavallo. Bob Cavallo was a total hard-ass mother of a businessman who'd guided the careers of top stars ranging from the Lovin' Spoonful and Earth, Wind and Fire to Prince. He'd even produced Prince's film debut, *Purple Rain.* He was clearly a serious music-industry heavy, and he was very interested in our band, but not without a crucial caveat. "I'm willing to sign you guys," he told us, "but on one condition: my son Robby has to produce you." He was basically pimping his own kid into the business, and it turned out "Robby" had never produced a record in his life. I can't imagine how many times that Bob Cavallo had that conversation before someone finally said yes: it's like having a gun held to your head, and when it shoots, out comes a recording contract that says, "My son is going to produce you or you're not signing to my label."

We turned him down. We wanted Bob Rock, who had produced Mötley Crüe smashes like *Dr. Feelgood,* or Bruce Fairbairn, who was the studio whiz behind Bon Jovi's twenty-two-million-selling *Slippery When Wet* and Aerosmith's ultra-massive comeback album *Permanent Vacation,* not little Robby Cavallo. We couldn't believe it: his dad was a bully, and was bullying him into the business. Of course, Robby Cavallo became the Rob Cavallo that is a huge producer. Huge. Sure, it didn't hurt that his dad was a big mogul doing everything to get his foot in the door, but Rob has undeniable talent and he's been involved in some great records since then, having recorded hits for everyone

from Green Day to My Chemical Romance. At press time, he serves as chairman of Warner Bros. Records. Nice one, Rob!

In hindsight, we made some mistakes in the name of hair metal. Probably one of the stupidest was when this guy starting a new label came to check us out. We were leery of being someone's guinea pig; we didn't want to take any chances signing to a label that didn't exist yet. That guy was producer Jimmy Iovine, and he was starting up Interscope Records. When he met with us, he told us stories about how he'd produced John Lennon and U2. Of course, we were not impressed. We were like, "So what? That's not Mötley Crüe, that's not KISS"—citing, like, all the worst examples of production ever. Of course, as my tastes developed, many of Jimmy Iovine's records would become my favorites. Interscope went on to be probably the most successful label ever, making huge stars out of, you know, Dr. Dre, 50 Cent, Eminem, Lady Gaga, No Doubt, Snoop Dogg, Tupac, Nine Inch Nails, Black Eyed Peas, the Pussycat Dolls, Dashboard Confessional, M.I.A. . . . Yeah, we passed on that one.

Still, ten months into moving to L.A., we felt our band was doing well enough. The quality of groupies went up immensely, we were able to get into more venues we couldn't get into before, and maybe we could afford to buy some kind of shady used car to get around; still, we certainly didn't have any real money yet. One minute we'd be hanging with Sam Kinison, porn stars, and whatever nutball characters were around, the next partying at The Rainbow every night with old-school showbiz legends, new-school metal heroes, and the vixens who loved them. Then we'd go back to our day jobs the next morning, which we had to work because we certainly were broke by normal societal standards. The first few months I lived there, I worked at this place on Hollywood Boulevard across from Grauman's Chinese Theater doing phone research. All day I'd call random people and try to get them to do surveys about their movie-going habits; I can't tell you how many times I had to say the line "Would you be interested

in going to see a movie starring Joe Pesci called *My Cousin Vinny*?" to a total stranger. Telemarketing was the true backbone, the enabler, of hair metal. I remember seeing so many guys in there from the Sunset Strip scene. Tim Kelly, the guitar player from that band Slaughter who would go on to die in a car crash after they got big, was in my telemarketing group. It was all so random.

Having six guys living together and sharing hair spray in a very small apartment started to grate as well. The constant smell of sweat and spandex made me really want to get away from my band, so, thankfully, I met a couple of hopefuls on the Sunset Strip who offered me a place to live in the Valley: they were Strip party girls by night and, get this, *preschool teachers by day*. I couldn't make this shit up. They even had an extra car they let me use for my new job. I was delivering business cards for this company called BCT, which stood for "Business Cards Tomorrow." I actually started making good money, decent enough so that I could buy groceries; it was a big deal to me to be able to live off more than $15 a week. Despite these creature comforts, I wanted to rock full-time, and finally I got my chance when the band realized our dream right on schedule, and Byte the Bullet finally got signed to a major-label record deal.

All the usual suspects courted us, of course. MCA came calling, but we weren't interested: MCA was doing so poorly in those days, it was nicknamed the "Music Cemetery of America"—and also "Metal Cemetery of America"—because they had the worst metal bands on their roster. Of course, MCA morphed into Universal Music, which is now the largest, most successful music company in the world. Epic also wanted to sign the band, but in the end we went with a company called Charisma, a new upstart label that was a subsidiary of Virgin Records. To commemorate this historic moment, on the day we got signed, Bill had our mural painted on the side of Gazzarri's, right next to Mötley Crüe, Ratt, and all the legends.

We were one of the first two bands to sign to Charisma. The other

was a band called Jellyfish, of whom I would become a huge fan. Later in my musical life, I became good friends with the key songwriter and musician of the band, Roger Manning, who played on my Marvelous 3 records as well as my solo album *Sycamore Meadows,* along with the likes of Air, Blink-182, and Beck. Another Jellyfish alumnus who would go on to big things was Jason Falkner, and we also became pals. Jellyfish got their deal at exactly the same time we did, and what a pair we made: we were the archetypal hair metal band, and they were the progressive, arty, hippie, Beatlesque pop band that was so fashionably out of place, and very underground, at the time. Jellyfish were throwback '70s psychedelia, with the crazy Dr. Seuss hats, bellbottoms, the whole thing; they lived it, even though it seemed weird to fashion yourself after the '70s when it was still the late '80s. This was way before the mustache went hipster—believe me, I've had a couple of those since. But at the time, '70s mustaches were not cool on the Sunset Strip, as opposed to now, when you are uncool if you *don't* have one.

We signed to Charisma because it was headed up by Phil Quartararo: he was *the guy,* a real music-biz legend. Everyone called him "Little Big Man," because he's really, really vertically challenged. That didn't matter, though, because everyone loved him. I loved him dearly: he was a great president who treated all of his artists with grace. He was the exact opposite of the typical record company president, like in the movie *That Thing You Do!,* where Jonathan Schaech's character approaches the president of Playtone Records and the guy responds, "Who is this kid? Get this damn kid away from me!" Phil Q was very artist-friendly and very well respected. He was a warm guy from Brooklyn who'd helped break U2 at Island Records, and you felt you were in good hands with him.

I couldn't say the same for our A&R guy, whom I ended up hating so much I can't remember his name. Per his title, he seemed to be more into alcohol and restaurants than music—Spago and cliché places like that, where it was more about being seen than anything else. All

he really seemed good for was to pay our dinner or bar tab, which he did religiously. To sign us, he played the game really hard, but he didn't have any bands I liked, to be honest. At that point, signing us wasn't exactly a genius move. Because Bill Gazzarri had taken us under his wing, we became that "buzz band." When you're selling out Gazzarri's night after night, you must have something going on, and that's when the labels take notice. Labels then didn't really develop a fan base for you: you had to get it yourself. Typically, all the label does is come in after you've sold a hundred thousand records and says, "Look what we did!" after racking up big bills for alcohol and restaurants, which is exactly what happened. We liked the deal our A&R guy offered, though, which was more than fair: half a million dollars per record. Yes, that's not including video. A video in those days cost half a million dollars alone.

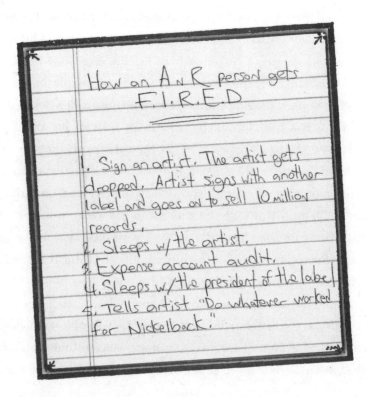

How an A.N.R person gets
F.I.R.E.D

1. Sign an artist. The artist gets dropped. Artist signs with another label and goes on to sell 10 million records.
2. Sleeps w/ the artist.
3. Expense account audit.
4. Sleeps w/ the president of the label
5. Tells artist "Do whatever worked for Nickelback."

First thing we had to do upon getting signed, of course, was change our name. Apparently, there were too many bands on the Strip with "bullet" in their name, like Bullet Boys, Bullit, Bullet, etc. Therefore, Byte the Bullet became SouthGang, the thinking being we were from the South, and we were so tight we were like a gang . . . *Genius.* Yeah, we created all this buzz, and even had BYTE THE BULLET painted on the side of Gazzarri's, and we had to change our name. Oh well. Next order of business was finding a producer. Our hearts were so dead-set on working with Bob Rock and Bruce Fairbairn, because we didn't know anybody else, and those were the names on the big hair metal records at the time. We met with some other producers, like Tom Werman, who had done some great records with Cheap Trick, Mötley Crüe, Mother's Finest, and a bunch of other stuff we loved, but at our meeting, he seemed to be hitting the sauce a little hard. The first record I ever made, however, ended up being done with a guy named Howard Benson.

If you're the kind of person who reads the tiny-print credits on CD liner notes—do they still make CD liner notes anymore?—then you might have heard of Howard Benson. He's become one of the most successful producers working today, with credits on smashes from the likes of Creed, Daughtry, My Chemical Romance, Gavin DeGraw, Kelly Clarkson, and All-American Rejects. In 1990, however, Howard Benson wasn't yet *that* Howard Benson. Our A&R guy set up a meeting with him, and we didn't have much in common; after all, Howard was very abrasive, older, and wore a tracksuit and comfortable shoes. It's taken me a long time to even be able to speak Howard Benson's name out loud, because I would come to hate him so much. We're fine and cordial now, but I'll put it like this: my sole purpose for learning how to produce records was because of how shitty my first experience with him was.

Our A&R guy had a boner for Howard for some reason, but we were like, "Who is this guy?" We were scared to death, since the most recent record Howard had produced was by Pretty Boy Floyd, and

that shit was terrible. He did have one record in his credits we really liked, however, by this band Bang Tango. Bang Tango was sort of like the great white hype as the next Guns N' Roses; they didn't get there, but they were still great musicians (and they had a dude named Kyle Kyle in the band—how cool is that?). We decided to work with Howard on the premise that we would hopefully get a record that sounded as decent as Bang Tango's. How it sounded was all we cared about. We didn't think we needed any help with songwriting—in our minds, the five songs that we had were "awesome."

We weren't ready, then, for the very heavy hand that Howard wields in the studio. Immediately, we got called out for not knowing shit; of course, our egos, and booze, got in the way, too. We were not a band to be messed with, and we were full of piss and vinegar—not to mention Jack Daniel's. We were a bunch of Southern redneck drunks, with a wicked mean streak if crossed, and Howard crossed us a lot. There were a lot of fights and near physical violence in the studio because of what a condescending asshole this guy was. Howard couldn't have been more demeaning: he tried to have Slug replaced as the drummer on some of the album, and did everything he could to have someone other than Jayce play bass on it, too. We had to fight hard to have our band actually play on our own record!

If Howard didn't want us actually playing on it, you can imagine how involved he wanted us in the production process. If I asked him what a button on the mixer did, he and the engineer would just start belly-laughing condescendingly. I remember to this day the words coming out of his mouth: "You're just a musician. You're supposed to fuck girls, do drugs, get drunk, and play rock and roll. Don't ask questions. That's why I get the big bucks." That did not sit well with me. Howard didn't realize where I'd come from—that I'd scrapped my way to this point from Cartersville, Georgia, and was very competitive. When he would talk to me like that, I thought, "I'm going to learn how to do your job." And I have.

To Howard's credit, it took him about fifteen years to become one of the biggest producers in the world, and his methods have inarguably paid off. There are some people who belong to the school of needing friction in the studio to feel like they're getting good results. They think that if it's too comfortable, then nothing good is going to come out of it. I came to prefer the opposite, because I didn't like being treated that way when I was making my first record. For most bands, their first record is probably going to be their last artistic statement before they go back to making doughnuts or selling guitar strings or business cards, so when you encounter an attitude like Howard's, it's like "What the hell?" You don't want making your first album to be this horrid experience, and you don't want it to suck. Well, we walked away from that record going, "That sure sucks." I also discovered during those sessions that most Alcohol & Restaurants guys are just living out their fantasies through the artists they sign—if they get to sleep with a groupie before they go home to their wife and kids, they're happy. One of our A&R guys used any excuse to bring girls to the studio while SouthGang was recording: he'd do bags of blow and get blow jobs from girls in the tracking room. Yeah, he was classy like that. Now, this was the tail end of the decadent '80s, so at the time, there was indeed a line between business and pleasure—and it was usually snorted. That model of the industry actually didn't change for quite a while, until the last five years, really, and it was only with a lot of kicking and screaming.

One thing that did make the record interesting was writing it with someone else. It's funny: now I can see how it would be completely disdained for a rock band to want to work with an outside songwriter to cowrite their songs—which is, of course, my current day job—but, above all, we wanted to *make it* and were willing to do anything to make that happen. We wanted SouthGang to be as big as some of our

favorite artists at that time, like Bon Jovi and Aerosmith, who, we discovered, cowrote all of their big hits with a guy named Desmond Child.

Desmond was the king of radio at that moment. He wrote "Livin' on a Prayer" and "You Give Love a Bad Name" for Bon Jovi, and "Dude (Looks Like a Lady)" for Aerosmith; later, he would go on to write "Livin' la Vida Loca" for Ricky Martin, among countless other hits. I went to our label and said, "We want Desmond Child. We want him to cowrite the album with me and the singer, and we want him to produce it if he can." He didn't really produce records, but we got him to agree to executive-produce. Desmond's title was actually way bigger than Howard's "produced by" credit, which served him right at that time.

Where I am now in my life, I'm very proud of my social and political views, and my stands on life and human rights. I think I'm a pretty good egg, and I've learned a lot over the years. That took growing up a little bit, recognizing that I've been a hypocrite at times, and I've had to let go of some of the baggage that you get coming from where I come from. I grew up in a very racist community in the South, and all these bad things get instilled in you, early and continually—not by your parents, I might add, but just from your friends, classmates, and generally ignorant people in your environment. When you grow up, as I did, hearing words like "nigger" and "faggot" in normal conversation, it's easy to get desensitized to them; I may have even been guilty of saying those words in my life, because when you grow up in the sticks, people are not educated enough to know that it is wrong. Where I am now is 180 degrees from that; I have seen the world and had my horizons broadened. But when I was a teenager working with Desmond Child, who was not only one of the most powerful people in the music industry at the time but also very gay and flamboyant, I was not so enlightened. Maybe I was even a little bit frightened.

On one level, hair metal was deeply homoerotic. I mean, Jayce, before he joined what would become SouthGang, was in a band called

Tickled Pink. In Tickled Pink, everything was bubblegum-pink—their hair, leather pants, amps, basses, drums, everything; it just doesn't get any more "pink" than that, does it? But if you pointed that out to them, you'd probably get punched in the face.

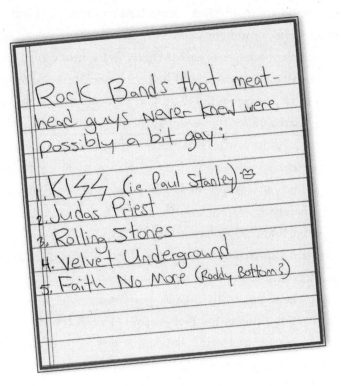

Indeed, despite the fact that most guys in Sunset Strip bands wore eyeliner and leather chaps, there were not very many openly gay people in that scene, but there was a lot of unintentionally ironic homophobia. Let's jump back in the story timeline a bit for a second. My only encounter with overt homosexuality was an aggressive phone call from a music manager, Bill Aucoin, who was pursuing South-Gang. Bill Aucoin was very famous, very powerful, and very notorious: he'd handled KISS since the '70s, and he loved little boys. I met one of Bill's boy toys on the Sunset Strip when I worked at a guitar store for two days. There was this French kid working there: he was

kind of homeless, so we took him in for a little bit while he was look-
ing for a place to live. Frenchie really wanted to be in my band, and
he had all the elements: he was cute, had the right haircut, and was a
whiz on bass. We needed a bass player because Jayce had stayed behind
in Georgia and hadn't yet committed to the idea of moving to L.A.,
so there was a moment when this guy might've joined our band. To
sweeten the package, Frenchie threw in his music-biz connections. "I
have zis manager who could help ze band," he told me. "He ees Bill
Aucoin, he manage KISS. You know heem?" And I'm like, "Are you
effing kidding me? I grew up as the biggest KISS freak in the world.
Of course I know who Bill Aucoin is!" Being my delusional young,
inexperienced self—we had yet to play a single gig in Hollywood at
this point—I was psyched: "Bill Aucoin—he'll make us famous
immediately!"

I told Frenchie to have Bill give us a call. However, instead of a
call during normal business hours, the phone rang one night at four in
the morning. Everybody else was asleep, so I answered the phone,
only to hear this really creepy, perverted voice that I'd never heard
before: "Hi Butchy, it's Bill Aucoin. I've got your picture right in
front of me here." He was looking at our picture, talking about how
cute we all are, and then he dropped the bomb: "So, do you like to
party?" "Yeah, man, we party," I responded. "We love partying!"
"Well," he continued, "I was thinking if it could just be me and you,
we could go party right now." When he said that, while sort of breath-
ing all creepy, I remember thinking, *Hmmm, something is wrong here,*
and I hung up the phone. Later in life, I'd hear many such stories
about Bill Aucoin, and my experience with him tied them together
for me. He managed KISS. Paul Stanley, the lead singer in KISS, had
somehow fooled millions of testosterone-fueled, juice-headed high
school dudes into yelling and fist-pumping to a guy onstage in a black
sequined unitard, high-heeled boots, lipstick, and big hair, while
prancing backward across the stage, puckering his lips, and saying shit

like "Y'all like to *paaaaarrrrtay*?????" I would like to thank Bill for clearing this all up for me.

Experiences like these, and being probably just a little bit homophobic fresh off the wagon wheel from Cartersville, didn't prepare me well for full immersion into the magical world of Desmond Child. You try on homophobia, you try on all this stuff because you're role-playing. You're just an ape, aping everything around you and seeing what fits you best. Today, some of my closest friends are gay, but back then, I was just learning how to deal with this new-to-me culture, and Desmond Child was no subtle introduction. He was not subtle about his sexuality at all. He was like the Jim Carrey of gay. I've come to love that he was that way, because it was not easy being gay some twenty years ago, let alone gay and *popular*. And Desmond wasn't just out—he was full-on rebellious about it, rubbing his sexuality in people's faces, turning it up even more if he perceived you as ignorant. I remember the first time we went to his house in Santa Monica to write. It was a big mansion, a beautiful place, and when we walked in, we were intimidated as shit as this huge, chiseled, muscled Ukrainian cabana boy came to the door, shook our hands, and smiled. We would come to call him FM, for "fuck machine"—that's what we figured Desmond had him around for. As we entered, we passed three or four more manservants, which was the vibe throughout the house; it was kind of like a gay version of a Puff Daddy video, where there're all these hot, available girls around. What Desmond had was everything I had ever wanted from success—well, minus FM.

Finally, we got to the music room at the back of the house and there was Desmond. I remember a lot of nervous tension: I was just so uncomfortable being around someone so powerful and all-talented. We were just hanging on for dear life, so it was hard to even approach him with a song idea, because I figured he'd just steamroll over us and write the song himself; that's pretty much the way it went. Whenever we'd suggest something, he would just say, "No, that sucks." He was

very opinionated, very brash, very brazen, very talented, and usually right. Desmond would just play and sing a line and make you feel inferior next to his talent. I remember one time he looked at me and said, "You're fat." He crushed me with that one. I had struggled with weight my whole life, and when he said that, I couldn't believe someone could be so bold and raw. The next day he looked at me and smiled like he had a diamond ring to give me, and maybe I thought this was his way of making up with me after ruining my life the day before. He said, "I got you a present." Are you ready for this? It was a membership to a Bally's gym—a goddamn gym membership . . . To get un-fat. Wow. I guess it kinda worked, though, because I went head-first into that gym and came out a lean, mean, hair metal machine. But I digress. Of course, at the time I had not shaken some of my country redneck vocabulary, so one time after he played something I wasn't sure about, I said, "It sounds gay." He stopped and looked at me and snapped, "Gay? What do you mean, *gay?*" I could feel my heart sink, like, "Oh my God, this record deal is gone now. I'm not going to work ever again because I said 'gay' as an insult and offended Desmond Child." I tried to cover myself, saying, "No, it sounds happy, like happy gay . . ." I'm sure he knew we were just rednecks and didn't care; he had a lot of fun intimidating us. Heck, I'm sure he'd heard the same stupid thing out of New Jersey knuckleheads like Richie Sambora and Jon Bon Jovi, anyway.

Sessions with Desmond could be just brutal. I remember once suggesting a lyric that featured the word "love," and he tore me apart. I mean, this guy wrote about love all the time—you know, "You Give Love a Bad Name" and all that. But when I came in with my little love lyric, he couldn't wait to stick it in . . . er . . . to me. He was like, "What do *you* know about love? You're not even a *person* yet." When he said that to me, it stuck so hard—it really hurt. I was like, "Piss off! What do you mean, I'm not a *person?*" I got so mad—then I realized, "Ha, he's right." Desmond, though, was a person: he knew who he

was. God only knows what he had been through as a gay guy growing up in the '70s, during the disco era and all of that, probably experiencing all kinds of mixed emotions and heartbreak and conflict. You live and learn: Desmond had obviously already lived a lot, but I was just beginning to do so myself. Between then and now, I probably experimented a little bit in my liberal years, as far as hanging out with dudes to see if I even maybe was missing out on something, but I wouldn't say I really started living my life and figuring out who I really was until I hit my mid-twenties.

The rest of the experience of making that record was really tense, frightening, and scary. Coming out of it, I guess we made a decent record for that time, but we definitely were spooked. That was a big lesson to learn; we didn't know how we would ever get our confidence back if we got the chance to make another record—if we actually got a budget approved to even make a second album. Back then, record labels were foolish enough to just throw a lot of money away, though: with the advent of the CD, they were doubling the amount of profit they were making but still giving artists the same deals that they gave them based on vinyl LPs that held eight songs. A vinyl album cost about ten bucks, but when they started selling CDs, they would charge something like $20 when the format was first introduced. A CD was even cheaper to manufacture than an album; it cost something around $1 to make a compact disc, even then. We were shocked when we learned that the SouthGang album was going to be one of the first records released solely on compact disc and cassette. We couldn't believe it—we were like, "Oh man, we're not going to do vinyl!" We were tripping, but the label was just like, "Yeah, vinyl is a dead format." It's pretty funny to hear that now, because now vinyl is big again, the compact disc is a near-dead format, and cassettes are definitely never coming back.

Those were different times, indeed, with stupid money to play around with. The video for the first single, "Tainted Angel," cost $400,000 . . . The *video.* We even got the guy who did all the big Aerosmith and Bon Jovi videos to direct, and it was a piece of shit. The video concept was great, and very original (*he said, his voice dripping sarcasm*): it was going to feature live performance footage of us on a huge sound stage, with our name written across the floor in big letters, cut in with footage of us at a strip bar, throwing money at dancers wearing angel wings. I know . . . I don't blame you if you are ready to return this book right now (I promise, I have grown up). The strip club footage turned out so badly, we didn't even use it. The video is hilarious to watch now: I'm licking my guitar and, you know, pointing at the camera and being as lame with my hair metal style as I could possibly be. Hey, I didn't know better; that was all I knew. In two days, we'd spent as much money on the video as it cost to make our entire record over the course of six months, all for something that only got played in the middle of the night on MTV's *Headbangers Ball* maybe twelve times. It was like, "Are you kidding me?"

How to Make a really Bad
music video in 1990:

* Hire guy who does all big Aerosmith videos.
* Spend 3x what the album cost to make (in 2 days).
* Make sure catering budget is more than a new Audi.
* Cocaine.
* Lots of "Amps".
* Synchronize your band's moves.

To show their love and support for bands that they really believed in, though, labels would throw these really expensive album-release parties. For SouthGang, they threw this outrageous, Victoria's Secret–style party at this club called Spice in Hollywood: they hired all these Playboy Playmates to dress up as angels because, duh, our album was called *Tainted Angel*. It was so ridiculous: we were surrounded by hot girls wearing lingerie and angel wings, and, naturally, there was an enormous ice sculpture of our band name. The only thing that would have been better was if our faces were carved in ice as well, Mount Rushmore style. It was all just so weird. But to us, we thought, "This is it. We've *arrived*!" Our parents came to town to attend, and of course we rolled up together in limos. We were supposed to play a triumphant live set, and Bill Gazzarri was set to introduce us, just like in the good ol' days. Everything started with Bill, so it seemed fitting.

When we got to Spice, we started doing the whole thing, shaking hands and having a great time right up until it was time for us to play. As we were about to go on, our manager, Pop, came up to us backstage; we were waiting for our introduction and noticed that Bill wasn't there. "Bill passed away tonight," he told us, sobbing; even a tough ex–Secret Service agent like him couldn't hold back the tears. Bill had passed away earlier in the evening, on the very night our record was released, which seemed like an eerie foreshadowing. His death was a big deal to us, because Bill gave us our *break*. He gave us our start and got our name out there. In the grand scheme of things, Bill gave us our life as a band: his endorsement was the green light that got us our first record deal. Bill got us to another level—out of the poverty that so many wannabes living in L.A. fester in as they try to make it—even though that little bit of fame wouldn't last long.

Bill's sad and unexpected death turned out to be bad timing for us, on all levels. Our record took a long time to make: from the time we started preproduction to when we actually finished the thing, it was six months—that's like a century in the music industry, where every-

thing changes minute to minute. I mean, now I can make a record in three weeks, or even one week; I just made my latest record in five days and it sounds better than that frikin' record that took us six months with that dude. There was no such thing as this thing called Auto-Tune back then: you either sang in tune or you did another take. Sometimes singers just cannot sing in tune, which is why it took us *two months* to do vocals alone. Auto-Tune didn't exist when we made *Tainted Angel,* but its invention gave people like Jennifer Lopez and T-Pain entire careers. Now, there are still some great singers out there. I've worked with Pink, who can sing her ass off. She'll usually do just one take, with no doctoring necessary, no timing issues, no pitch problems. Others, though, are a little different: they also do just one take, but then they fix it up with Auto-Tune.

In many ways, Bill's passing was poetic: for us, and numerous others, it was the end of an era. Bill's dying was the death of the Sunset Strip, the death of heavy metal. Our record came out right when Nirvana's breakthrough happened: we were the dinosaurs, and they were like spaceships, passing us on their way to the stars. By the time our album came out, it just sounded overthought and overproduced (which it was) next to Nirvana and the grunge revolution. Our buzz just started dying so quickly: we were a copy of a copy of a copy of a copy, and, rightfully, we just needed to die and go away. Of course, we decided to go on tour instead.

I knew the world was passing us by, though. Honestly, you'd think I would've been upset about it, but I loved it. I was just evolving and maturing a lot faster musically, especially compared to our peers, and definitely compared to the people at our record label. They thought we had to look and sound a certain way: "You guys should sound like Bon Jovi." "You're the next Poison." *Whatever, never mind . . .* I just was over it already—like, "This isn't cool music, what we're doing is not cool, and no one cares." We could sell out the Thirsty Whale in Schaumburg, Illinois, sure, but I had higher ambitions. I was striving to get to

a place that was tangible and real, and I remember thinking we were really not that at all. Our attitudes and views were so different within the band that our singer Jesse and I were at war constantly. You can imagine how that turned out: put a bunch of drunk Southern rednecks with differences in a tour bus for a year and see what happens. They gave us the keys to the kingdom back when record deals were exorbitant, and we looted it dry. In the end, the only things left emptier than our bank accounts were our souls, as we would find out soon enough.

THREE

THE END OF AN ERROR
My Hair Metal Band Went to China, and All I Got Was This Lousy, Copyright-infringed Tour T-shirt

She likes hair bands on satellite radio
But I was in one
So it's a little too close to home.
—*Butch Walker and the Black Widows, "She Likes Hair Bands"*

Out in the great wide open
A rebel without a clue . . .
—*Tom Petty and the Heartbreakers, "Into the Great Wide Open"*

Going on tour: it's the lifeblood of any rock band—or its killer. The touring life is a storied one: tales from ye olde road make up numerous rock legends (and the majority of each episode of VH1's *Behind the Music*). And while there is a lot to laugh about on the road, you won't often find a copy of *This Is Spinal Tap* in too many tour bus DVD players: it's just too painful to watch. *Spinal Tap* gets it too right about life on the road; if one is watching it as a professional gigging musician, it seems kinda like a depressingly absurd documentary about

one's current state of existence. For SouthGang, touring made one sad fact very clear: we were never going to be all that big. In days of yore, a band would tour to promote a new album; today, however, the album exists only to promote the tour. In our case, well, nobody cared much about either, and going on the road only made that abundantly clear.

We definitely weren't going to be as popular as even the bands whose gear we purchased for our stage show. We bought all the staging stuff from a now-forgotten hard rock band called Autograph, which they had amassed for their opening slot on Van Halen's *1984* arena tour: we got all of their drum risers and stage amps—shit to make the band seem huge onstage. The thing was, unlike Van Halen, we were playing clubs, not arenas. Our heads, hearts, and dreams were bigger than we were as a band. It was all so very *Spinal Tap,* indeed: we couldn't even get our equipment onstage, usually—most of it was too big to be wheeled into the tiny venues we were booked in. As a result, every show was a reminder of how small SouthGang really was. Every day on tour, with all our road crew and production, we were living in a fantasy world—and a very expensive one at that. The label had made the mistake of giving us exactly what we wanted, regardless of the fact that it was our very first tour ever, on a record that barely sold a hundred thousand copies, with a single that was barely on the radio (today, selling a hundred thousand albums would be a success, but in the pre-download 1990s, that was considered abysmal). As a reward for this failure, we were given a full tour bus, with six crew guys at our disposal. Of course, we never touched any of our gear. Ever. We had to do it the same way the big rock stars did—and to call ourselves "rock stars" wasn't exactly accurate, either.

The math was painful: six crew guys + four band members + a tour bus = many drunken nights in bars, brawls, and bloody noses. Yes, we were learning how absolutely wild it was on the road, and living every bit of it. I probably shouldn't have gotten that tattoo of the SouthGang logo on my left arm that night in Pensacola by that drug

dealer in his double-wide; after all, your first record deal with your first band means you will *obviously* be huge and you will *never* break up. At least I was well anesthetized by Dr. Jack Daniel's: that also helped with the fights I was having with our heavy-drinking lead singer, who by now had discovered how well (or not) booze goes with Xanax.

It was always weird to me how easy it was to get laid being in a band (especially looking as un-awesome as we did). I witnessed a lot of that on our first tour—group sex, and a bunch of other kinky, filthy things I had never really seen before. But I was in a relationship back home, so I was the goody-goody on the road, and in a way, I partly regret it. I missed out on a lot of the mindless fun of just being a twenty-year-old boy with a guitar and an endless hard-on; I just had perma-blue balls and a very large long-distance bill. But whatever—I was in love and had something to prove. At the time, communication was so tough: there was no iChat, no Skype, no way to see the spouse or girlfriend you'd left behind back home.

My relationships became all about calling cards and whatever working pay phone you might find at a rest stop. I had a serious girlfriend through the entire recording of *Tainted Angel;* I was with her from before we got signed. When the two schoolteachers I lived with found out I had a girlfriend, they kicked me out of our apartment in a jealous rage. I had no choice but to move in with my future ex-wife, whom I'd known all of two weeks. I met her one night playing pool at a club in the Valley called Filthy McNasty's FM Station; cut to being together for six years. She was pretty normal, but five years older than me, so she became a different person as we grew up and grew apart. She was already so much older and wiser and more mature than I, a still-immature little twenty-two-year-old shit. We were together through SouthGang's whole second record and tour as well. All that we went through—the creative differences, the fighting, the

drinking, and the traveling—broke up not just my relationship but also my band.

Incredibly, considering how insanely dodgy the whole *Tainted Angel* experience was, SouthGang made our second record with Howard Benson! We were kind of forced into it yet again by our Alcohol & Restaurants guy. Even though that first record was not a success, selling a hundred thousand records was just enough to keep us alive for one more try. The thinking was Howard would at least keep us at that level regardless, even if we didn't magically turn into superstars. For that to happen, however, the numbers were against us. This time around, our budgets would be severely reduced—for videos, for recording, for everything. We started production with a new mentality: *Screw Howard, screw everybody, we're going to do this album the way we want to do it and just steamroll over everyone who gets in our way.* Of course, we relied on booze for that Dutch courage, so there was a lot more tension. We were drinking a lot, and we didn't talk to each other much, especially Jesse and me.

To keep things fresh, we recorded a lot of the record naked. This was obviously due to the influence of the Red Hot Chili Peppers: we were getting into all kinds of music from outside our genre—hardcore punk like the Bad Brains, funky '70s rock like Bad Company, Mother's Finest, Free; the Southern rock we grew up on—Lynyrd Skynyrd, the Allmans—was also rearing its head in our new material. We wanted that full spectrum of sounds to come out in our music, but the label was just pushing us to remake the first SouthGang record all over again. We knew that wasn't going to work, but our A&R guy was delusional: he was in denial that Nirvana and grunge hadn't already killed our genre. We figured the best thing we could do at that moment was go as classic rock as possible. To us, a lot of the grunge genre just sounded like a cross between punk and classic rock,

anyway. Pearl Jam was like a newer, hipper, flannel-wearing version of Bad Company and Free; Soundgarden was like Rainbow meets Black Sabbath—that is, if Ozzy actually looked good with his shirt off. That music was just solid rock, and that's what ran in our veins. We just wanted so badly for our second album to be different from the first one, and the battles with the label were right there in front of us.

There was no writing with Desmond Child on the new album; we couldn't afford him, anyway. Instead, the singer and I would write all the songs; because we kinda didn't like each other, there was no way that the creative process was going to work well. I detested his lyrics: they epitomized every bad rock-and-roll cliché in the universe. I was getting into more heady songwriting—well, as much as I could. I just wanted to see us grow out of "Baby, baby, Friday night is all right/ Now give me your beer and blow me." I thought that stuff was uncool; we were never going to get any respect being this party band or whatever, so I just shredded all through that record, blowing my nut on my guitar parts, doing totally excessive five-minute solos whenever possible. I was like, "Screw all of you. If this album is going to suck, at least I'm going to get some respect from the guitar community." It was dark, man.

SouthGang's second and final album finally came out in 1992; we titled it *Group Therapy,* which is exactly what we needed, as we had to be insane to continue. *Group Therapy* couldn't have died a more quick yet miserable death. Now there was way more drinking, way more pills, way more tension, way more all of that. I just couldn't deal with Jesse anymore, so I would just get loaded to hide from him, and he stayed as messed up as possible. I do love him deep down, as we shared a lot of teenage rampage together, but I just don't know how he will turn out when all is said and done.

Despite the fact that some members of SouthGang could barely

stand to be within ten feet of each other, we still went on the road forever in a van with another band, playing in clubs to definitely smaller crowds, and having near-death experiences. Midway through the tour, there was a blizzard that came through Flagstaff, Arizona: we could either brave it with snow chains and drive ten miles an hour on through the Grand Canyon on a two-lane road, or just sit in the middle of nowhere and miss a bunch of shows. So we went, but we didn't realize the road we were on in the Grand Canyon was closed; it was deserted for miles in either direction. We were so bored through this long slog, we stopped and took trash bags from a rest area, tied them with a rope to the back of the van, and backslid through the slush; one of the crew videotaped the shenanigans through the back window. At that point, we'd do anything to pass the time.

I remember when it was my turn. I pulled myself up and rested my feet on the back of the bumpers, holding the rope right there between my legs while the van skidded all over the road. On the video, the camera is pointed down at me, and then, all of a sudden, you see me slip under the van and disappear. At that point, the van spun out of control and slid off the road to the edge of a cliff, hanging over a three-hundred-foot drop. Everybody in the van piled up in the back so the weight dispersion would make it stay up. I caught the bumper as I flew under it, just missing having my legs chopped off by the axle, which had fallen out. We sat there and waited for hours until a snowplow came down and towed the van to safety. By that time, our feet were purple: we were all wearing canvas Chuck Taylors, just freezing in the deep snow.

That was but one of many stories from that time, but it wasn't the darkest memory from SouthGang's whole end of an era. That came when we fired Pop, our manager—a very emotional parting. We felt we were being held back, so we let him go. It's a very common sce-

nario: if the band is failing, fire the manager. Blame him, blame everybody; just don't blame the band. When we got rid of Pop, we switched to the band Warrant's management company, Tom Hewlett and Associates. Big-shot Hewlett, of course, didn't actually sully his hands with us: he assigned us to a day-to-day manager named Eddie Wenrick. Eddie was a total asshole, a loser, and I fucking hated him. Eddie played God on everything, but he was no angel. Switching managers to Hewlett was the worst mistake we ever made, and I blame myself for possibly being the band member who had pushed the hardest to do so.

The biggest thing Hewlett wanted to do was get us out of the country; the label wanted us out of their hair because we were just bothering everybody. Now all business can be done via one e-mail, or on a cell phone call, or on iChat, but not in the early '90s. If we weren't on tour, we would hang out in the label offices, because we were just so concerned about not missing out on anything. If you wanted anything done, if you needed answers to some pressing question, you had to go to the label four or five times a week just to approve artwork, check publicity pictures, and have conferences on whatever. There was always some conference we needed to be at—it was just conference, conference, conference all the time. At one of these many very important conferences, they proposed a situation for SouthGang to go overseas: "You guys can be the first American rock band in history to ever play in *China*!" What they were proposing was true—they had apparently struck some kind of deal with a talent agency in Beijing to make SouthGang the first rock band to tour China and Mongolia. And then there was the promise of cash. Hewlett dangled a large sum in our faces, more money than we'd ever heard of. We'd get something like a check for ten grand at the end, which would have been more than we'd ever made from a tour.

When we heard this, we suddenly got stars in our eyes: "Oh yeah, let's go! If we're big in China, we'll be huge! Great!" I think the

thinking was, as presented to us, something along the lines of "Hey, heavy metal worked in Japan, so let's try China! It's an even bigger country!" In truth, there was no practical or promotional reason for us to do this. There was no such thing as intellectual property or copyright law there, so it wasn't like our album was in Chinese stores. We weren't going to sell anything, and it wasn't like there were any radio stations there that played SouthGang; hell, there weren't any radio stations playing us in *America*. I think the label and management just wanted us out of their hair for a month or two while they were busy not promoting a record that was well past its due date.

The tour was booked for six weeks, and none of us had ever been out of the country. They sent us over there with this guy Bob Hoskins (not the actor of *Who Framed Roger Rabbit?* and *Super Mario Brothers* fame). Bob was the liaison for management, the day-to-day guy who would be our guide in China; he was kind of a tour manager, except that he had no experience doing this whatsoever. We shipped over all of our gear via air freight—our full tour setup went by plane, except for the PA system and lights; that was supposed to be provided. Getting there required a twenty-hour plane ride, and we were pretty miserable when we arrived at the airport in Guilin just outside of Beijing. Snow was falling, and this creaky, nearly broken-down old show bus appeared in the middle of nowhere to take us to the first stop.

We all got really sick quickly. I was ill by the second day: I ended up getting such a bad flu I didn't eat for three days after that. I was convinced it was the food, you know, so I ate peanuts for a full week. With my young naiveté, I was convinced we were eating dog, cat, or whatever, if it resembled meat, and I thought that my normal (albeit uncultured and uneducated) diet of Taco Bell for every meal would be absent for quite some time. So I sat there and ate my nuts without argument. China opened not just my gut but also my mind. Seeing two-thousand-year-old Buddhist temples definitely made me question what I knew about religion, especially the fact that here was a

faith even older than Christianity, which had been shoved down our throats ever since we were kids. And I saw how much Americans were hated overseas. That's something they don't know here in the good ol' USA: everybody just thinks we're so "kickass" and that other countries love us because we're the greatest country above all else. Note to untraveled Americans: don't believe everything you are told.

That and everything else about China was a surprise: literally, everything proved so baffling that every single day, for six weeks straight, there would be some massive meltdown and communication failure. One example: before we left, we were told that we would be playing sports arenas, which helped seal the deal. "You mean we're going to play for thousands and thousands of people who have not even heard us every night, spending their month's wages for their families to come see us play? And then we're going to make all of this money at the end of it all? Why wouldn't we do that?" SouthGang was built to be that kind of band, so if you dangled an arena in front of us, we'd play it no matter where it was. Uruguay? No problem. We did play arenas in China—that much was true; too bad they didn't have adequate sound systems for such massive spaces. The first gig we arrived at, I remember them wheeling the PA in—if you could actually call it a PA. Our sound guy Tony gave us the bad news: "Um, the entire PA system is just four monitor speakers." Indeed, the sound system they'd provided was barely adequate to use for stage monitors for, say, the drummer to hear the band onstage—and absolutely useless for a twenty-thousand-capacity arena.

So the first gig we played in China was in an arena with just four tiny amps that wouldn't even suffice for a garage rehearsal. The lights were a joke. They were tomato cans with lightbulbs in them, hung from bamboo trussing; I can't make this shit up, I swear. We were also warned that we would only be playing on the groundsill on the floor

in the middle of their arena, with the entire crowd seated in the bleachers and the stands; no one was allowed on the floors, because everything had to be rigidly controlled. That was ensured by the constant presence of rifle-wielding military police. MPs were everywhere, making sure nobody got out of line, as the audiences were not going to be allowed to stand up or cheer; they were permitted, however, to sit and clap. Yes, we weren't on the Sunset Strip anymore. The first concert we played in China, the crowd was silent, and we had those four tiny speakers pointing up, with nothing in them but vocals; they weren't even strong enough to put drums in. It was basically like the Beatles playing at Shea Stadium but without all the screaming, and, like, girls . . . and stuff.

The crazy part is, most of the arenas we played were fairly full. Setting up, we'd be like, "Damn, there are a lot of people here!" But it was just weird. Because there was no PA, they couldn't really hear us, and as the closest person in the audience was a hundred feet away, they couldn't really see us, either. And there were always new rules being forced on us, like how we couldn't go off the stage during the show; every day something like that happened, so we would get even more mad. The local officials were making outrageous requests like "Could you please learn to play the Chinese national anthem?" or "Could you please learn a song by a famous pop singer from China?" It was more than enough chirpy shit for us, being young and inexperienced and uncultured, to take in. We were like, "This is bullshit. We want to go home, but we have to stay because we're going to make money. We can't forfeit the opportunity." But by the third or fourth show, we started to get a little rebellious: we had wireless hookups on our instruments, so we started running up into the audience. Sometimes Jayce and I would stop playing and just dance and do cartwheels across the stage in the middle of the show. Slug would be laughing his ass off behind the drums, while Jayce and I made fools of Americans everywhere to the bemused Chinese concertgoers. Our

singer, who took it all *waaaay* too seriously, would just boil, because the spotlight was being taken off him. But what could they do about it? We came to rock, damn it, and that's what we were going to do, one beer at a time.

What else did they expect, really? They were laying down all these fascist rules to our rowdy, drunken rock band that came over there thinking we were in for the time of our lives. We were thinking China's going to be like, you know, the decadent Shanghai brothels in Mötley Crüe's "Too Young to Fall in Love" video, and it was definitely not. Alcohol? Not enough. Groupies? Girls? No. Sure, there would be all kinds of hookers in the hotel lobbies saying, "You want quickie?" We were told, though, that we would be punished and taken to jail if we mingled with any "girls" over there. The authorities scared us to death, telling us that we'd spend the rest of our lives in these six-foot-by-four-foot jail cell cubes with no light. So yeah, it was a sausage party for six weeks, except there were lots of gay guys who would hit on us.

We would have guys come up to us all the time and ask us, "Are you gay?" At the time, of course, we were still very uncultured, a little bit redneck, and Slug, our drummer, was particularly gullible. I remember when we were in Beijing, this one guy—named Fun, naturally—really had a thing for Slug. Fun would follow us around from hotel to hotel, calling Slug's room all the time, saying, "Oh, you drummah? I'm Fun!" Slug met with Fun finally and told us all about it: "Yeah, man, this guy is going to bring me a whole Chinese military uniform and all this cool army shit! How cool will that be to rock onstage?" Fun, just like his namesake, was looking for some. He did bring Slug an outfit to wear, but he wanted him to wear it alone for him in his hotel room, for some kind of sexual role-playing game.

We did manage to find some booze, finally. We were in the middle of nowhere on a thirty-two-hour van ride from Guilin to Guangzhou when we passed a Pabst Blue Ribbon plant! Yes, of all things, the beer

that's like the quintessential white-trash Americana, hipster-approved staple, was made right there in China! Somehow we got somebody to score us cases and cases of PBR; as there was no ice—we discovered Coca-Cola was always served at room temperature in China—we'd put the beers on the windowsills outside of our hotel rooms to keep them cold. I developed a special affinity for Pabst Blue Ribbon after that. Maybe I missed America and PBR reminded me of home; more likely, however, I just needed to stay as drunk as possible to deal with the bullshit that was surrounding us, and growing, every single day.

One particularly memorable instance was a party we attended in Mongolia with the governor, all the local officials, and this random Mongolian rock band. They took us to this huge red-carpet dinner where everything on our plates had a head and was flopping around. That freaked us out, four young guys who ate McDonald's for every meal: it was weird for us to eat grasshopper, live fish, and crazy delicacies like that. But we were all knocking back this 180-proof firewater called Old Cellar, and everyone got so wasted because us Southern boys were drinking everyone blind; the officials were so bombed they were falling off their chairs onto the ground. None of us could understand a damn thing the other was saying, but we all spoke the universal language of liquor.

The Australians saved us in China—and introduced us to the Chinese concept of dog sledding. In Beijing, we would hang out in this Aussie bar near the Australian consulate called the Mexican Wave. The details are fuzzy, but on one of our days off, our new Aussie expat pals took us skiing up on the border near North Korea and Russia. Of course, me wearing a size 13 shoe presented a problem in Asia. The largest size ski boot they had was size 9, which I managed to squeeze into somehow; it was excruciating, but I didn't want to miss out on the fun. To go up the hill, we rode these insanely rickety, rusty ski

chairs that were terrifying. Once we reached the top, however, we saw what looked like mangled dog carcasses pressed down into the snow: you could see their tails and the tops of their heads sticking out of the powder. We were like, "Look at all those poor dead dogs over there—that's messed up . . ." Right then, one of the locals runs by, picks up a dog carcass by the tail, jumps on its back, and slides down the hill on it: basically, they were using frozen dog skins as sleds. Now we had seen everything. I have pictures somewhere, but now that I rarely even eat meat and I am older and more "sensitive," I don't even wanna see them. Ah, those are the little tails that stick out in my mind from when hair metal first invaded China . . .

Somehow we got to the end of the tour, dead dog sleds and all, and there were only three shows left. We arrived at this sports arena where they had been training for the Winter Olympics, and the powers that be failed to tell us that we would be playing on ice. We're like, "Okay, how does that work?" Imagine being connected via cables and what-not to the thousands of volts of electricity it takes to run a rock concert: we took one look at that setup and said, "We're not doing it." "No, you have to," the officials responded. "You have to play, or you're forfeiting your contract and you won't make the rest of your money." As a solu-tion, the promoters came up with this genius plan where we'd play on these packing crates that got us about six inches off the ground. Each one of us had a pallet the size of an IKEA coffee table to stand on out there on the freezing ice; we had to do a two-hour show on these ram-shackle platforms. That meant we couldn't move at all, which was anathema to a party band known for "exploring," running around everywhere, and basically what we considered to be "feeling it."

Naturally, this restriction brought out the Georgia Rebel in us: we made sure to get plenty boozed up on PBR or Tsingtao beer or Old Cellar before we even started. Instead of playing the Chinese national anthem as "instructed," I played the American one instead, blasting feedback and licking the guitar like an acid-fueled guy with an Afro

once did. In no time, Slug's jumping off the drum kit and sliding across the ice, right in the middle of a song. Yeah, we were that hammered. We were just miserable and wanted to go home, because we weren't prepared for that kind of culture shock—or the harsh reality of "Wow, we're failing . . ."

This was a massive fail, and we never came back from it. That was made clear on what was supposed to be our second-to-last concert of the tour. We were playing this one arena in one of the smaller towns, and it was very packed—so much so, they had to seat people on the floor as well. In fact, it was the only gig where the officials actually allowed the audience that close to us: they made them sit Indian-style on the ground—the crowd wasn't even allowed to stand. By this point, the tension was bad, and we were just over everything: China, the band, each other, you name it. So when the show started, it was an almost involuntary reaction to test the boundaries of what we could get away with.

As we started to play, we could feel the excitement growing in the crowd. It was clear these rural Chinese folk had never seen anything like a Sunset Strip metal band before in their lives, and they were *rocking*. They began throwing things onstage—candy, money, stuff they had made, whatever; these days, when people throw stuff, they're throwing it to smash your head in, but this was like a gesture of gratitude. Seeing this reaction, halfway through the show we started encouraging people in the audience to get on their feet: "Come on, everybody! Get up! Stand up!"

At this, you could see the authorities getting nervous, because people were just rising up, clapping, and really getting into it. They were like caged rats that, having been suppressed their whole lives, found this unexpected opportunity to go nuts and just *went for it*. There was so much weird energy that night: the crowd started running up on the stage, trying to pull our hair; after a while, guys and girls alike were grabbing our faces, kissing us, and literally pulling our

hair out. They just wanted a piece of us, which took us by surprise—even in the U.S., we'd never experienced that kind of frenzy at our shows. By the end, people had gotten completely out of hand and were going crazy, rushing the stage and setting off smoke bombs. Next thing we knew, we're being yanked offstage by the authorities, who shoved us into a little room backstage as a full-on riot broke out in the arena. As soon as they could, the Red Army cops put us in a van and whisked us away. We couldn't stop high-fiving each other: "That was totally wild, man! Finally, we've started a riot!" We thought it was great—our own little taste of Guns N' Roses–style bedlam. In hindsight, we were idiots to think that was a good thing. We were completely oblivious to the fact that many of the people in the crowd that night were probably getting beaten, whipped, and sent to prison for rocking out a little too hard to a failing American cock-rock band.

Next thing we knew, we woke up drunk on the train to the next city, which was supposed to be the last stop on hair metal's inaugural invasion of China. It was a twenty-four-hour train ride, and we had our own little *Darjeeling Limited*–style boxcars, split up in pairs. Jayce and I shared one, and on this journey we decided together to break up the "Gang." We had had it: we were already just so over the band anyway, and everything about it—our label, our management, the works. We plotted out our whole exit strategy: when we got home, after we broke up SouthGang, we'd made a pact to start a new band. We got so excited we started writing songs for the next band immediately, while we were in those rickety Chinese train cars. The whole time, we were listening to tons of Van Morrison and Al Green, Allman Brothers, Lynyrd Skynyrd—anything but hair metal. Our musical tastes had grown, whereas our singer's had not.

God, we were so ready to get out of there and call it a day. We had just one more show to do before we could go home and collect our

money from the tour; then we'd have enough cash to actually leave the label for a while, take care of ourselves, and figure out the next move. The way the deal for the China tour worked was we got a big advance upfront, and then another large payment when we completed the tour. Of course, most of the upfront cash went to management for its cut off the top, and then the rest to the lawyer fees, and the business manager, and so on; we basically saw none of it. They were all saying, "Well, yeah, there's not much left from the first payment, but you guys are getting *all* of the back half." Big mistake: after the riot, the Chinese authorities had no intention of letting us finish the tour. Instead of arriving at the next destination on the itinerary, the next thing we knew we were being escorted off the train in Beijing at the airport. They were sending us home, but we had no idea what was going on. We couldn't find our interpreters, and no one in our entourage could speak the language; Bob, our supposed tour manager/management-liaison dude, was long gone. There were no cell phones; in fact, there were no phones anywhere. We were properly freaking the hell out, going from arena-rock spazz insanity to John Le Carré international incident overnight. And, of course, we'd come to find out that we were never going to see that back half of the tour advance, because we didn't complete the shows, even though we had no choice in the matter since the Chinese authorities didn't give us the option. Uh-huh—we were really screwed. I still, to this day, get a little twitch in my eye whenever I hear the words "Chinese democracy." And you thought Axl had issues . . .

Stranded at the airport, we had no clue how we were going to get home. We didn't have any money, and we'd already fired our management the day before in a fit of drunken fury. Somehow we were able to get to the hotel we'd been staying at in Beijing, where we tracked down our tour manager Bob and promptly started threatening his life. Bob claimed he was there to actually straighten everything out and smooth things over, but we always figured he was just trying to save his own ass. After countless hours haggling

and screaming, we finally got plane tickets back to Los Angeles.

The relief didn't last long. Just before we were about to board the plane, we realized we didn't know what was happening with all our equipment: "Oh my God—where's our gear? We're not leaving without our gear!" We were traveling with a semi-truck full of thousands of dollars worth of vintage instruments and precious rare amps: this gear was all we owned—it was the only stuff we'd ever bought with our advances from the label deal—and it was nowhere to be seen. It's a testament to our road crew that they volunteered to stay behind in China until they found the gear and got it home safe. And, in an age of no sophisticated communication technology, in a completely foreign and hostile country where no one spoke English, our loyal crew managed to track it all down. Today, these guys are among the highest-paid touring technicians working with the biggest artists, and the level of commitment and skill they demonstrated on that China tour is the reason why they're at the level they're at now. I can't afford them anymore, but back then they were just guys who moved out from Rome, Georgia, with us; they'd never even tuned a guitar in their life before they went on tour with SouthGang. One of them is now a guitar tech, another is a production manager, and they're part of the crucial touring machinery for the likes of Mötley Crüe, KISS, Linkin Park, Rage Against the Machine, and countless other bands that sell lots of concert tickets. Back then, though, they were our guys, just little dudes with no experience, but all heart. They flew back to the States with all our gear in a *cargo plane,* their backs literally on the road cases for a twenty-hour flight. That's what our road crew did for us, and I thank them to this day for that dedication. Thank you, John "Larry" Cromer and Robert "Ragman" Long. I owe you guys beers soon.

Part of the deal with the whole China tour was that the label was going to pay for all the shipping. That expense was specifically not

coming out of our money: it was like ten grand each way just to move our gear back and forth. But after the riot fiasco, the promoters naturally sent the gear back C.O.D., which meant that we had to pony up for the shipping when we got back or we didn't get the gear—some of which we'd rented and were getting charged for by the day. If we didn't get the gear out of customs at the airport in the U.S., the vendors were planning to sue us. We didn't have any money, so our gear ended up stuck in customs for weeks. We literally got off the plane, broke up the band, and then Jayce and I got on the phone to our dads, begging. We didn't come from money, so our families pulled together and took out loans: each of our dads took out a $3,300 loan to help us. Our singer didn't really own any of the gear, so he was off the hook, I suppose, but the three of us—Jayce, Slug, and I—pooled all our family money together and eventually got everything out of seizure.

That was the end of our China debacle. While it was hell, I can't say it didn't open my mind to the world beyond my limited experience. It was such a blessing at a young age to go over there and do what we got to do. Most kids our age were still stuck in places like Rome, Georgia, where they would never learn of another country's culture, religion, or government. We experienced so much cultural weirdness in China—eating at a Kentucky Fried Chicken next to the Great Wall, say, or literally going deep into Siberia to play a gig. This was just after the Tiananmen Square massacre; we'd run around in that very same spot where the students were killed. We were so ignorant, we had no idea about what had happened there, or how controlled that society was; everything was like one big "Wow, man" to our uncultured bumpkin asses. It was really insane to see that world from the stage and through the eyes of the Chinese audiences, who were experiencing something like us (for better or worse) for the first time. Not to get all hokey, but it was incredible to see something like that overtake people's emotions in the way that it did; it just went to show how primitive and primal music is. Most of all, in China we

discovered our inner reservoirs of strength; we figured out whom we could trust, who was really committed and who wasn't. Most important, we started to figure out (a little) who *we* were.

Returning to Los Angeles after all that happened on the China tour was a real wake-up call; it reminded me of the culture shock we felt when the band first moved to California. As soon as you arrived in Hollywood for the first time, the big claim to fame was to go to Sunset Tattoo on the Sunset Strip and get a tattoo—usually something really bad, like a heart with a Flying V guitar busting through it, which is exactly what I got. I figured out later that the Flying V/ heart design is also the original logo for Tom Petty and the Heartbreakers, which is probably now one of my all-time favorite bands— and I'd unwittingly tatted that logo on my right shoulder! It was pure stupidity to walk in and just pick a random design off the wall, but I had no patience, tact, or self-control. I was new in town and couldn't wait for L.A. to put its mark on me.

It's so funny, because just two or three years later, I had already been chewed up and spit out of Los Angeles. After SouthGang's big record deal had failed to turn me into a hair metal god, the sparkle had kind of worn off of L.A. for me a little bit, and I was ready to move back to Georgia. I missed my family and friends back in Atlanta, plus an original music scene was finally starting to flourish there. Jayce and Slug and I wanted to go back and be a part of that, because that's where we were from. I experienced a moment of clarity one night as we were packing up to go back home: we had MTV on the TV in the background, and the video for "Into the Great Wide Open" by Tom Petty and the Heartbreakers came on. Seeing it, I felt like I was watching a most familiar story. Eddie, the video's protagonist as played by Johnny Depp, leaves his hayseed small town right after he'd finished high school to "make it" as a rocker in Hollywood; the first thing he does when he arrives is get a heart tattoo on the Sunset Strip. As Tom Petty narrated the rise and fall of Eddie in his Mad Hatter top

hat and round Lennon specs, I thought to myself, "Well, that's really creepy and ironic." This was art imitating life—*my life*. The parallels were indeed eerie. Eddie's A&R man, like mine, said, "I don't hear a single"; when the going got tough, Eddie fired his manager instead of looking at what he'd done wrong; and, when the smoke of so-called success had cleared, all his personal relationships with women were shattered to dust. But once again, adversity strengthened my resolve to win on my own terms, not the game's. I wasn't going to be a cliché anymore—or, as Tom Petty put it, a "rebel without a clue." No, I was going to be a rebel *with* a clue for once. Sometimes, though, knowing too much can be a hindrance as much as a help . . .

TOO MUCH OF A ROCK STAR FOR A ONE-HIT WONDER
Playing the Numbers with Marvelous 3

Tell me I sold out
Tell me I sold out—go ahead.
—*Marvelous 3, "Freak of the Week"*

It's funny: however much success I hope I have as a producer or song-writer, I never stop wanting to continue as a performer. Even when I was in my deepest addiction to Aqua Net and Mixolydian minor guitar solos, I never foresaw a time when I wasn't performing on a stage. I don't think that desire will ever go away in me. Tom Petty is still my role model here; he's the classic example of someone who rocks no matter what era it is. Regardless of how old he gets or what's happening in contemporary music, Tom always tells a great story, and still gets away with wearing a scarf.

For me, music ain't about where you're from, it's where you're at. Occasionally, I will succumb to the perils of the Internet and stumble upon a brash or condescending conversation that uses me as the target. They try to use my past as a crutch, to be like, "Oh yeah, he was in a *hair metal* band, so we can't take him seriously." That's fine if that's what they feel, but I was just being true to myself at the time. I guar-

antee you, those Internet haters were idiots when they were seventeen, too, and most of them probably don't even play an instrument, either. Hindsight is 20/20: not many kids are blessed with having the musical knowledge of Lester Bangs when they're that age. I certainly didn't; I was reacting to what I was exposed to at the time, which was the radio. FM radio was my only tool to discover new music, and all I heard on that was rock radio. Therefore, I played rock radio music until I got out into the world and saw what else was going on. Traveling a little bit with my eyes and ears open led me out of the hair metal ghetto, and into some greener pastures to graze. It seems like I reinvented the wheel musically for myself, but like always, I was just being true to what I was into. Lo and behold, that approach gave me my first hit single as a performer, and rocketed me back into that whole major-label, music business insanity all over again. Oops.

What's funny is I'm glad SouthGang failed as much as we did. We failed *just enough;* if we'd succeeded, I wouldn't be here right now with you, writing these words. Instead, I'd be *that* guy from *that* band from years ago, who maybe gets offered a spot on *Celebrity Fat Club,* no matter how good of a singer or songwriter I might have grown into. Hell, if things had been really good, I might have merited an episode of *Behind the Music,* but that's it. I don't care what anybody says—it's just for purely nostalgic reasons that anyone wants to hear, say, another record out of Backstreet Boys right now. No one is going to take that seriously, nor a new Winger album, or an Ugly Kid Joe reunion, for that matter. For all we know, Ugly Kid Joe could be working on a better record than *Kid A,* and we'd never be able to comprehend it as such. The past perception will forever be instilled into our brains as what it was, and not what it could ever be. And except for maybe die-hard fans, no one's really going to give a hoot if Marvelous 3—the band with whom I had my lone hit single, "Freak of the Week," in 1998—reunited, to be honest with you. If we had been bigger, we would have definitely flunked out: we were just

obscure and under the radar enough where we'd just be respected a little bit in case I wanted to do it again. Right now, I'll take almost-winning for the rest of my life; I couldn't imagine winning the sprint when I was nineteen or twenty years old, but then not being able to run in the marathon. Like Petty, it's all about staying in the race, but admittedly he's crossed the finish line a few more times than I have. Me, I've been really lucky to just barely win or barely lose.

Honestly, all the cool opportunities I've had up until now are due to the fact that I chose to be a little adventurous. Not like in the of Montreal kind of musical adventurousness; more in the sense that I always wanted to explore new avenues, new endeavors. "Oh, maybe I'll become a producer one day." "Maybe I'll write songs for pop acts while I can still tour and play songwriter to a nice little fan base of my own." I like it; it's awesome, and I don't have to play "Freak of the Week" or, God forbid, some old SouthGang song. It's easy to take that attitude now, though, I admit. Coming out of the SouthGang debacle, landing back in Georgia with nothing to show for it, especially credibility—yes, reinventing myself out of that wasn't so straightforward back in 1993. It was more like, okay, what are we going to do now after having a label wipe our ass and pay for everything? We just did the only thing we knew how to do: start a band and immediately go on tour in a van.

Our new band consisted of three-quarters of SouthGang—Slug, Jayce, and myself—plus an additional singer, Chrystina. Chrystina is like a sister to me, and an actual wife to Jayce, because they ended up getting married; they're still together to this day, with three of the loveliest kids I have ever met. This new group was the beginning of my true bond with Jayce and Slug, and the beginning of a very tight-knit, emotional roller-coaster relationship that continues to this day. Sure, we were united in the rock of cock in SouthGang, but taking this next step definitely made us brothers. I can't say enough about how well

that's worked out over time: we easily came close to killing each other and wanting never to see or speak to each other ever again several times, especially after some of the bad business decisions that I made— oh hell, let's just say I made a number of bad decisions *period* as I forced myself into power. It was a wild ride, all of us tasting real success for the first time, but it didn't come right away. First came the hard work.

We called our new band Floyd's Funk Revival. Floyd County is the name of the county we were all born in, so it *naturally* was the wise choice of inspiration. We thought it sounded cool, even though we weren't necessarily a funk band. We were more of a rock band, sure, but we thought that it was cool to play with people's perceptions and expectations, just like one of my favorite bands at the time, Jon Spencer Blues Explosion, did with their name. We wanted to keep people guessing, because we were guessing ourselves through it, too. Our hope was that, from the name alone, it was clear we were the total opposite of what we had been up to before in SouthGang. Finally, we were able to say "Forget hair metal" once and for all, with no label telling us how to look or sound.

This was the bloom of the '90s: by then, we were knee-deep into grunge, but also more folk- and blues-inspired music, too. This was the moment of the H.O.R.D.E. Festival and Lilith Fair—artists like Widespread Panic, Alanis Morissette, Blind Melon, and Blues Traveler were playing to huge crowds. We also loved the more successful bands that were still relevant at this point, like Smashing Pumpkins and Pearl Jam. Oh yeah! We were exploring all of those routes, trying to get into a space that would work on a contemporary level. What impressed me most was how much organic, soulful musicality was around, regardless of genre: the first Sheryl Crow record, for example, was amazing to me in that sense. When I heard that, I was like, "Whoa, this has a super pop sensibility with amazing production, yet it's roots-laden and organic sorta like (yeah him again) Tom Petty." We loved the reckless intensity of the Red Hot Chili Peppers, and the groovy '70s staple of

Mother's Finest, a great black rock band that we actually got to open for a few times. I also idolized people like Prince, who were way more mysterious, who led that quadruple life of being an entertainer, an artist, a producer, and a songwriter. I loved how Prince gave himself completely to people when he played, but then clearly loved going in the studio and knocking out a hit for somebody else.

Most of all, I wanted this new band to be true to ourselves and where we came from; to us, that meant being a little bit more . . . Southern. Indeed, we were rediscovering the Southern rock we'd loved as kids—stuff like the Allman Brothers and Lynyrd Skynyrd, the kind of music we listened to before butt rock came along and castrated it. Incorporating all that was cool for us: we were going down all those roads, but just didn't know yet how to get where we wanted to go. Sharing vocals with a female was interesting; in Jesse, SouthGang had a dude who looked like a lady for a front man, but now I was sharing a stage with a real woman for once, and one who could hold her own musically against me, too. Nope, this wasn't your mother's hair metal anymore, but we didn't know what it was, either. We spent a couple of years just playing and figuring all that out, exploring new sounds and ultimately trying to be something that we probably officially weren't. I just was not developed as a songwriter yet. Looking back, I'm kind of embarrassed about the songwriting that I did then, but I had to go completely opposite of where I'd been and just marinate in the new: we needed to run kicking and screaming from where we came from to find ourselves in something completely fresh. And together we made for a pretty darn amazing live band. As much fun as we were having playing again, of course there was real life to cope with, too. Not long after we moved back to Georgia, I got my divorce on.

Pretty soon after I got back from China, I'd married my girlfriend, Lisa, in the backyard at my parents' house. We were only married for

two years, but it was pretty clear from the beginning where the relationship was going. Right away, the vibe I was getting from her was "Okay, you don't have a record deal, no more band—maybe you should think about getting a *real job*." Lisa was very supportive of me, but I think maybe she was frustrated because she was getting older: she was already approaching thirty, but I was still in my early twenties and not ready to settle. I remember when we moved back to Atlanta, we ended up living out in Woodstock, Georgia, in a rented house. It was a suburban neighborhood where I didn't know any of my neighbors, but I knew none of them were anything like me. I could sense Lisa getting impatient with me when I was gone on tour and wasn't available to cut the grass, or if I had bands to record and wasn't available to change a lightbulb she couldn't reach. I was so excited about my new band getting ready to go out and tackle the world, but when I was home, I was miserable because she was miserable.

I still remember where the end happened. I was sitting across the table from Lisa at the Ru San's sushi restaurant in Midtown Atlanta, at the corner of Piedmont and Monroe, when I heard the words "I want a divorce" come out of her choked-up throat, in between tears; I still cannot go back to that joint to eat. I definitely thought I was in love with Lisa. In retrospect, I suppose I was more in love with the idea of love. I thought I had to have somebody and be married and have this life of cliché. I remember us trying for kids—thank God it didn't happen. I really didn't want kids then, because I was really freaked out about losing my first love, which was music. So many of my friends bowed out from following their passion in their early twenties for marriage, kids, whatever; I knew it was impossible to live that life if you weren't established already, and I wasn't. I was broke, had no record deal, and needed a job, so I went back to work at a guitar shop with Jayce. In my mind, I was like, "What has my life become at twenty-three? What the hell is going on?" I couldn't figure it out: how was I back to square one in Nowheresville, Georgia, trying to

claw my way out again? I was in a very resentful and self-destructive place, scarred and jaded by the idea of love from my sour marriage. I was not a real songwriter yet—I was like, "Screw love songs!" At that point, the main thing I was focused on was never writing anything about love ever again; I didn't even want the word appearing in a song, and it took me several albums before I would use the word again. I almost gave up on my dreams—something I'd been aspiring to since I was in second grade—just because somebody wanted me to. In my mind, I'd been married to music way longer than I had been to any girl.

Thank God I was with my band that I loved: having just survived a mountainous, monumental level of stress and heartache and breakup with me, they were very understanding of my state of mind (or lack thereof). Amazingly, I had a role model for positive male-female relations in my own band. We were touring all the time, but Jayce and Chrystina had a beautiful relationship. Traveling with a married couple was a pro and a con—and I say that with nothing but love for both of them, because they're my favorite people on the planet—but traveling and performing together was never a problem for them. Only a few times did I have to pull them apart during a drunken fight, which was fine, because I kind of always got a kick out of that, sadistically. We also had to bring their dog on the road, so the band always had a spazzed-out Brittany spaniel with us for years, because they couldn't afford to put it in a kennel. We were all in it together, and if that meant the dog was going on tour, that's life; besides, we were having the time of our lives proving that we could do it on our own (and the dog slept with me most of the time). Indeed, we'd gone from nothing and playing in bars in Rome again to becoming a draw on the Atlanta club scene. We were growing: we changed our name to the Floyds and started sounding a bit different. Over the course of three years or so, we reflected a big pivotal change in music and the music scene, and in my life. All of that dovetailed with my divorce finally going through.

After that, I basically became a new person. I'd never been alone, ever, and now I was independent for the first time in my life.

At first, I didn't even want to be a lead singer. In SouthGang, I used to always sing at sound checks and stuff, since our singer's voice would be too shredded; at a couple of gigs, I actually sang a good bit of the set, because he had partied his throat out. People would always say, "Why don't you sing?" And I was like, "No, I'm a guitar player." Back then, my vision of the ideal band had me as the Jimmy Page guitarist with a classic front man. I guess what happened was I was (a) being too much of a control freak and (b) experiencing a developing interest in lyrics. I really didn't feel like I should just be the guitar player anymore. Still, it took a lot of convincing on Jayce's part. The band actually auditioned singers and made me audition! After that, they were like, "Forget it, man! We should just be a three-piece, or get another guitar player—and you should be the lead singer."

Still, I had zero confidence as a front man; I had never done it at all. Some of the early shows were all about playing in Rome to thirty people just to get our shit together, and for me to get my confidence up and learn how to front a band. I was nervous, often not saying a word between songs; I just didn't know if people were going to tear me apart because I wasn't the typical lead singer. I didn't have that "front man" look, and besides, I would never *not* play guitar: I still wanted to be the lead guitarist who happened to also sing, and you never saw that much. This was still the age of the iconic front man, like Axl Rose in Guns N' Roses, Layne Staley in Alice in Chains, Chris Cornell in Soundgarden. We sounded nothing like that, and besides, a lot of underground bands were changing the script of what a rock band had to be: we'd see two-man bands like the Flat Duo Jets and all kinds of alternative music starting to really boom. Alternative rock radio was growing as well, and it wasn't Nickelback that ruled

the airwaves then, but actually good music: the Posies, the Pixies, Belly, Jane's Addiction—just so many good bands were getting played on commercial radio for the first time. That was when it got exciting for us, because we also had a girl in the group: Chrystina was incredible, with a great soul voice that was anything but timid. There were still a lot of bands around at that time on the post-grunge bandwagon that sounded meek and feeble. That wasn't the Floyds.

We got so much inspiration from the vital local scene around us in Atlanta, especially in the Little Five Points area, which, at that point in time, was still not very gentrified. There, I'd hang out in the local, very *High Fidelity*–esque record store, Criminal Records, where I'd soak up all kinds of new music like a sponge. I lived right behind Criminal in a two-bedroom townhome with my friend Harold Sellers. Harold had a day job, but he'd occasionally play percussion with the Floyds. His wife was a flight attendant and got free flights everywhere, so he would fly in with his congas and jam with us on the weekends when we played out of town, which was most weekends. At our peak, we played almost 250 shows a year. There was a great local venue that the Floyds used to play all the time, called the Point, which is now a vintage clothing store, selling dresses to young hipster girls who think they are living in 1965. The Point only had capacity for a couple hundred or so people, but it's where I saw the Wallflowers play around the time of their first record; I saw Pearl Jam early on there, too. I even saw Korn there touring for their first album—not that I've ever really cared about seeing Korn, but I would just walk down there, pop in, and see who was playing. I would watch all of the shows and get in for free, and most times drink for free. I knew everybody who worked at the Point: lots of skinheads and punk rockers all worked there, and they loved me—the tall, skinny, goofy guy who co-fronted a poppy Southern rock band with a female—for some reason. We spent most of our time drinking between the Point and the Highlander, where I kind of lost my virginity for the twentieth time: there

would just be crazy stuff going on in the bathrooms there, and it was the one bar that would be open until three or four in the morning. All the rockers hung out there, and all the punkers and the hippies and even the mods (there was even a little local mod scene happening, too). I never did mingle much with the whole Atlanta hip-hop scene during that time; that whole thing was very much segregated then, and it was still very underground, too. Funny enough, I would later become friends with OutKast, Rico Wade, and Shakespeare from the Dungeon Family. I also became tight with Cee-Lo, and got him to sing on a song I wrote for Coca-Cola over a decade later. Funny . . .

I was so glad to be home. Every night, I'd be really excited about being a part of Atlanta and its culture, sucking in all of the music it had to offer. The Floyds weren't part of a scene per se, but we played in all the different local bars, like the Point, the Cotton Club, the Dark Horse, and Smith's. Playing the Cotton Club was huge for us— it was where you graduated to when you hit mid-level status and couldn't play the two-hundred-cap rooms anymore—although we'd still play secret gigs at the tiny Dark Horse all the way through the Marvelous 3 years. I had an especially good rapport with all of the bookers in town, and all of the club people, because that world was just my life. That's where I boozed every night, drinking with randoms and becoming good friends with them over music.

After a couple of years doing the circuit, the Floyds could sell out the Cotton Club every time we played; there weren't a lot of unsigned bands that were able to do that in town. We'd really become a force as a live band, but I don't know if our music was any good; that might have had something to do with why nobody would sign us at the time. We couldn't get arrested with a record deal, but I think that's also because, while I wanted to get signed, I wasn't willing to play politics and sell out and write a commercial three-minute pop hit.

"Screw that! I'm not going to be that—I'm not going to sell out!" was my mantra during that era; we were an actual "indie" band, and we did everything ourselves. When we toured, we drove countless miles, with trees sometimes smashing into our trailer in tornadoes; we would go to Kinko's, where we'd design and make our own j-cards for our demo cassettes. We'd get our cassettes mass-duplicated by this guy who worked out of his basement in Atlanta, and on the way to every show, someone would be folding j-cards, or putting stickers on mail-outs. In the pre-Internet era, we even did snail-mail mail-outs of handmade postcards with our gig dates written on them. We got those addresses from mailing lists on handwritten sheets, collected by hand, by each of us after the shows.

The band van became an office where everyone in the group had a job. We became a business by day and a party machine by night, which became the model for a lot of bands around that time. That was what you did on the indie circuit and college-rock scene, which is where we really belonged. We embraced that status—we figured it was the only way forward: "Here we are, a band of three guys and one girl, except that the three guys had their first major-label record deal blown out to epic proportions." In SouthGang, we didn't have to do anything: the amount of money spent licking our asses and having everything done for us was an illusion. The Floyds' knee-jerk, 180-degree reaction to that was to be entirely self-contained, to do everything ourselves, and to earn our fans one by one. We didn't have any tangible fans left over from SouthGang, because we never started the process from the ground up in that band. We weren't going to let that happen again with the Floyds.

Eventually, the Floyds did get an independent label to put our records out. A company called Deep South Entertainment out of North Carolina was the first label that actually offered us a record deal. Deep South was a very small operation, but we loved them and they stood behind us 100 percent. This deal still wasn't like the real

distribution or promotion that we knew we needed, though. Not many CDs of the Floyds' first and only album probably made it to stores; mostly we sold them at shows. We were able to SoundScan them, though, and we could sell up to two hundred CDs a night sometimes, which is a lot when you're playing to five hundred people.

In a way, back then we were "sort of" doing the pre-Internet version of what Radiohead did with *In Rainbows*. Being responsible for our own destiny was the best thing that ever happened to us: it definitely helped build our character and made us learn how to play the game. Using the Internet to break into the music business makes it so much easier now: I hate to sound like an old, jaded asshole, but bands today don't know how much easier they have it with the promotional power of the Web. If you're cute, have a haircut similar to a rat's nest, and sound a little like Fall Out Boy, you're ready, man. Musicians have definitely become insanely good marketing gurus and brand entrepreneurs: so many bands, who often have more T-shirt designs than actual songs, now sell out their first shows to five hundred kids because of Twitter, Facebook, or MySpace (R.I.P.?). Having built an audience grassroots-style makes me appreciate how easy it is now, but it didn't necessarily make me a better songwriter then. That was still yet to come. And while I was definitely proud of what we were able to accomplish with the Floyds, I'd be lying if I didn't say we didn't want to take our careers to another level. The rebellious twentysomething in me just didn't want my success to be because of a sell-out, commercial pop song. Having my big first record with SouthGang flunk out, with the songs completely cowritten by a big pop songwriter, still continued to weigh heavily on me. Even after playing a great show, I was like, "Shit! I've got a lot to prove." Soon, I was on a mission.

After a while, it grew discouraging to see other bands from our scene—bands that were playing the same venues as us—getting scooped up by major labels. This band called Sister Hazel, from Gainesville, Florida, used to open for the Floyds: we were friends with them, and

then they blew up in 1997 with a big hit, "All for You." We were still stuck in the college/indie rock phase of our careers, though, and our lives. The Floyds were more concerned with funking out and going nuts in outrageous three-hour live shows that were so sweaty that my guitars wouldn't even work by the end; the pickups would be flooded. I would sometimes have to take salt tablets after I came offstage, because my whole body would cramp up. I lost so much weight I became emaciated: I weighed 210 when I moved to Hollywood, and during the Floyds I weighed closer to 160 pounds. We thought that we were killing it when we had those kinds of shows, but there was no focus on structured songs, which is what other bands like Sister Hazel were doing. "That doesn't make any sense," I'd think to myself. "We're better than those bands." I was living under a rock: it's obvious when you turn on pop radio that raw musical talent isn't the solution to creating pop hits—it's the bells and whistles, the simple lyrics and sugary hooks. I didn't want to admit it to myself, but all of that took a skill I didn't have just yet.

As the Floyds ground on, I had started getting into doing production, recording indie albums and demos for local bands in Atlanta whenever I wasn't on the road. My dad let me put a little sixteen-track setup in his garage: I built it out, soundproofed it, installed my two ADAT digital recorders, and started recording bands to make a living. It was the only way I could make $200 a day—after all, every bit of the money we were making with the Floyds was going back into the band; very rarely did we put money in our pocket. I always had produced our own independent records, and they sounded better and better as I gained more experience. As those made their way around the college-town circuit, my reputation as a producer grew. Florida was a big market for the Floyds, because there are a lot of college towns there, and there was one particular place we used to play down in Tallahassee that I'll never forget. We actually played the grand opening of this venue—ironically, it was named Floyd's Music Store; I think they liked the tie-in with our name, actually. We knew the

guys who owned the place; they were all part of a little good-ol'-boy network down there. Pretty quickly, the Floyds were selling out Floyd's, and it was a decent-size place. I remember there were these two kids who would always be in the front row every time we played there. The last thing we ever wanted to do is talk to people when we came offstage soaked in sweat, but those same two annoying guys would always charge backstage right as we were wringing out our sweaty clothes; they would be high-fiving and yelling, "Dude, that was *great* and do you guys wanna *party* and . . . !" We just wanted five seconds to dry off, but all they wanted to talk about was their band: "Hey, here's our demo—we play music, too!"

The next time we came back through Tallahassee, Jeff, the bartender at Floyd's Music Store, helped us load in our gear. Jeff was awful friendly—a real good ol' boy. Afterwards, he pulled me aside. "I manage these kids," he told me, "and I really think they've got something. I want to put them in a studio with you. They're playing upstairs tonight, if you want to go check them out." I told him I would, and sure enough, I walked up there before we started playing and popped my head in: there was nobody in the room except for the band onstage—who turned out to be those two guys who were always in the front row, who'd foisted their demo tape on us backstage the last time we were in town. They were literally playing what sounded to me like Pearl Jam covers; at the time, I'm thinking, "This is very weird and sad. They're five years too late." At this point in rock history, every band that was on the radio and their mothers sounded like Pearl Jam. I did have a little bit of integrity in that moment and just didn't want to do that kind of music. I was so burned out on that sound, and I didn't think this band really had anything going on. Besides, they only seemed to be a Pearl Jam cover band, anyway.

As soon as I got back to Atlanta, I got a call from bartender Jeff, hitting me up one last time. "I really want you to produce this record," he said. "I've got this new, small upstart label that wants to

back them and give them a bunch of money and put them in a studio and make a record and *blah blah blah* . . ." Ultimately, I wasn't interested, because there wasn't really any money in it for me, anyway: the deal Jeff was offering was more like, if the album took off or something, I would get "points" on it (points are royalties deducted from album sales—five "points," for example, would equal 5 percent of the total album royalties). Jeff wasn't taking no for an answer: if I wasn't going to produce his pet band, he begged me and pleaded me to put them on the road with the Floyds as openers—for free. I relented grudgingly, putting them on two week's worth of dates. I'd be lying if I said that they weren't getting heckled, booed, and hated on by the audiences waiting to see us every night; the front man, who had no stage presence, had to sing facing the drummer the entire show, because he was freaked out. I felt bad for them: they were friends of our friends at a venue we played all the time, and they were fans of our band. We wanted them to go over, but they just weren't very good. I remember Chrystina and I walking into Rickenbacker's in Gainesville, Florida, before the Floyds' set, and they were onstage: a packed house was just ignoring them, talking over them while they were playing. Chrystina turned around and looked at me. "Oh my," she said. "Not pretty. Not good."

Later on, Jeff sent me the album this band ended up finishing with John Kurzweg, a local producer from Tallahassee who'd worked with all of the hippie bands down there. Of course, it turns out this record that I turned down producing was a huge smash when it came out in 1997; it would go on to sell over 6 million copies. What I thought were all Pearl Jam covers were actually the original songs from the album. I heard it on the radio literally two months later, and I was like, "What the hell is happening here?" I remember the deejays even having a lot of disdain for having to play it: they're not supposed to be opinionated, but I would still hear jocks go, "Well, for some reason, I have to play this song for you." And they would play the single. Any-

body with taste was like, "This is really horrible." But they were blowing up. They were huge. Even though they were selling millions of records, I had to decide whether or not I regretted not taking that production gig in the end. I don't think I regret my decision; it was a lesson in being careful with the decisions you make early on in your career. People would love to be able to stereotype you into a corner—believe me, I have a hard enough time with everybody in the industry thinking that I'm the "pop guy" because the pop artists I've worked with have sold a good number of records. My heart just wasn't in it, and besides, I didn't care for that kind of music anyway. Oh yeah, I forgot to tell you the name of the band that I am talking about. They're called Creed.

Of course, my band was going through its own evolutions. Chrystina had come to a Floyds rehearsal one day, crying; she didn't know how to break it to us, but she was pregnant—she and Jayce were having a baby. We were a little shocked by the news, as the band was our life and we didn't know how to proceed. They were thinking that they could still do it, and sure enough, we played shows all the way up until she was seven and a half months' pregnant, which was awesome. Chrystina is a firecracker, man: it was rock-and-roll as hell to see a big pregnant chick up onstage rocking shows. But we were at a low point. I knew my career was at a lull when the Floyds were booked to play at some weird festival on a lake in Arkansas. The comedy of it was we were playing on a platform floating like a buoy or a pontoon boat; meanwhile, the audience was made up of Arkansas's finest inbred, all in cowboy boots and hats and buttoned-up Oxford shirts. Everything that could go wrong did: from the first note, they complained that we were too loud. So we practically turned our amps off, and they still thought we were too loud. Everybody was just looking at us funny, like they wanted to poison us; after twenty minutes or so of these bad vibes, we just gave up and ended our set. Then the creepiest, weirdest thing that I've ever seen in my life happened: as we're breaking down

our gear, they start piping in music off a CD into the house speakers. After a minute, I realized it was "Closer" by Nine Inch Nails that I was hearing. The crowd went into a somewhat trance-like state: I watched as fifty-year-old men walked calmly to the dance floor and started line-dancing with fourteen-year-old girls while Trent Reznor sang, "I'm going to fuck you like an animal!" Seeing that, I was like, "This is where my life *stops*." I couldn't get out of there fast enough.

I cried after that gig. I'd just gotten divorced from my first wife, and I remember thinking to myself, "What the hell? What's going on here?" I had to figure out a plan B. "Look, I don't necessarily want to break the band up," I told everyone, "but I can't stop and wait until you're ready. You guys are going to need some time to get your family together, and you can't just go right back out on the road. That's not going to happen. So, I'm going to do a little side project in the mean-time." I figured that made everything equal. Chrystina and Jayce got to have a baby, and I'd get my own little baby side project, too. Enter the Marvelous 3. . .

It seemed like the perfect time for a change, anyway. By now, the Floyds had already been morphing into a new look and sound. The Britpop invasion was exploding, and I loved it—I found albums like Blur's *Country House* and Oasis's *Definitely Maybe* the perfect antidote to the likes of, well, Creed. The whole hippie-rock thing was also starting to sound all the same to me, too, so I cut my hair and really embraced this counterculture moment that was happening. There was a whole subculture of kids around town that had a glam-mod thing happening, and I was like, "I can get with this!" It reminded me of all the stuff from my childhood that I listened to when I wasn't listening to metal: local Atlanta power-pop bands like the Producers, as well as the Knack, the Raspberries, the Kinks, the Jam, and, of course, the Beatles. I also idolized Bowie when I was growing up, and I was com-ing into my serious Elvis Costello fandom at this point—maybe too serious. When I was a child and first became aware of Elvis Costello,

I was kind of frightened by him; I saw pictures of him with his big glasses, his pompadour, and that big gap in his teeth, and thought, "What's *wrong* with him?" But then I got so into his music, I ended up getting a tattoo of his face on my arm—a choice that would come back to haunt me. Much later in my career, I'd spent the night getting totally wasted with friends at the Chateau Marmont. Around midnight, I got in the elevator to go to my room, and who is there but Elvis Costello! I was so startled (and drunk) I didn't know what to do, so I just made a strange noise, stuck out my arm, and pointed to the tattoo of his face. He looked at me like I was the most pathetic creature on earth, said, "Oh, that's quite nice," and started pushing the OPEN DOOR button repeatedly before getting off at the next floor. I think he figured I probably had an ice pick in my back pocket. Anyways, my dreams of drinking wine by a fire and having a serious conversation with Elvis Costello about songwriting and just overall "bro-ing out" were dashed in that moment.

During the period when we were first getting Marvelous 3 together, music just seemed to get better and better: there was room for so many sounds and personalities. I'd just discovered Jeff Buckley, and Radiohead; this sound brought all of these influences together for me so perfectly it freaked me out. It was a great time for music. Radiohead was my favorite band at this point, and they were at the top of their game. I know it sounds so cliché and overdone to say that you love Radiohead now, but you're not a true Radiohead fan unless you go back to early albums like *Pablo Honey* and *The Bends*. I'm not ashamed to admit it, but I liked them better before *Kid A*. They were writing amazing pop songs, but executed with passion, awkwardness, and weirdness—it was the sound I'd always heard in my head, but never could put my finger on. I remember driving in Chico, California, when the Floyds were still on tour, coming back from a gig in Tahoe.

Everything was so beautiful: the perfect Northern California fall weather, the blue sky, the amazingly grandiose trees, the colors of green and blue saturating my periphery. I was just high on life, on being in a band and listening over and over and over to this amazing new music I'd encountered. I put on a Radiohead CD and felt like everything was changing for me. By the time we hit Stillwater, Oklahoma, we had Weezer's first album on heavy rotation, and that flipped me out, too. I couldn't get enough of Rivers's pop sensibilities, smart lyrics, and tongue-in-ass-cheek cynicism. I was still trying to figure out who the hell I was, but hearing those albums gave me the answer. I was screaming out the windows, "Wait, it really *can* work! Finally I've got it! This is *who I am!*"

All those bands made it cool to embrace not just pop songs again, but real pop—not the Candlebox stuff that was all over the radio. At that moment, I knew I had to become my own version of this new movement, this new feeling. I'm thinking, "Okay, Chrystina's pregnant, they're having a baby, so I'm going to just go write a bunch of songs." That was it for me: I holed myself up in a guesthouse where this girl who'd split for a while to California was letting me housesit. I spent all my time demoing new songs in the guesthouse. I was excited: these were the best songs I'd ever written in my life, and I wasn't going to let a big producer ruin them. I was going to make sure they were perfectly rendered, my way. I just wasn't sure exactly how that was going to happen.

For one, I didn't have a dollar to my name. Once again, I was back with Jayce working at the guitar shop, Famous Bargain Music, in Alpharetta. I couldn't afford an expensive professional recording studio, since the good ones were renting for $2,000 a day, and I'd kind of given up my little sixteen-track setup. There was, however, this new kind of recording rig I'd heard about, called Pro Tools, where you didn't need all that big studio stuff.

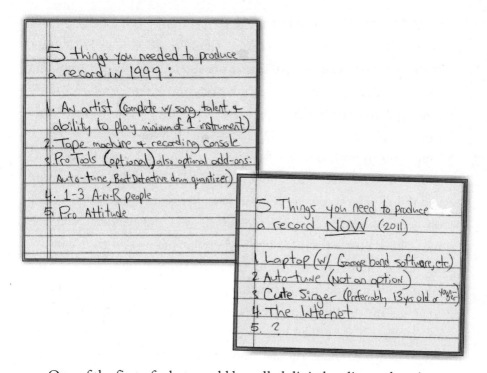

One of the first of what would be called digital audio workstations (now typically abbreviated as DAWs), Pro Tools ran on consumer computers, so, conceivably, you could use it at home. I received what seemed to be the answer to my prayers when a used Pro Tools setup sailed into a local music shop one day. An Atlanta R&B group called Silk—famous for their 1993 hit "Freak Me," although I'd never heard it—came in trying to unload their Pro Tools system. I took one look at that thing and knew that it was the future of recording. This was the oldest, most primitive version of Pro Tools: it allowed for only sixteen tracks and ran on a super-old Mac computer—there were even Silk's leftover background vocal tracks on the hard drive, haunting the machine like a ghost. Even used, though, the rig still came out to around $4,000 (today, of course, all Apple computers come with their own DAW software, GarageBand, already installed). I didn't have that kind of money. However, my girlfriend, Nora, who is now my wife of thirteen years, offered to buy it for me. I certainly didn't come to

her for it; I'd just mentioned it casually, thinking out loud one time. "People are recording on this thing called Pro Tools now," I told her. "I think I could really make bigger productions and better-sounding records with it. I think I can really revolutionize this home-recording thing and make my songs come to life better than with my shitty little tape-based sixteen-track ADAT system." I remember her saying, "Well, I want to buy it for you, then." Of course I was like, "I don't want you to do that." I fought her on the whole idea; I was very proud and didn't want to take her up on her offer, which meant her giving up her life savings. I considered myself very independent, which is why I lived on the floor at a place where I could stay for free in return for doing the house chores. At the same time, I didn't have a band anymore that could tour or function, so she told me she was just going to go get me the Pro Tools setup anyway, even if I didn't let her. I was so grateful. "I'll pay you back, I promise one day I will"; yes, I gave Nora the whole cliché rap that comes out of a broke musician's mouth, but eventually I made good on my promise. I was thinking, "Fella, it's sink-or-swim time now." That's what lit the fire under my ass: I knew if I let her give me the money, I'd have to succeed with what I did with it or I would not be able to live with myself.

Digital recording is pretty much the industry standard now, but back then I was just trying to make sense of this used, sloppy, shabby system that I could barely record on. It would mess up and give errors all the time—besides the fact, of course, that I didn't know what I was doing. I remember learning Pro Tools during the very last shows that the Floyds were contracted to do, studying the manual while driving around in the van. I started writing a collection of songs with a new outlook, and recorded them on that rig: I holed up for a month with two guitars, one microphone, and this Pro Tools system on the living-room floor, and the songs just came pouring out. I played guitar and sang, Slug played drums, and I even had Jayce come play some bass between diaper sessions. I was like, "This is my side project. I don't

know what I'm calling it yet," but it was clear what it was: very straight-up British, Kinks, and Elvis Costello–influenced, spazzed-out power pop. I cut every corner I could so that I didn't owe anybody anything; I mixed the tracks at my friend's studio after hours at, like, three in the morning so I didn't have to pay normal rates. The result was what would become Marvelous 3's first album, *Math and Other Problems*. I kinda had an Elvis Costello inflection in my voice on *Math,* which was a little silly and forced, but he was my current obsession, and I was still trying to find my identity. This was me finally becoming me—me finally becoming Butch. I had been aping him for years, but eventually I was like, "Okay, I've got to lose the Elvis Costello inflection thing and admit that I'm a tenor." People didn't seem to mind, though. We did that record, and all of a sudden, people started taking notice. We self-released it at first, but not long after, Deep South loved it and wanted to put it out, too. I thought I needed to play some shows with this project, so, on a drunken night at my local haunt, we instantly became Marvelous 3, upon my British pal Ian's band-name suggestion.

Marvelous 3 did maybe one or two shows locally in Atlanta to warm up, and the reception was just super-great; soon we were driving around playing shows in the Southeast, building up this following again. There was a lot of curiosity with leftover Floyds fans, so the shows were pretty packed. Now there was a connection, though, not only to the live show but to the *songs.* I was writing songs that were real structured songs—catchy, not just jammy and drawn-out like a typical Floyds number. There were some real breakthroughs on *Math and Other Problems,* mostly because I learned to actually write about something real; even if masked in wit, if the song was based on something real, suddenly it came to life, and people would relate. One song, "Katrina," was about being in love with a lesbian; another, "Valium," was about when I'd rolled my ankle onstage for the eightieth time and got pilled out of my brain after the ankle surgery—an experience I adapted as a love song. To be honest, really every song

was about girls: they were the "problems" I, and seemingly everyone else, needed to figure out. All of the songs I'd written were basically about these girls I'd gone nuts over for the past five years. I'd been single in Atlanta just living out my rock-and-roll fantasy, and that record was a testament to every girl I tried to court in the whole tri-state area.

One thing led to another, and this deejay named Steve Craig started playing Marvelous 3 songs on his own show on the radio station 99X, which was the big alternative station in Atlanta. Steve loved Britpop and power pop, and he had his own hour on Sundays where he'd play local bands in the evening; pretty soon he was playing us all the time. I felt a little bit guilty about leaving my Floyds behind, but I didn't have time to really process those feelings, because Marvelous 3 just started taking off and doing really well. It's funny about labor-of-love projects like that: you think, "Well, it's not really going to matter, so I'm just going to put everything into it, and whatever happens, cool." Of course, that's the thing that takes off. I was on a mission now, on top of my game, my confidence back, and definitely feeling comfortable being a front man. It wasn't until the end of Marvelous 3 that I felt like I actually became a good singer. That didn't seem to matter, because we had a hit song before I realized I couldn't sing.

In no time, I'd started recording a new group of songs for the next Marvelous 3 album. One day I went to work at the guitar shop as usual, and before we started our shift, Jayce and I went out to my hundred-dollar Volvo to listen to my new demos. (The music-store owner had a Volvo station wagon with 300,000 miles on it, which had been sitting there in the parking lot for years; he told me, "If you can get it to crank, you can have it for a hundred bucks." I didn't even have a hundred bucks to my name: I had eighty, but my dad gave me twenty bucks. We jumped it, I drove it home, and it's still running to this day.)

As we were sitting there in the parking lot, I remember the last song of the batch came on, a song called "Freak of the Week." As soon

as it started, I immediately started making apologies, like, "I don't care about this one—it's a silly pop song. It's kind of a sell-out song, really." I was deep in my indie-rock phase, protective about not conforming; I wanted to keep my songs *off* the radio, but Jayce had never been methodical, calculated, or technical. He's all heart, so when he heard "Freak of the Week," I knew he was honest in his reaction. "That's the song, man!" he exclaimed excitedly. "That song is killer! That's the one!" I was like, "Yeah, whatever." I just shrugged it off. I was more concerned about making an artistic statement with these songs—and I was worried about being considered the ultimate sellout.

In fact, "Freak of the Week" was about coming to terms with being a sellout—that was the irony of the whole thing. I got the idea for the song one day, listening to the radio as I drove back home from the guitar shop in my hundred-dollar Volvo. There was some song playing—I don't remember which one—that made me think about how hypocritical it was that someone was capitalizing on pain and weakness in a pop song. Co-opting misery was such a big thing all through '90s alternative rock; I thought that the real thing missing were all the riches and fame that came with making that gloom so damn catchy. At the top of my lungs, right there in the car, I started singing what would become the chorus to "Freak of the Week": "Can you make me a promise/To stop it before we begin?/Will you hold on to my head/If I ever lose it again?" Immediately, I said something smug, like "Oh no! That could be one of those songs on the radio."

I was both hardened and enchanted by this contradiction, and I rushed home to lay the song down on my Pro Tools rig. I felt really good about what I came up with almost instantaneously, marrying that chorus to a cool verse and guitar line. "Freak of the Week" was like an interpolation of several of my favorite songs: the bass line was inspired by Elvis Costello's "Pump It Up," while the guitar had a little bit of XTC's "Mayor of Simpleton" in it. Funny enough, critics called me out about the verse melody resembling "So You Wanna Be a Rock

'n' Roll Star" by the Byrds, which I had no idea about. That was sub-conscious, I swear! The song actually has a similar lyrical connotation to the Byrds' song, but when I read those critiques, I was like, "That's funny—I was ripping off XTC."

After we finished recording the track, I gave it to Steve at 99X. I actually went to the station to give it to him, and we sat together in his cubicle as he heard the new Marvelous 3 songs for the first time. He just sat there listening intently, not saying a word; when it was over, he took the tape out immediately and said, "Come with me." He walked me into the office of 99X's program director, Leslie Fram—an amazing lady, and for sure an exception to the rule in radio. Unlike so many of her peers, Leslie is an avid music lover who had as big a jones for Britpop and power pop as Steve and I had. Leslie was actually having a meeting with some-body, but Steve burst right in: "Leslie, I want you to meet Butch Walker."

I was really tripping out and nervous to meet her, let alone inter-rupt her meeting. I was sketched out by anybody who had the power to get my song on the radio and have millions of people hear it; I was thinking, "Is this just going to piss her off?" Leslie had real influence. She'd just broken wide-open this artist named Shawn Mullins, a great songwriter whom I would later become neighbors with. Leslie had rolled the dice on Shawn's song "Lullaby," and it had become a huge smash in 1998. That song was undeniable, and Leslie had spun it over the airwaves before anybody else. As a result of her efforts, Shawn got offered a huge record deal with Columbia. This was all going through my mind right then and there. Of course, Leslie was totally cool. "Nice to meet you, Butch," she said, shaking my hand. "I've heard a lot of things about you from the Sister Hazel guys and John Mayer." (Yeah, *that* John Mayer, of the famous white-supremacist penis—at the time, he was a rising star on the Atlanta jam-band scene.)

Steve interrupted her, causing me to jump: "Do you have a min-ute, Leslie? Can you listen to something?" He put the Marvelous 3 tracks on, and she listened to the first five songs uninterrupted. Of

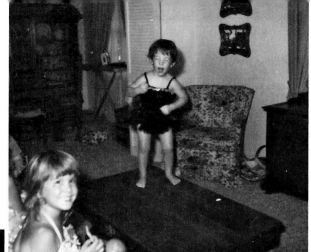

My first show.
(Dad was worried
about my costume.)

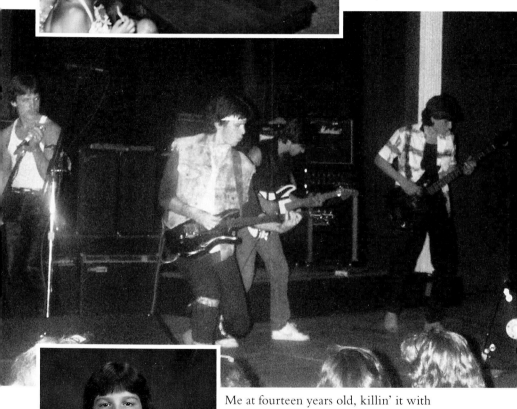

Me at fourteen years old, killin' it with
The Scene at the Desoto Theatre in Rome.

My short-lived preppy phase.

Note to self: Never do your hair like this again.

Note to self: Don't show up on yearbook photo day.

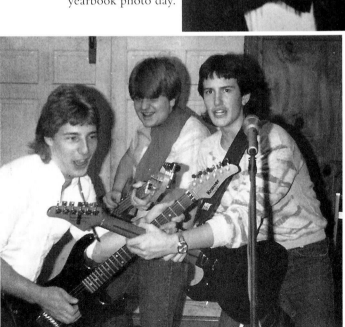

David, Tommy, and me of Standing Room Only trying to rock.

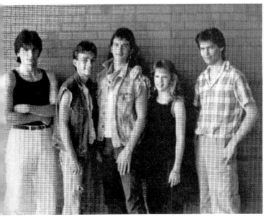

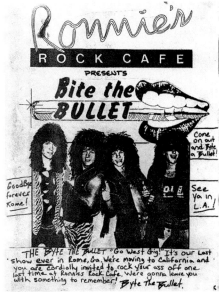

An unfortunate promo pic of The Scene.
(My girlfriend Laura is to my right.)

The flyer for Byte the Bullet's last
show in Georgia. (I don't know
why I drew hair on it.)

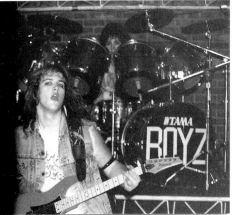

With Badd Boyz in Rome
at seventeen years old.

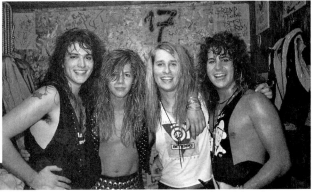

This was a look in
the late '80s.

You're always happy when you have hair like this.

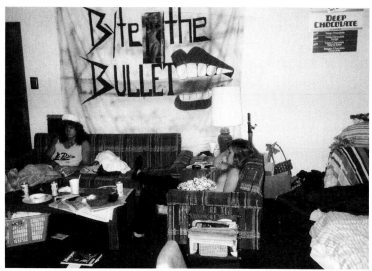

A busy day at the apartment (in the pre–cell phone era).

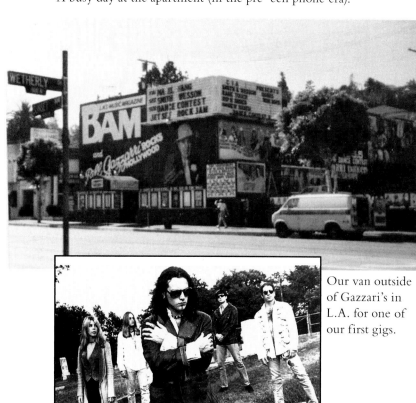

Our van outside of Gazzari's in L.A. for one of our first gigs.

The promo shot for Floyd's Funk Revival.

Sid and Nancy in Berlin.

Me and Jim Bianco doing our thing on the Hotel Café tour.

Rollin' around during the LGOTS tour.

Me and Jamie Blue in Nashville in 2010.

A challenging day at work.

My seat at Smith's Olde Bar in Atlanta.

course, when "Freak of the Week," came on, I got defensive. "I don't really know about this one," I muttered. Leslie was more equivocal. "That song is a smash!" she exclaimed when it finished. "That song is *it*! I'm going to start playing this." In silent prayer, I said to God, "Okay, twist my arm and please don't let this be a cruel joke."

Outwardly, I kept it cool, but inside I was *freaking out*. This was the best reaction from a real industry player that Marvelous 3 had gotten yet. We had already been showcasing at this point for labels, exhausting ourselves through the music business, with little to show for it. Nancy, our manager at the time, was all heart: she worshipped us, and I'd never seen someone more passionate about her job. Nancy had arranged for us to go to New York and showcase for big shots like Craig Kallman at Atlantic Records and Clive Davis when he ran Arista. Of course, these industry showcases, which they still do to this day, are so damn lame and pointless. There's nothing real about the showcase process: you have to perform in these closed rehearsal rooms at four in the afternoon with no fans in the crowd, just industry stiffs sitting in chairs with their arms crossed (sorta like the feeling of being the opening act at a James Taylor concert).

Of course, we tanked; my thought was, "Come see us in a club and you'll have a different opinion." Until Leslie added "Freak of the Week" to 99X, we were getting turned down and turned down and turned down by everyone. Leslie helped us to keep our heads through the whole process, telling me, "Don't sign anything with anybody yet." "I hope you're not messing with me, because I'll murder myself if you're lying to me," I told her subtly. "Trust me," she said. "Don't sign anything yet. I'm going to play this song and watch what happens."

Leslie didn't say that in a cocky way; she just said it as if she was genuinely excited. That excitement would multiply exponentially. "Freak of the Week" hitting the radio naturally changed everything; suddenly all the labels who'd told us they "didn't hear a single" and rejected us previously were interested all over again. Sure enough,

Leslie called me when I was out doing a showcase in Los Angeles, which was not going so well. She just said, "Hey, listen—do you hear that? That's your song on the radio." And, after playing "Freak of the Week," she said the phones went ballistic: people were requesting the song like crazy. Leslie was a tastemaker; people just followed her lead and jumped right in. Soon, every other major modern-rock station— like KROQ in Los Angeles, DC101 in DC, Q101 in Chicago—was playing "Freak," too. Leslie remained cautious, though. "Don't sign anything with anybody yet," she kept repeating, like a mantra.

It was tough advice to follow: we were an unsigned band with a radio hit blowing up, and labels were now offering us blank checks. We started getting flown everywhere all over again, to the same places, and now some different places, too. The success of "Freak of the Week" ended up being a very wild ride for us. Everything happened very quickly: there was a lot of sitting around and waiting for something to happen forever, and then it happened way too fast. For one, there was no album yet. We had a version of the record that was later known to fans as the indie *Hey! Album.* The indie *Hey! Album* had a blue cover with a photograph of the three of us, along with two or three extra songs that didn't end up on the major release, as well as the original version of "Freak of the Week." Despite that version being the one that got all the airplay, of course "Freak" would be partly rerecorded when it finally appeared on a major label.

A little backstory, if you will . . . In the build-up to all this craziness, Marvelous 3 continued to play all the music conferences—South by Southwest in Austin, Texas; CMJ in New York City—in the hopes of getting noticed. Atlanta had its own little conference called Atlantis, which is where I ran into Jeff the bartender again. By this time, his band Creed had already sold a gazillion records, and Jeff was the "white trash wins Lotto" manager of the year. At this point, he was the most powerful manager in the music business, because he controlled the biggest-selling band probably of all time. Jeff was savvy, but I wouldn't say he

was an intelligent man; he was more street-smart than anything, and definitely not subtle. When I saw him at Atlantis, Jeff was standing with this dickhead attorney from New York whom I hated, laughing loudly, drinking brandy, smoking cigars, and flashing the fancy watch exactly like the gaudy, evil-looking corporate manager he had become. He sidled up to me in one of the little VIP rooms and said snidely, "Yeah, Butch. You know, I really feel sorry for you [!]. So if there's anything I can do, let me know." When Jeff the bartender/manager said he felt sorry for me, I almost pushed him through the window of the hotel.

He was basically telling me I blew it, turning down the chance to produce the almighty Creed. I can't say that I wasn't jaded by that fact, but I still am a man of scruples: life isn't based on money. Now I just laugh at the fact that someone was actually stupid enough to say something like that; the best part of the story, though, is what he said right after. I hadn't been exposed to the seediest underside of the industry yet, and it was very taboo to talk about the exploitation that really went into making a record a hit. Jeff, though, wasn't that smooth. "Yeah, Butch," he drawled between cigar puffs, "don't let anybody tell you that promotion money and promotion points aren't the key to success." And I was like, "Okay, I get it now."

What Jeff was telling me was, in essence, the reason why this song by Creed got so big was because when they did their deal, they gave something like five points—more than the band and the manager would get put together—to an independent radio promotions guy. The labels couldn't afford to get in trouble anymore for payola, so they just got independent promoters to do it for them. Independent promotion bigwigs are hired to go in to radio stations and do favors, like giving them season tickets and condo time-shares in exchange for playing questionable music. And that's exactly what they did to break Creed. People always wonder why music that gets played on the radio isn't so great—it's because of these independent promo goons. For some reason, when you play anything enough times, people react to it

in a positive way; they just shove shit down people's throats until they go, "Yeah, I'll take it." In that system, it's not a surprise Creed are rock stars, 3 Doors Down are rock stars—even Nickelback are rock stars (*"Hayyy hayyy, I wonnah be a rawk starrrr . . ."*). They all sound like the same band to me, but whatever: if it smells, it sells.

It didn't make any sense to me why, when I was on a major label with SouthGang, that the label had an in-house radio promotions staff, yet they still doled out hundreds of thousands of dollars for independent marketing to people like the Creed promo dude. We were thinking, "Why? What does that guy have? How hard is it to walk into a radio station and say, 'Would you mind listening to this music?'" For some reason, he had the magic beans—maybe snortable, maybe smokeable, maybe in the form of a plane ticket to the Bahamas or a VIP box at a Lakers game. That's pretty much how that whole thing went down, and it took a bartender-turned-millionaire to really hit the nail on the head for me. Previously, I was confused. Oh, by the way, the person who "managed" 3 Doors Down when they first came out? The same independent promo guy who worked Creed. That made even more sense: I remember when 3 Doors Down's song "Kryptonite" was on the radio, and I was like, "What is this Superman song? It's so . . ." No offense to them—their lead singer is a super-nice guy—but I couldn't understand how alternative radio could have morphed from being so influential and interesting with music like The Cure, R.E.M., Blur, and many others, to playing regurgitated grunge. In the end, I really appreciated that white-trash-wins-Lotto guy with a cigar and his designer watch opening his mouth and saying something that stupid to me out loud. He exposed the system for me, which was valuable knowledge, as that system was about to chew up and spit out Marvelous 3.

There's nothing like the feeding frenzy of a classic major-label bidding war: there hasn't been anything like that since the '90s, because that

kind of excess just hasn't been possible since the labels got eaten alive by downloads. Marvelous 3 experienced the phenomenon to its fullest, however—we got all the limo rides we wanted, all the expensive steak dinners, goody bags, clothes, and everything that you know you could possibly want bought for you on someone's "Alcohol & Restaurants" expense account. I was probably taking advantage of the situation, getting a lot of cheap shots in due to the built-up baggage from my previous ten years of failing upwards through the music business. The first time around, though, I was young and stupid; with Marvelous 3, however, I was a whip-smart road rat. I basically considered the whole situation as payback, of which there were a lot of fun moments. For years, no one would touch me, and now they all wanted to touch me, figuratively and sometimes literally.

I can remember being out in L.A., getting a very aggressive deal offer by a female A&R exec: doing whatever I wanted to her was part of the deal. I remember thinking to myself this is flattering and cool and all, but at the same time I considered myself a very serious musician. While it seemed like the ultimate rock-star *Penthouse Forum* fantasy (not that I've ever read those, ahem), I was a little turned off; I probably would've preferred she talk to me in detail about, you know, our songs and the music. I was that guy who would ask the clueless Alcohol & Restaurants douchebags shit like, "Do you even know the lyrics to the rest of our songs, other than 'Freak of the Week'?" I remember one girl telling us, "I listened to your record all the way through"—as if that was something to be proud of! "Wow, all the way through?" I responded. "That's great! It must have been very difficult for you. Where did you find the time to do that, *in between posting your frustrations with a failing A&R career on* The Velvet Rope *and dining with Chingy?*" Oh dude, we were cocky, filled with piss and vinegar. It was game time: "Okay, we'll show you label guys—if you want us, we're gonna make all of you *sweat.*" Acting out like that felt a little vindicating for us. Mostly, it was just mean. And fun.

Keep in mind, this was all pre-Internet, too. The Web really took the mystique out of music—like, at one time I believed that KISS's Ace Frehley, aka "The Spaceman," might *actually* have been from space. And that Gene Simmons really *did* have a cow's tongue surgically attached by Satan so that he could lick groupies' va-jay-jays better. You know why I believed such things? Because I never saw pictures of KISS going grocery shopping with their makeup off on Perez Hilton.com. In the late '90s, the Internet still had not really caught on. People were just starting to use e-mail regularly—yeah, I had a Prodigy account, remember those? Search engines? *Fuhgeddaboudit.*

We used this period of pre-Internet ignorance to our advantage. In the post-Nirvana '90s, credibility really mattered: nobody wanted damaged goods—everyone wanted new meat. Nobody wanted something that had already been signed before, or was associated in any way with a bygone genre like hair metal. All of those hair bands could have reinvented the wheel and it would still have been impossible for them to get a second chance from a big label. Many tried, switching out their spandex for flannel, swapping high tops for combat boots. I know—I did it, too; on the last SouthGang album, there very well might be photographic evidence of me rocking an early-'90s goatee. We thought that's what we had to do with our "image," and it felt lame. Just humor yourself on Google one day by typing in "Butch Walker SouthGang" and enjoy the ride. While you are at it, research the singer for indie-punk stalwart Flogging Molly and realize that he used to be in the '80s hair metal band Fastway. Pure comedy . . . He hates it when people talk about his metal past— hey, man, I can relate.

Being in a failed hair band couldn't help matters, but being in a successful hair band would've made getting signed impossible: there's no way we would've been taken seriously, especially on '90s alternative radio where we currently and rightly belonged. The industry would not accept that anyone could change or evolve and move on if

they had been involved in something that was considered a joke. Very, very few were able to overcome that rep: the Beastie Boys and the Chili Peppers did, but history's littered with a ton more MC Hammers and Vanilla Ices. And did any critic ever consider that maybe we were just dumb teenage kids when we started that metal band? Even today, any mention I get on some hipster blog site, they follow it up with a fucking picture of me from SouthGang, like "Yeah, right. Look at *this* guy." I was eighteen years old, you know. Let me see *your* yearbook photo, just to make sure I'm not the only aging hipster doofus in the room; I'm sure it's no different, or worse. However, in 1998, as we never got as big as all the other members of the Hair Nation, and Google was yet to exist, the record companies had no clue as to Marvelous 3's previous existence. It was great for us, because we'd sit at these meetings with people like Jimmy Iovine, who didn't remember ever meeting with us in SouthGang. He gave us a whole song and dance about what it's like when you get signed for the first time, and what you'll go through as a band, having no idea he gave us the same rap ten years earlier when he was courting SouthGang. He's giving us this whole "Here's how it is in the music biz, baby" spiel, and we were just kicking each other under the table, because our secret was we'd already been through all this and they would never know. Lack of success saved our ass: if SouthGang blew up, eventually we would've been written off and stuck playing Rocklahoma Fest instead of meeting with Jimmy Iovine. I'd put a bullet through my hair weave if I had to do that.

Fairly late in the bidding-war process, we were in New York City, having pretty much decided to sign with Elektra Records. However, there was one A&R guy who had been courting us forever on behalf of Universal. He was very much a "You babe" kind of schmoozer, but he was very dedicated to the Marvelous 3 cause, even before "Freak of the Week," so we cut him some slack; besides, he would always come and pay for our dinners even when we were meeting with other labels—

snaky shit that we thought was killer-funny. He loved us, but before we had a song on the radio, he was powerless: he didn't have the juice to get the higher-ups to pay attention or care, but he kept us on a leash, always trying to get us more showcases, so we loved the guy. He had egg on his face because now Universal was like "go sign Marvelous 3 now!"—to which he responded, "Dude, they're not going to sign with me now, because you guys wouldn't sign them after three tries. These guys are rowdy rednecks: their pride—and mine—won't settle for that."

I remember Mr. Universal A&R Guy offered to take us to lunch one day, when it was already a poorly kept industry secret that we were leaning towards Elektra. We all had a good, cocky swagger on, because at this point, with Elektra pretty much decided as the winner, we didn't need to be on our best behavior. We were like, "We don't need this guy now. We don't need this label. Fuck them." The ultimate payoff came when somehow during this lunch with the Universal A&R, the conversation turned to other bands that had come from Atlanta over the years. We began naming all these bands—the Georgia Satellites, the Brains, the Producers, *blah blah blah*—and then I went in for the kill. I asked him, "What was that one hair metal band from Atlanta back in the day?" I looked mischievously at Jayce and Slug. They played dumb, shrugging. "I don't remember." I turned to the A&R guy: "Do you remember their name?"

He lit up like a Christmas tree. "SouthGang!" he exclaimed. We just egged him on: "Yeah, yeah—that's who it was!" He just kept going and didn't stop. "I loved SouthGang! I had that band on my radio show when I was a college metal DJ back in the day," the A&R guy continued. "They were the coolest people—*Tainted Angel* was the best album ever!" Then he jumped up and actually started air-guitaring and singing SouthGang songs; we were looking at each other like, "He has no idea." We just rolled with it, letting him sit there and talk about all the guys in the band: "Yeah, I remember the singer's name was Jesse!" I looked at him and said, "I think the bass player was Jayce,

and I'm pretty sure the drummer was named Slug. And what was the guitar player's name? Wasn't the guitar player named . . . *Butch*?" The A&R's face turned white. "You assholes!" he screamed. "You guys let me sit there and talk all that A&R bullshit about getting signed, and you knew the whole time because you guys were in SouthGang!" He was so embarrassed and mortified, and we were high-fiving, loving it. That was a big moment of validation for us—our first great rock-and-roll swindle. The result was bittersweet, though: I heard the guy might have actually gotten fired for not signing us. That pissed me off more than anything. He and I had bonded big-time; I give a lot of credit to someone who would stick his neck out for a band that was always five years too early and fifteen years too late.

That pretty much summed up our career. Five years later, every band wore eyeliner and skinny ties, but when we were wearing that shit, radio programmers would meet us and say under their breath, "These guys look like *fags*." We didn't look like Creed and Static-X; we didn't have designer leather pants and goatees. Well, we had leather pants, but they were more Ramones or The Romantics than "The Stapp." We foresaw the glitter-punk thing as something that could be cool; after all, we'd come from this little glam scene in Atlanta. But it wasn't fashionable to the mainstream yet. We had a beef with an idiot program director at a radio station we'll call KDORK. Mr. Rainon-myparade was a big-shot radio programmer, and he played the shit out of "Freak of the Week" at first. Then he came to see us play a show in his hometown and didn't want anything to do with us afterwards. He said our look wasn't "modern" enough—that we looked too "retro." We were unapologetic about it: eyeliner, tight jeans, and skinny ties were our thing. Of course, every band that KDORK plays now looks like we used to. My Chemical Romance, anyone?

Elektra, where we finally landed, didn't mind our eyeliner—at first, anyway. We'd almost signed with this small company called Red Ant; they actually gave us an offer before we had a song on the radio,

and they'd put out the comeback record from Cheap Trick, one of my all-time favorite bands. Red Ant was a cool little indie label, but I didn't feel that bad, because the company dissolved a year after they'd approached us. Elektra had the edge, because they were riding a good wave with bands like Better Than Ezra, Third Eye Blind, and a few other "number" bands that we'd be in good company with. Elektra also had that band Metallica—they'd done okay, I guess—and were pretty high on the label's history. They were always going on about how they had The Doors and The Cars in their catalog, to which I replied, "You don't have those bands anymore. That was thirty years ago, and they probably wouldn't sign with you now."

Alas, I ignored some other early red flags. One of the reasons that I wanted to sign to Elektra was because they'd released Jason Falkner's solo records, and Superdrag's album *Head Trip in Every Key,* which I'd gotten a promo copy of and couldn't stop listening to. When I told them that, the execs were like, "Yeah, well, we don't care about those records." "Well, I do, and you should," I responded. "They're great!" The truth is, we were looking for a big paycheck, and in that department Elektra shined. We wanted a good million bucks offer for a couple of records: we thought all that cash would make up for the hard times we'd gone through. Most of all, that money was proof to us that all the pompous bullshit opinions of these industry people didn't mean squat. We knew they didn't know what the hell they were talking about: they'd heard "Freak of the Week" and glazed over it until Leslie played it, at which point they all offered us anything we wanted.

Another reason we signed to Elektra was because we'd been strung along a number of times by one of their big A&R guys, a man we'll call Joey Douche, whom I'd grown to despise. He was a real jackass, and I could tell that he was just a frustrated musician: he would have his minion scout criticize me and my music, telling me what I needed to do to get signed, to which I always thought, "Screw you, you don't

know what you're talking about." Then "Freak" blew up, and suddenly the president of Elektra, Sylvia Rhone, was flying into town to meet with us, ready to sign Marvelous 3. I remember thinking, in my devious, Scorpionic way, that it actually might be pretty sweet to sign with Elektra Records after Vice President of A&R, Joey Douche, had already passed on us. This time, however, I would effectively be going over Joey Douche's head, signing directly with the president of the company. He didn't like that too much, and actually tried to get in the way. SPOILER ALERT: Joey Douche would eventually go on to be *my* A&R guy; you can imagine how my fate panned out there. Let me finish, though . . .

By the time "Freak of the Week" was a Top 5 hit, Elektra wanted to rerelease the indie version of *Hey!* and just rush it out. I understand that they wanted to capitalize on the momentum of a hit song, but my artistic pride got in the way: I wanted the record to be good, and the indie *Hey! Album* just wasn't fully realized. To finish it, the band went to Bearsville, New York, near Woodstock. There we holed up in a cabin in the woods during Christmastime to finish the record while the industry shut down. Our producer was a friend of mine, Jim Ebert, an early believer who also produced Jason Falkner's solo record; for two or three weeks, we basically just rerecorded parts, and then mixed it right after in Manhattan. We had to recut the drums for "Freak of the Week," and I remember they sent the song to a big, hot radio mixer named Tom Lord-Alge to redo. Tom did a great job; it was the first time that I'd heard my music mixed and sounding the way I'd always wanted to hear it. I was like, "Holy hell, I can't believe how good this sounds!" But even he couldn't do anything with it at first, because the drums weren't separated out on different tracks: there were no separate kicks, no individual toms and cymbals—they were all together on two tracks already premixed by me, due to my limited production setup at the time of recording.

The radio stations were playing my original version, anyway,

which I mixed in Pro Tools after recording it at home. I didn't really know what I was doing, but people thought it sounded awesome, and that's when I knew I could be a producer. I knew that recording was never going to be the same again: it was a revolution for me and a lot of other people, who finally got to take back control from the audio gatekeepers. While the new version sounded great, I still felt the success of the original version validated my championing of home recording. With that song, I hopefully proved that you don't have to have a big huge studio and a major producer to make a hit record, because I made the thing in a living room on sixteen tracks! Remember when the Beatles did it with four tracks? No? Well, the geeks out there understand what I'm talking about.

My destiny, meanwhile, was changing rapidly, so much so my head was spinning. Marvelous 3 was getting calls to be on Leno, Letterman, and Conan. I was negotiating my first publishing deal as well with Warner/Chappell Music Publishing.

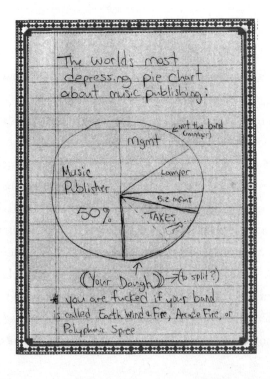

I waited until my song was a smash before asking for a stupid amount of money. I wanted a million dollars to sell my publishing; that was as much as you could get, unless you were a huge artist, like Bruce Springsteen. When they actually gave me a million dollars, I broke down and cried right in front of them like a damn baby. I'd been scraping by for so many years; I told them, "This will certainly improve my lifestyle, considering I drive a hundred-dollar Volvo and live on the floor in a guesthouse." Yes, the major-label excess had returned. We shot a video for "Freak of the Week," the expense of and terrible treatment for mirroring our experiences shooting music videos in the SouthGang days. I remember the treatment we actually wanted to do came from this director named McG, who would go on to direct *Charlie's Angels* and *Terminator: Salvation*. McG's specialty was making bands with no personalities look like they had personalities; I figured working with him would be genius, because we already had (too much) personality. But instead of McG—who had this totally cool vision that combined retro-inspired punk/New Wave elements from the '70s and '80s, bold imagery and colors, and referenced the Police's "Roxanne" video—Elektra hired this kid Little X, who had been the assistant to Hype Williams, a director famous for making blinged-out rap videos. Little X's premise was that there was a little girl who brings her big brother, who happens to be a rock star, to class for show-and-tell. On the shoot, I found myself playing in a cafeteria while a bunch of kids had a food fight. Go figure.

This is when I knew I was at the wrong place. Elektra's president Sylvia Rhone actually told me, and I quote, "I don't think that McG's treatment is right for you—it makes you look too much like a *rock star*." She thought that all the bands in our genre weren't rock stars, which on one level was very true: "modern rock" was filled with bands that were just faceless, generic mounds of flesh with really good pop records. Marvelous 3 wanted to be perceived differently, so for her to actually say that killed the band right there. "Too much of a rock star?" I was perplexed. "That's a *problem* to you? What are you talking about?"

She wanted to tone me down and make me not express myself the way I normally would, which is what people really wanted to see. Of course, right after that, the rock-star invasion happened: artists like Kid Rock (it's in his name) with strong personalities swept the faceless "number" bands all by the wayside. Rob Zombie ate our numbers for breakfast on a skull-shaped plate. We were losing the popularity contest, and I just remember thinking, "Oh, this is *great*."

In other words, I was back to life on a major label, business as usual. There were a lot of things I didn't like about Sylvia: she would tell you what you wanted to hear and then do something completely different (such a shocker in the major-label world). Our biggest beef with the label stemmed from Elektra wanting to put our album out at full price. I thought this was a completely greedy and insane idea: at that time, bands were coming out and selling shitloads of records at $7.99; basically, they were giving their record away as a two for one. Elektra, however, wanted to put our record out for something like $15. I said, "You're not going to sell any copies." The problem was that the label waited too long to put the album out: the single had already run its course. The entire time "Freak" was in heavy rotation on radio and MTV, we didn't have an album out. And instead of following it up with a proper video and a real push for a second single, they just dumped the album out; it sold around ten thousand copies the first week, and then slid down from there. Basically, to put it in perspective for you, if this were to be in the now, the single would've been released immediately on iTunes *and* the radio, and the single probably would've gone gold or platinum. Back then, in pre–digital invasion days, singles weren't a hot commodity—just albums; it also took a lot more work and planning to get tangible goods into a store (remember record stores?). We kinda fell victim to the ever-growing attention deficit disorder starting to take over the popular culture.

For the next single, we didn't have another song like "Freak of the Week" on the album. That was the only song that I wrote about selling

out. Instead, we released a song that I thought was the album's best song, "Every Monday"; it had a good lyric, but it's not the best hit-single candidate. For one, it's in 6/8 time, and there were no songs on the radio at the time in 6/8—maybe country and ballads, but not rock songs. The radio people violently hated "Every Monday"; nobody played it, and there was no video for it. Ironically, that was one of the Marvelous 3 fans' favorite songs, but then they were real fans who didn't give a shit at the end of the day about a hit—they came for the single and left believing in the band. "Freak of the Week" was a gateway drug, but we kept a lot of fans because they liked our live show and the rest of our songs. Remember, and I will say this a few times in this read, sometimes there's a difference between a hit song and a good song.

Regardless of whatever ridiculous thing was happening with our label, we toured everywhere for about a year—the U.S., of course, but also Australia and Canada. We had decent crowds touring as headliners; we had numerous "here today, gone later today" opening bands come and open shows for us, and we also got good opening slots on tours opening for all the "number" bands. It was sweet vindication for us, in a way: here we were, back in a tour bus again after working our asses off in the van for almost a decade. I remember some lucid moments on that bus with a proud but watery eye: "Well, we did it— we got back to this place, at least." We didn't know if it was going to last, but at least we were there. We'd worked hard to get there, and then lo and behold, we'd actually kinda made it. What next?

Partying, of course. The debauchery on the road got worse, because this was the most success we'd ever tasted, even though it was still capped at one hit single. I'd never had a hit song before, none of us had, and we all went crazy. There was a lot of sexual deviancy, a lot of alcohol making us bad people, and a lot of stupid decisions being made. We were starting to lose the plot, and I definitely lost Jayce. We'd already split up SouthGang in part due to our singer's problems with alcohol, and Jayce was now exercising his inner alcoholic. Our tour bus wasn't

exactly the Betty Ford mobile clinic, either: nobody in the band was straight, and we partied together nonstop. I thought that came with the territory of being in a rock band, so I was a bit more lighthearted than I should have been about it. The problem was, Slug and I weren't destructive drinkers, but Jayce was. He did really bad things when he was drunk, plus he had a family at home. I could see Jayce was destroying so much that he loved in his life, partly as a defense mechanism. Actually, what Jayce felt wasn't resentment as much as pressure—pressure on him, pressure on his family. He wasn't seeing his wife enough, and he was missing his kid growing up, so he just drowned himself in alcohol, and alcohol treated him poorly. We would even try to talk to him about it, but he would just get belligerent on us. But his drinking didn't become a horrible problem until we started touring on Marvelous 3's second record, *ReadySexGo,* which would also be our last record. On that one, things really started going *Rock Band.*

When *ReadySexGo* was ready to come out in 2000, we wanted to know what was going to happen next. Were we going to do another record for this stupid label? I didn't want to; things had gotten even more discombobulated, because our day-to-day person at Elektra, Nancy Jeffries, was leaving. Nancy was a Vice President of A&R, definitely the coolest person at the company, and she had a bit more of the hipper roster. But Nancy had done her time: she was often disenchanted with what was happening at the label, hating the industry and ready to get out, and then she finally did. She was more of an artistic person, so when she saw the writing on the wall with what was happening to the music business, she quit—right before we were supposed to record *ReadySexGo.* And that's when I inherited my favorite person in Alcohol & Restaurants, Joey Douche.

When Joey Douche finally became our A&R guy, I thought, "Well, this is career suicide." We'd alienated him even before we were signed, so I knew Joey was going to make damn sure that nothing happened with my record. He didn't like me and wanted to spite me because he'd

passed on me when we were trying to get signed; he then had further egg on his face when "Freak of the Week" blew up and we went over his head—signing at his label but with the *president:* our impending failure became a self-fulfilling prophecy. Joey had said to someone that Marvelous 3 were nothing but a "bar band," but he'd never said it to my face—hell, no! The one time I talked to him, he called me to talk about our next record. "You know, I don't like you and you don't really like me, so I don't know what this is all about," I told him. "I don't know why we don't just get dropped." He was making an attempt to be nice on that call, but I could see through his bullshit and he could probably see through mine. I was dying for Elektra Records to drop Marvelous 3: I'd had under-the-table meetings with two other labels who were offering me deals. Donnie Ienner, the head of Columbia, and L. A. Reid, who had just taken over Arista, both made me the same offer: "If you can get out of your deal, you can come here."

Ironically, my next two solo album deals would be with, respectively, Arista and then Epic, which was weird. Not as weird as what happened with *ReadySexGo,* however. I played the demos for the album for Sylvia Rhone and told her, "I want to make an over-the-top arena rock record, like Def Leppard's *Pyromania.*" To that, she was unequivocal: "No, you can't do that. It will never sell—that sound will never be big again. You're just like Eve 6, so you just need to *be* Eve 6." I know, I know: I'm trying to figure that statement out still to this day. I was so insulted by that, because we were the furthest thing from Eve 6: we were an actual rock band. We'd opened for Eve 6 on our first tour, in fact. The first show Marvelous 3 played with those guys, they were having a huge hit, "Inside Out"; even though we were unknown at the time, we kinda wiped them off the stage. As we came offstage after our set that first night, all three of the guys in Eve 6 looked like they'd seen a ghost: they just stared at us distrustfully. I remember the drummer asking, "Who are you guys? You've done this before, haven't you?" It was just ironic that anyone would compare us to *them.*

In a way, I was self-sabotaging: I wanted to do this arena-rock record so that we could turn it in and get dropped. I knew I'd get picked up by one of these other labels that actually liked my music and was ready to really do something with my career. The music business is small and porous, though: I'm pretty sure Elektra had gotten wind that other people were interested, so "No, no, no" suddenly became "We think it's great. We're definitely going to put it out!" That's how labels are: if someone else likes it, they like it, too, by reflex. I wasn't really excited about that: I knew they were just going to put *Ready-SexGo* out and let it flounder. Even that, though, was better than what Elektra Records did to Superdrag. Superdrag had made an incredible album, *Head Trip in Every Key,* but Elektra chose not to release it out of spite—well, that and the fact that the record was written as a hateful rant against Joey Douche, who was Superdrag's A&R guy; it's no surprise it wasn't championed and never really physically came out. Superdrag could've gone on to sign with anybody else, but they couldn't, because Elektra were able to contractually hold the band in limbo. Elektra didn't want the embarrassment if they let them go and they met with success at another label. That's exactly why our label president wouldn't let us go—Sylvia's ego would never be able to stand the fact that we could do well somewhere else without her.

Another stumbling block was that I actually wanted to produce our album. After all, I'd produced and written the only hit song on our first album, so who was to say I couldn't produce? My demos sounded like finished recordings; they sounded like records on the radio. But the head of Elektra wouldn't have it. "It won't be good unless you have an A-list producer," Sylvia told me. *So* major label. I met with some producers Elektra was interested in, and they all said the same thing: the songs sounded like they were finished, so what did I need them to do? "You don't need us," they told me. I'd lived hand to mouth for ten years making records in my house, so why did I have to start doing it any differently now? I definitely had something to prove. But don't I always?

Regardless, I dutifully made my way through the A-listers Elektra Records kept throwing at me—people like Eric Valentine, who'd produced hits for the likes of Third Eye Blind (*Surprise! A number band!*), and Don Gilmore, who'd scored big with Eve 6 (*Surprise! Another number band!*). But when Jerry Finn's name came up, I got really excited about the idea of working with him. If I had to work with another producer, it had to be Jerry. For one, he'd worked on that Superdrag record I loved. Second, he agreed to coproduce it with me, which was a big credit to him. This guy was a real legend—he'd come up making so many great punk albums from bands like the Vandals, Bad Religion, Pennywise, Jawbreaker, Rancid, and Offspring, and then don't forget this little band called Green Day. Jerry also did all of those Blink-182 records that were *huge*. We'd played festivals with Blink-182; in fact, it was Tom DeLonge from Blink who told Jerry to go with us. I remember Jerry telling me that. He said, "Yeah, it was actually Tom from Blink who said that I should work with Marvelous 3, because if anybody was being punk rock at the time, it was those three guys with black jeans, skinny ties, and eyeliner." Indeed, I think the only reason Jerry did jump on *ReadySexGo* is because he thought that making a new version of *Pyromania* was such a contrary, punk-rock diss move against the current music-biz establishment.

Working with Jerry made for a happier time. We made the record at my place, which was another cool thing. "I'll work with you in Atlanta at your own home studio," Jerry told me. He had very DIY punk-rock ethics, so he understood that I didn't want to work in a big studio and piss all the money away. The budget for our second record was $250,000 or something like that, which we knew was way more than we needed; I knew we could bring the record in under that so my band could have some money for once. Everybody always does these records with these big producers, spending thousands of dollars on food budgets and massive studios where they get nothing done. Then they go over budget, spending a couple hundred grand to make

a record when it should've cost fifty—and in the current times, you could make it for free on a laptop.

Jerry preferred to work on analog tape, so I bought the same Studer two-inch, twenty-four-track machine from a studio that Smashing Pumpkins' *Siamese Dream* was made on, and at a discount; the seller had a bad coke habit, so it was priced to snort . . . er, move. Jerry and I put the Studer in my studio, and synced it up to Pro Tools, so we had tons of tracks to play with. Jerry taught me so much that was invaluable to me: I told him, "I'm going to go on and be a producer one day, and I'm going to have you to thank for that."

My Studio:

1984 – Boombox (then hold up to 2nd Boombox and overdub record on it)
1985 – Ross 4-track cassette recorder
1989 – Akai 8-track w/ drum machine
1990 – Tascam 38 (8-track ½" tape reel to reel w/ Brother Sequencer for drums)
1991 – Same (but added a 12-ch Yamaha recording console & Alesis D5 drum module)
1995 – Alesis ADAT (digital tape multitrack recorded on VHS tapes!)
1998 – Pro Tools (early 16 channel version!) (no plugins, Auto-tune, etc!)
2000 – Pro Tools, Studer A800 2 in. tape machine, lots of mics, processors, etc.
2003 – SSL 48ch. Recording console and full studio

2005 – Neve 60ch. VR console, way more gear, full building studio
2007 – Nothing but laptop (FIRE.)
2009 – 3 Tape machines, Studer (didn't burn) Pro Tools, custom console, Neve board, and pretty much everything else I need! :)

Jerry was never that egotistical, insecure guy who was scared that someone, if he learned too much, might steal a job from him. Jerry actually encouraged me: we had long talks in the studio about how he wanted to share his knowledge. Between Jerry and Jim Ebert, they taught me everything I knew about how to be a real recording engineer. I knew how to produce, but I was self-taught, so I definitely needed someone to show me the best techniques for miking amps, using compression, and so on. But, luckily, there was no telling me what to do on the songs. Half the tracks we kept from the demos I'd already recorded, and at the end of the day, we had this big, arena rock–sounding record that was very misunderstood and, as usual, five years too early.

Several bands came out later, dressing and sounding kinda like we did on that album. At the time, the main people who didn't get it were at the label. "Sugarbuzz," the first single, was oddly like "Pour Some Sugar on Me" meets "Baba O'Reilly," with a snarky, cynical lyric. The style suited me at that point in my life; Elektra Records, not so much. The A&Rs always gave me the same rap: "Arena rock is never going to sell, *blah, blah, blah.*" People thought I was unfashionable then, but I just looked at it as doing something different and individual; I didn't want to be muddled up doing the same thing as everyone else. Sure enough, six months after *ReadySexGo* came out, Andrew W.K.'s first album was released, and then a few years later, The Darkness made a big splash with ironic cock rock that felt all too familiar. As all this stuff started happening, everybody began to kick me under the table, saying, "Can you believe this?" I could believe it, but it's not something that made me feel bad. I felt great about it—I felt relieved that I was actually not crazy but that my instincts were right.

We had proven a lot at this point in our life, but we had a lot more to prove, because our last record didn't live up to everyone's expectations—or our own personal ones. "Cigarette Lighter Love Song" off *ReadySexGo* is probably the most important song to me from the Mar-

velous 3 era: I still play it live, and it continues to hold a lot of meaning to me. "Cigarette" reflects a really dark period where I almost lost my wife, due to me being an idiot, getting caught up in success, "the road," and all the clichés that come along with it. That song in particular reminds me of coming home from tour and things being very weird between Nora and me. The lyric goes, "I know you're not asleep/I can feel you moving over there/You've been playing with the seam in your worn-out underwear/My lips are raw as hell from biting on them just to stay awake/It's not like I'm going to need them/You won't be around to see them bleed and break." That pretty much captures that awkward feeling that I'd felt too many times, when you stop knowing the person you know better than anybody else; so many times I returned from tour, I'm sure Nora didn't recognize the person sleeping next to her.

The next verse goes, "I drove out of east Atlanta with a headache the size of my car/I called to say I was okay, anyway/'Cause I know how you are." A lot of people go through that scenario when they're in a relationship that's in turmoil and they don't know when they're going to see the other person again. That was a dark period; at least it inspired a good song. I regret so much about those times. She's the person who lent me the money to buy the rig that I recorded "Freak" with; she was there for me through thick and thin, and there was a lotta thin, when most people kinda stopped believing. That's why that song means so much to me: the rest of *ReadySexGo* was disconnected emotionally—it was all about bigness and excess and partying. The celebratory vibe came from us feeling like we'd won again: finally we could celebrate having a hit single, which bled into the touring and the craziness that ensued. "Cigarette Lighter Love Song" was probably the last song on *ReadySexGo* for a reason: everything else on the record was a sex song, an attitude song, an empowerment song, but not a love song. And that was a song about someone I love to this day—as brutally honest as I could make it but filled with love for the person who never let me down.

As always, we went out and toured right as *ReadySexGo* was getting ready to come out, but it was pretty clear that the sun was setting on Marvelous 3. Me being me, I had to go out with a bang—maybe even a couple bangs. Right before we were getting ready to do a big promo tour, Marvelous 3 headlined a festival in Alabama, just before the new album was going to be released. At the last note of the first song, I jumped off the drum riser and snapped my Achilles tendon in half. There went the show, there went the tour, there went the album, and there went Marvelous 3: they put me in a cast, surgery, rehab, the whole thing. If you look at the group photo on the back of *ReadySexGo,* I've got a bulge under my leather pants: it's a cast, and I'm on crutches, too. When they took that photo, I was right in the middle of dealing with the recovery from my injury. I was trotting to all these radio stations around the country with my record reps playing the album's single, trying to get them hyped on it; I started realizing that I was in trouble, and that Marvelous 3's future was in great peril, because of the shift that was happening. We were entering that generational decline when Fred Durst crowd-surfed as the audience rioted at the revival of Woodstock. Eat, screw, drink, fight, rinse, repeat: America was definitely reaching its lowest knuckle-dragging point.

The evidence of the decline of Western civilization was coming out of the radio, and we didn't stand a chance facing this onslaught that spoke directly to the disenfranchised youth of this new America. The rock they were playing on the radio had grown much more aggressive and macho: playlists were now all about aggro bands like Korn, Disturbed, and Limp Bizkit. The nü-metal bands that were getting big were either heavy and dark or they just cried and moaned a lot, and we weren't doing any of those things; hair metal was back, but this time, instead of a Vince Neil clone up front, it was a depressing bald white dude trying to rap. I could see where this was going when I saw all the DJs at these radio stations were these kinda overweight dudes wearing baggy black shorts and long jet-black hair, with

"weird beards" and Static-X posters all over the walls. Seeing them, I realized, "Wait, these guys want to *be* like those bands—they don't want to see a guy wearing eyeliner and a cast. They don't like me because girls probably like our music." It was like *Revenge of the Nerds* with a mullet and a goatee.

We felt that caveman mentality glaring at us whenever we played shows with this new breed of bands: audiences just seemed frightened by what we were playing. We had to play as hard as we could, and yell instead of sing, because they weren't even listening. They just wanted to hear somebody scream: rock had become scream therapy for all these kids whose parents hadn't raised them right. I didn't really want to be a part of that, to be honest—I was still too young and self-centered to be a self-help hotline with a seven-string guitar and drop D tuning. All I did was make fun of bands like that; I realized they served a purpose for the youth, but it just wasn't what I wanted to convey. I wanted to take things to maybe a little bit smarter place. I mean, sure, I redid the *Pyromania* vibe with *ReadySexGo,* but it was meant as more of a wink and a nod—a statement saying the world needs more color right now. But people took it literally, not with a grain of salt like they should have. That definitely was a big issue for me, too; to this day, I still have so many fans who are just fans of *that* record and didn't get the joke. I never intended *ReadySexGo* to represent what I was going to be for the rest of my life. People weren't used to that; they'd gotten used to bands *not* evolving. Me, I loved the artists who changed with every record to keep people interested and pique their curiosity. I liked people like Bowie and Prince for that reason, but at the end of the '90s, it was all about the new Staind album sounding the same as the last one. You got one Limp Bizkit record, the next one was sure to sound the same. I knew our fans were smarter than that, and I didn't want to let them down.

When I knew it was the end of the road for Marvelous 3, I sent Elektra a salvo over the Internet, which was in full effect at this point.

It was an open letter to Sylvia Rhone, which I posted on the Marvel-
ous 3 Web site. It went a little something like this:

> *There has been an incredible amount of "lack of interest" for the*
> *band over at Elektra ("cough, ahem, Neglectra, cough, cough")*
> *Records lately, and that comes as no surprise, seeing that every*
> *record they put out most recently sinks like a dead, anchored body in*
> *the Hudson River. . . . Well, the time has come. We are free from*
> *Elektra Records. I asked them to let us go, and they did.*

Everybody in the industry read it—everybody I've met in the last
ten years would say something like "Yeah, I read your letter." Now,
there's been a bunch of departing letters since then: every band now
has a blog where they either praise or dis their label (depending on
what stage of the record deal they're in). I was just saying what I felt:
"You can't contain us and keep us here. If we break up, you can't have
Jayce, you can't have Slug, and you can't have me. Fuck you, we're
done: the three of us are going to do whatever we want, and you're
never going to make a dime off of us ever."

That letter was the most scathing thing I'd ever written. I was a
much different person then than I am now—very cutthroat and sharp-
tongued in the way I handled people—and my infamous missive
arrived right at the breaking point. Debauchery and sadness had just
taken their toll on everybody. It was like, here we are again, ten years
later: it was the same scenario we went through with SouthGang,
except this time, it was Jayce who'd gone off the deep end with his
drinking. It took his family practically walking out on him to scare
him straight. He pulled me aside one night, tears in his eyes, and told
me he was leaving. "I can't imagine not playing in a band with you
guys," he said. "I've spent half of my life with you, but I can't do
this—I've got to get out. I've got to focus on my family, and I can't
drink anymore."

We saw it coming, but it was still sad; that's when we decided that we would disband for good. For our last shows, we brought it all back home. First we headlined Music Midtown, a big three-day festival in Atlanta; then we threw a big concert for free out in Centennial Park, to which thirty thousand people showed up. Our last show ever as a band was incredible. It was both amazing and weird to look out into the audience and see everybody singing along to songs that were deep album cuts, and not just "Freak of the Week." We could even see people crying: it was a big deal, because of our shared history. At this point, we knew it was never going to be the same—we were never going to be the same three guys who had been playing in a band together for fifteen years. This was it.

All these memories came rushing back through us during that final show. It was an amazing experience: all our friends and family were there, in what was a bizarre combination of celebration and funeral. After finishing our set with "Cigarette Lighter Love Song," we walked offstage, walked straight to the bus, went right to the back lounge, and just started bawling like little babies, holding each other. It was really weird to see those fifteen years come to an end: we were brothers, absolutely brothers, and we were moving on. Leaving the game, loving each other as much as we did, still knowing this was for the best . . . It was the hardest divorce ever. It was a sad moment, but it was a great moment, and then we went our separate ways.

LEFT OF SELF-CENTERED
Failing Upwards into a Solo Career

There is no right or wrong way, for certain
Make up your own version, sing along. . .
—*Butch Walker, "Ladies and Gentlemen . . .*
 The Let's-Go-Out-Tonites!"

He could lick 'em by smiling
He could leave 'em to hang . . .
 —*David Bowie, "Ziggy Stardust"*

I can't lie: by the end of Marvelous 3, we all just got good and sick of "Freak of the Week." If you eat a banana every day for an entire year, well, you just don't want to see another damn banana. That song was my banana. I was ready to move on to another food group, but the rest of the world was still stuck on bananas.

The last Marvelous 3 show was advertised as such, and when word got out, the feeding frenzy began. The weird thing was, there were already labels there at the gig, entertaining the idea of what I was going to do next. Here I was, drying my eyes, yet having to talk to

people about whether or not I was going to do a solo record. Eventually I would sign a deal with Arista and its then-CEO L.A. Reid, who's now the head of Epic. My first solo album was called *Left of Self-Centered*—great album title, dodgy album. I'd say about a quarter of my fan base, that's their favorite record from me, but it's not mine. I was basically just satisfying Marvelous 3 fans with something very similar; it's not exactly a cerebral record. I was caught between the two—between a rock and a soft place. I was scared of losing the Marvelous 3 fans, so I just made a desperate attempt to try to keep them; I should have taken some chances, and I didn't. Meanwhile, Arista didn't know what the hell to do with me. The label didn't know what to do with a solo rock singer in his thirties, especially one who didn't even know what *he* wanted to be. They knew what to do with Avril Lavigne, but they didn't know what to do with me, and neither did I.

Oh yeah, Avril Lavigne was on Arista, too—coincidence, coincidence; we actually shared the same A&R guy, Josh Sarubin. When we met in Josh's office, she hadn't yet developed her pop-punk image yet: she walked in wearing glasses and a sundress (looking very Lisa Loeb) while Josh and I were going over photos for my album artwork. In the photos, I was wearing skinny jeans, Chuck Taylors, some sort of a striped armband, and a wife-beater with a tie hanging around my neck. I remember her looking at the photos and going, "That's cool! I like that armband. That's a cool tie!" We said our good-byes, and I think I remember even saying, "Good luck with your album and all." Not even two weeks later, they shot her first video, and in it, she's wearing the exact same outfit I was wearing in those photos, which would become an iconic fashion statement everywhere (for some reason). Let's keep in mind, I'm excited the look worked for her so well; it was a pretty bad look for me. The fact that I wore that shit was not so great; it just looked stupid on me, especially as I was in my thirties. I was just trying too hard with all that junk, overaccessorizing and overdoing it to make some *statement,* because I didn't know exactly

who I was. I was in a weird world: I was a solo artist trying to be a rock artist, at a time when there were no solo artists being rock artists—there's no way I was going to compete with Korn. In my usual fashion, I made a really horrible video for the album's first single, "My Way," a song that I won't play ever again in my entire life. "My Way" was like "Sugarbuzz, Part 2": another song about not holding back *blah blah* not conforming *blah blah* I'm a rebel *blah blah*—oh, and screw you, too. *Yawn.* Hearing "My Way" today, I just wish I could've told myself then, "Come on, man. You're in your *thirties* now." That's what tripped me out—I finally started realizing I had to act my age and be a little more, dare I say, *sincere.*

With my usual sense of timing, *Left of Self-Centered* hit right when bands like the Strokes were coming on the scene. Rock had a whole different face of pretension: it had nothing to do with Kid Rock anymore, and everything to do with the music I liked fifteen years earlier. I loved the Strokes and their ilk, and I also loved a lot of singer-songwriter acts at the time, and I was trying to figure out where I fit in. I felt like I'd lost my identity again, especially after that first solo single didn't really happen the way I'd desperately hoped it would. I had to rethink things, buckle up, and disappear for a minute. I wanted to marinate outside myself for a bit—I thought I might figure out who I was, maybe.

Producing and writing for other musicians seemed to be the antidote, as people were becoming organically more excited about that skill set of mine, anyway. My first success outside of my own band happened when I was stuck in a leg cast and unable to tour with Marvelous 3. I got a call from Andy, the guy who was in charge of the record label Deep South that had put out the early Marvelous 3 and Floyds stuff. Andy was managing a new "number" band called SR-71, which had just gotten signed to a big major-label deal. They sounded very similar to Marvelous 3—I'd even heard people in the music business jokingly call them "Marvelous 2½." As a matter of fact, the singer

from SR-71 had seen Marvelous 3 play at a festival in North Carolina right when we were starting out. He was in one of the opening bands, and he busted into our dressing room immediately after we got off-stage. "That was amazing! You guys are great!" he exclaimed. "My band just played, too, but I'm changing everything: we're going to have to be a little more like you guys now!" And that's exactly what he did. Cut to a year or two later, his band, renamed SR-71, had already recorded an album with producer Gil Norton: to make it, they'd gone $750,000 into the hole, but they didn't have a single. So Andy calls me and asks, "Could you cowrite a song like 'Freak of the Week' with the band?" And I said, "Well, I suppose . . ." The banana had been peeled again.

Other than Desmond Child during the SouthGang days, I'd never cowritten a song with anybody else; I had no idea how to go about it. Regardless, SR-71's singer, Mitch, sent me a cassette that had the nucleus of a song on it: a drum machine beat, a guitar line, and humming—there were no lyrics, but he had hummed a melody for the chorus. I immediately came up with the words for the chorus: "Why do you always kick me when I'm high?/Knock me down, 'til we see eye to eye . . ." That demo became SR-71's single "Right Now," which, ironically, went on to become a bigger hit than "Freak of the Week." Some bananas are clearly tastier than others . . .

The funny thing is, my manager at the time and pretty much everyone else close to me were advising me not to work on "Right Now." They were like, "Forget that! You're not cowriting their hit! Don't give them anything!" To which I said, "Are you kidding me?" I knew if it was a big hit, I was going to make money from it—*my manager* was going to make money from it. I did it anyway, and lo and behold, "Right Now" became huge. That soured my relationship with my representation for a while, but it made me believe that I always have to follow my own instincts—well, not about fashion choices (as in the *Left of Self-Centered* album cover); with songs, though,

I was right most of the time. "Right Now" propelled me back into doing the backstroke in the sea of irony yet again. All of a sudden, as the cowriter of a hit single, I had this whole new recognition in my life: publishing companies wanted to renegotiate my deals and give me more money, and fun things like that.

In this mode, I ended up producing this band from Atlanta, called Injected. I thought Injected was really great—more of a hard-rock band, and there wasn't even a number in their name! "I want to do four songs with you, and I think we can get this signed," I told them; sure enough, the demos we did together got Injected a deal with Island/Def Jam. There were two or three labels bidding, actually. I did cowrite a song on Injected's 2002 debut album, *Burn It Black,* but the band's front man, Danny Grady, was just so prolific, period. Danny's an amazing songwriter, a ridiculous guitar player, a great singer, a good kid, and one of my best friends at that time. (Danny and I would also collaborate on "So at Last," a song from my second solo album, *Letters.*) Instantly after Injected got signed, I was in the studio producing the rest of Injected's album—my first major-label record outside of my own, all within the course of a few years. It was great. *Burn It Black* came out awesome, and the first single, "Faithless," even charted as a Top 20 modern-rock hit.

Injected wasn't the only return to my bleached hard-rock roots. Apparently, I couldn't stay away from the hair metal, because around this time I became acquaintances with Nikki Sixx. I met Nikki at the NAMM Show, an annual trade convention for gear geeks and musicians with ponytails: we connected through Sam Maloney, a friend of mine who was the drummer in Hole and then the drummer in Mötley Crüe when Tommy left for a while to explore rap-metal waters. Nikki told me he loved Marvelous 3, and that one of his favorite records was *ReadySexGo.* He was like, "Hey, man! What's happening! Dude, you've got to call me and we'll hook up and get together and hang out and jam!" I'm thinking, "This is kind of weird and out of

context for me now, where I'm at in my life"; even when I was with Marvelous 3, it would have seemed out of context. However, I figured it would be fun to hang out with someone whom I'd idolized when I was fifteen. At the very least, it would prove to be a memorable experience. Please read on, won't you?

I remember my first deep hang with Nikki went down around midnight on a Tuesday night. I was leaving the studio while mixing the Injected record in L.A., and my cell phone rang: "Walker, it's Sixx. What are you doing?" "Well, I just got out of the studio," I said. "I'm going back to my hotel." "No, you're coming to my house," Nikki responded. "Stop and get something to drink. Bring some of the hard stuff." He sounded a little toasted already. Nikki was in a dark place, going through his divorce with Donna D'Errico at the time. She had custody of their kids, and he had lost his house—and a bit of his mind—to her. He had yet to get another house, so he was stuck in an Encino Hills rent-a-mansion all by himself at the time; Nikki's mind, however, was still a work in progress.

I didn't know what was going to happen as I got off the highway in Encino Hills; I do remember thinking, "This is going to be really weird in the best way possible." Little did I know our first encounter would exceed all expectations. I pulled into this big, gated mansion and rang the buzzer. Over the intercom, Nikki's voice crackled. "Just park up there next to the Ferrari," he slurred. It was tough to find the space he was talking about: there were more vintage muscle cars, new Lamborghinis, and classic motorcycles lining the entire driveway than I'd ever seen.

All the lights were off in the house, but in the darkness, silhouetted in the doorway, I saw this iconic shock of hair that just defines who Nikki Sixx is. Immediately he poured me a drink, finishing off a bottle. "Let's go back to the studio," he said, clearly wasted. "I've got to see if I have any of the harder stuff left." In the studio, he pulled out a fresh bottle of Jack Daniel's; there was also cocaine laid out on a plat-

ter—everything you'd expect, really. "I can't believe this is happening," I told myself as I politely declined the blow. At that, Nikki picked up an acoustic guitar, trying to riff and sing. "Let's jam and write some music together," he said excitedly, but he was so wasted it was clear that was not going to happen.

At this point, I was feeling way too lucid for this whole experience. At a loss for what to do next, I tried to play him some of the Injected album, but the CD player in the studio wouldn't play the disc I'd brought, for some reason. Nikki suggested we listen to it in the living room. We walked in there, and the lights were all off. It was completely dark, and I could hear a hacking, coughing noise as I sat there fiddling with the CD player; I thought it was a dog or something. Then Nikki turned on a light, and I saw this old man wheezing and rustling around on the couch. Nikki sees him and goes, "Sorry, Dad." I'm like, "*Dad?* Whose dad is this?"

I knew Nikki's real father had died a long time ago. Why was this guy here? What the hell was going on? With the booze, the platter of cocaine, the mystery old man sleeping on the couch, I felt like I was in *Spinal Tap* as directed by David Lynch. Then the gate buzzer rang. Nikki picked up the phone: "Hello? Yeah, come in." After hanging up, he just looked at me and said, "Pussy's here." Like the pizza had arrived. On cue, three Playboy Playmates walk in the door. I'm like, "This is how Tuesday night goes down in Encino, huh?" Ridiculous. At this point, Nikki was way past the peak of Mötley Crüe's craziest years, but he still got the checklist right (girls, drugs, asthmatic old mystery men on couches). Clearly, I had zero game.

I don't know if it was the next day or a year later, but I remember getting a phone call from him as he was taking off in a plane somewhere: "Yeah, man! About that night, listen, I've been going through a rough time, and I don't know what all went down, but I just hope we're cool." I was like, "Dude, you're amazing. That was incredible." And it was! When I saw him again, around when I was making *Left of*

Self-Centered, he was really clearheaded and lucid at that point in his life, using no drugs or alcohol whatsoever. He came and played on a couple of songs, and that was also a trip. Can you imagine telling your thirteen-year-old self that Nikki Sixx was going to be playing bass on your record? He's just a cool dude, and he exceeded my expectations of how he should be. However, my Mötley Crüe ride wasn't over (literally): eventually, I would work with Tommy Lee. But that will come later . . .

Anyway, *Left of Self-Centered* came out, and, well, not much happened. "My Way" failed to do anything, really, except play in the background relentlessly on VH1 shows. That's the only time I ever heard the song—as background music every five seconds on VH1. They sure loved the "whoa, whoa" part. That was weird. I really had some serious thinking to do: I felt like I'd lost the plot as an artist again, but the second I stopped thinking about me and did stuff for other people, all these great things started happening. I had a Top 5 hit that I cowrote with a band that came out of nowhere, that I didn't even know. Then, with Injected, I had an album on the charts, with a single on the radio: this band was doing better than Marvelous 3 ever did—Injected sold over 100,000 records, easy. After that, of course, I started getting calls from other people to do stuff, which really made me step back and reassess where I belonged in my career. That's when the floodgates opened up: "Hey, Simple Plan called, and they want you to work with them." I know, I know . . . Not exactly Queen calling to make a magnum opus, but hey, times were tough, and I knew pop-punk and power-pop like the back of my left wrist's studded bracelet.

Case in point: Bowling for Soup. I cowrote a hit with them out of nowhere, "Girl All the Bad Guys Want," and then we had another big single together, "1985." Interesting enough, I would cowrite all the singles on Bowling for Soup's first two albums. "1985" was actually found by me and my manager, Jonathan Daniel, buried as the eleventh

track on an import of that SR-71 band's third album, which was only released in Japan. When I heard it, I said, "That's the Bowling for Soup single." We rejiggered it a lot and rewrote it a little bit; I didn't take a cowrite credit on it because I really, really liked Jaret from Bowling for Soup and the other guys in the group. They're a funny kind of a band, and people kind of wrote them off as that, but they're good dudes, and lifers: older guys and family men who really worked hard to do what they did, and who were in on their own joke. They really care about the idea of being in a band as their life, and I remember Jaret telling me this story, in a very disheartened way, that they weren't going to be able to get the publishing advance on their record.

I'd been through this in SouthGang with Desmond Child: when Desmond Child cowrote our entire record with us, we never saw half of our publishing advance, because we failed to read the fine print that said we would be forfeiting the back half of our advance if we did not deliver at least 80 percent of the music on the record. Technically, 50 percent is all we delivered, because Desmond Child took the other 50 percent (rightfully so). So when Jaret told me what was happening, it hit a soft spot in my heart. "I don't know what your publishing take is going to be on this," he said, "but I'm definitely going to get screwed. They're not going to give us our publishing advance, because we're not delivering half of the song." I didn't want that to happen, so I forfeited my publishing on it. I was already making money off of Bowling for Soup's last record that I cowrote, and I just wanted to see the band have a decent shot out there in punk-pop purgatory. "1985," of course, proved Bowling for Soup's biggest hit yet.

Immediately, I tried to differentiate myself from those Hollywood-type songwriters for hire, who would hang out with you one minute and be like, *"Oh! I've got to write with you! I can't wait! You're so great! You're so talented! Let's go nail some hit songs together! Um, what are you working on right now?"* "Oh, I'm working on the new _____ record." *"Oh, that's cool!"* Then they slink off to the bathroom, get out

their iPhone, and text their agents: *"Get me on that _____ record! Now!"* The next day, they'll be in the studio with the artist you're working with. It's just so gross, like, "Really?" I never did that; I never thought I'd have to. I never felt like I had to be *that* competitive to win, and I've done just fine; maybe you do have to be, but that just wasn't my speed. The only person I compete against is myself. Of course, I lose to myself all the time . . . Speaking of losing myself, let's go back to when I took that big sabbatical and decided not to do any more "me" for a while. Really, the moment when everything just all opened up was when I did a song with Simple Plan called "Don't Want to Think About You" for the soundtrack to the *Scooby-Doo* movie. Because of that, I ended up working with Avril.

Simple Plan had been on tour with their fellow Canadian Ms. Lavigne, who had sold around a gazillion records at that point. What happened was, she really loved Simple Plan—in particular, David, who's Simple Plan's bass player and the real muso in the band. David and I are friends: he's a great, passionate, and smart music guy. Graciously, David was all about me and praised my abilities to Avril. He was talking to her one night on the phone, and she was like, "What are you guys doing?" "Oh, we're in the studio with Butch Walker," David told her. Her response probably sounded something like this: "Really? Well, if Simple Plan is in the studio with Butch, *I* want to be in the studio with him, too." She remembered we'd met in her A&R's office; she was all about the poppy-punky sound, and she really liked the song that I'd cowritten for SR-71, too. The irony is, at that point in my life, I was not excited about that genre of music. I was, and am currently, so over it. After "My Way" didn't happen, I was like, "Forget this shit. I'm too old to be wearing eyeliner and having a funny haircut. I don't even play this kind of music anymore. I don't want to do it. I don't want to be a part of it. I just want to be the singer-songwriter I know that I really am." I needed to go back to writing quirky power-pop songs—something I knew how to do,

and with no pretense whatsoever. So, naturally, I went into the studio with Avril.

Avril had a short break from the road, so the label flew me to New York to go into a studio with her to work on three songs. Except for the fact that there were no songs. *Nada*. However, she and her guitar player, Evan Taubenfeld—whom I love and who is a good kid—had three song *ideas* they'd gotten together: they were incomplete, though, without all the lyrics. I remember listening to these demos, thinking, "Oh brother! What are we doing? These are great song ideas, but . . . What am I going to do?" Basically, I had four days to make three singles for Avril Lavigne out of . . . not much. And working with someone like Avril was still uncharted territory for me. Keep in mind, I was not a pop producer at the time; I'd come from rock and metal. I didn't do things conventionally—that is, "Oh, we'll just get the singer to sing it twice, and then we'll take the vocal, Auto-Tune the shit out of it, create our own melodies, and then put a really bouncy, computer-generated beat and bass line behind it, full of drum machines and synthetic sounds." I had never done that; I knew nothing about that way of recording. I only knew about recording completed songs with real drums, real amps, real guitars, and real microphones, where the singer sings until they get it right; I never even knew how to use Auto-Tune. It scared me. I thought it was a little too Stanley Kubrick, post-apocalyptic, "end of music as we know it"–type shit. Boy, would I go on to be wrong about that. Years later to come, the whole pop-music world would be, um, "reinvented" by the sound of what one can only describe as Ke$ha and T-Pain screwing on a slot machine in a casino at two A.M.—but this is a rant for another time.

Back to Avril: I had to sit her down and finish writing these songs with her. However, Avril's manager at the time was very cutthroat and dickish; he told me, "You can cowrite the songs all day long, but you're not getting any publishing credit on them." At the time, Avril was going through a scandal: she was claiming she had written songs

that a producing/songwriting team known as The Matrix was also taking credit for. Because of that situation, Avril's management wanted to be very clear from the start about who was going to be getting songwriting credit—i.e., not me. Still, even though I was getting ripped off, I wanted to do it. I'd never gotten to produce something so big: it was possible I'd have some tracks on a multimillion worldwide seller. In the end, I helped cowrite the lyrics to the bridge of one of the songs, and helped with the other lyrics for the rest. Miraculously, I got all the songs finished in four days, and Avril loved them. They came out great—and then I didn't hear from her for a very long time.

About six months to a year later, Avril finally got off her tour, and I heard she was working with fifteen other producers on her second record—all folks who had hits out at the time. I just wrote it off and went back to metal, producing a Sevendust record, which came out great, and went on to be critically praised and liked by a good bit of people. I knew the Sevendust guys since I was sixteen years old, from the heavy metal band scene back in Atlanta; the demos that got them a record deal, I actually produced in my mom and dad's garage. Now, living back in Atlanta, I'd set up my first real studio there, in the process kinda starting my own business. I was enjoying life as a working producer, writing and producing for acts. I think I may have even tinkered with the idea of making my own business card . . . Kidding.

I eventually did hear from Avril, though, not long after I'd started working on my second solo album, *Letters,* which would come out in 2004. She left me a message: "Hey, Butch, how are you doing? This is Avril. I'm working on my record in L.A. and it's almost done, but the label still thinks that the best stuff is the first demos we did together." In particular, the label thought that the song "Don't Tell Me" might be the first single. Of course, that's one of the songs that I cowrote the bridge for, a song that I wasn't allowed to get any publishing or credit for.

"Don't Tell Me" would indeed ultimately become the first single for Avril's second album, *Under My Skin,* which came out in 2004.

But at the time she was making it, Avril, ever ambitious, was deter-
mined to keep pushing. "I think we can beat it," she said. "We can do
a better song than that, for sure." She wanted me to come to L.A. and
help her write a song, so they flew me out to L.A. Before that hap-
pened, however, I had to lay down the law. "Okay, first, the label and
your management decide that the song that I cowrote that I don't have
any publishing credit on is the big first single," I said. "And now you
want me to come out there and do another song with you, and write
it from scratch? Obviously, the playing field is going to be different
this time." I'd gotten some songs under my belt at this point, so our
respective management teams had some discussions and worked it all
out. In fact, we ended up working on several songs—in particular,
one called "My Happy Ending" would become the biggest song I've
ever worked on. Even when we first finished a rough version of that
song, we both knew it was going to be *huge.* "This is the one," Avril
said. "We got it."

I definitely thought "My Happy Ending" sounded like a hit while
we were working on it, but it's weird. That song came from this kind
of stoic piano ballad that I'd been saving for myself, written in a low
key, with these very Jeff Buckley, minor-chord verses. I used to play
it for Nora: it was real pretty, but I couldn't figure out a chorus for it.
I was like, "Whatever—I'll figure it out one day." And I did. On the
day that I played it for Avril, everything came together: I played it on
guitar instead of piano, and higher, in her key. By the time Avril and
I figured out what to do in the chorus, the song suddenly made sense.

"Don't Tell Me" always remained the leadoff single from *Under
My Skin,* and I was pretty happy with that: I'd produced it, it went
Top 10 at pop and was a hit. I never was able to really get paid for that
one, but the next single was "My Happy Ending," and it went straight
to No. 1. Ah, my first No. 1 . . . That was definitely a big deal for both
of us, actually: that was going to be the big one, and we cowrote it
together from scratch. That was the first time Avril could truly be able

to say she was "right" to her record company, which gave her new power. She had picked "My Happy Ending" as a single, was correct in her choice, and was very excited about that. Avril called me, screaming and flipping out when "My Happy Ending" reached No. 1; I might have screamed and flipped out a little, too. I couldn't believe all this just happened out of nowhere. All of a sudden, I was getting calls for big jobs: I was now a "pop" producer. How did *that* happen? In the disheveled words of one David Lee Roth, "When life gives you lemons . . . Stick 'em down your pants!"

Yeah, it's funny: when I finally stopped thinking about myself for once, that's when everything started happening for me. I was also able to really find myself as an artist again. I felt like I had lost the plot, just trying to bridge a gap of desperation. Until that point, I hadn't really changed much at all, and anything from my solo career sounded like it could have been done with Marvelous 3. Then again, it had always kind of been my egg to fry in the studio; I was so heavy-handed, I rarely let anyone do the cooking. Believe me, if I could have played the drums as well as Slug, I would have probably tried to play the drums, too. Goddamn control freaks: I was just always able to say, "Everybody play *this*! Everybody do *that*!" Then I would sing all the leads, do all the backgrounds, and come up with all the parts. You kind of had to get out of my way in the studio, because I just wouldn't stop—I would steamroll over anybody, including the producer, which was why I needed to have a pretty passive coproducer if I was going to have to work with someone else. Jerry Finn didn't have any ego: he would be like, "Okay, that's cool." I knew it would be good if I'd be allowed to just do me. I remember having a conversation in my manager's kitchen with the guys in Marvelous 3 about the way things were going to be. "This is not SouthGang, this is not the Floyds, this is my band," I said. "This is not a democracy." Wow, what a dickhead I was. I had a perfectly good chance to ruin our friendships in Marvelous 3 with the way I acted, the way I treated my bandmates, and the way I

definitely controlled everything and everybody. There was tension for sure, always; that's my biggest regret, actually. The mistake that I made was that I'm just such a proud and driven person, and I've always been that way. I've always had this lion's pride, not letting people run over me or get in my way, laughing in the face of adversity. I couldn't deal with anybody else trying to get in the way of that. I told those guys later, way after Marvelous 3's breakup, how I appreciated them being so great when I was such a prick. Maybe, you have to be a prick sometimes to make things happen; I think they knew that (but they still should have beaten the shit out of me). We continue to see each other: we get together and have dinner, and two-thirds of it is just drinking and talking about the good ol' days. Our good ol' days go back to when we were fifteen years old, so there remains a lot of ground to cover.

Okay, enough with the nostalgic reminiscing detour. Back to the story. Then again, nostalgia and memory prove so central to *this* story—especially to songwriting. After the success of working with Avril, an irony had set in: I'd started getting calls to do all these records that, really, reflected more where I was five years earlier. I just wasn't feeling that kind of music in my bones anymore. Since I was a kid, I have always had such a sponge mentality, absorbing every kind of music and then trying to extract the good bits out of all of it. I also experience these periods in my life where I go through little cycles of nostalgia—where I really get back into a certain music that I loved growing up, and that music then reflects in my songwriting. That's what makes me . . . *me*. I definitely went through a massive Bowie-driven, '70s glam-rock phase, and that showed on my next record after *Letters,* 2006's *The Rise and Fall of Butch Walker and the Let's-Go-Out-Tonites*. I mean, I couldn't get any more obvious with the *Ziggy Stardust* reference in the title, could I? It was all pomp, but that's where I was at that moment. Musically and lyrically, it reflects where I was in life.

After *Letters,* I stepped back for a good two years, not doing anything until about 2003. *Rise and Fall . . .* was a knee-jerk reaction to Marvelous 3, and I was going through a post–Marvelous 3 depression. I was numbed from touring for years, numbed by so many things. I'd come out of a depressed state, with my first solo record not really mattering—and not really mattering to me anymore. Yeah, in the grand scheme of popular music, I was burned. One thing that helped me out of my funk was my band that I recorded *The Rise and Fall . . .* with. I was playing with new guys for the first time in a long while, and I was very excited about it. I was finally playing with a different drummer, a different bass player, and a different guitar player for once. I would get a little homesick for Slug and Jayce on some songs, and it wasn't the same, which of course the fans of your old band are going to say, too. But these were pretty amazing musicians playing with me, which made everything so much easier.

I was asking myself so many questions during that time. Was I living in the shadow of my former self? Was I always going to have to live up to people's standards based on what I *used to do*? Am I always going to have to hear somebody say something to the effect of "Man, why did you and your last girlfriend break up? I liked her better than your new one." That's how it feels when people are just not connecting to your art because they like what you *were* and not what you *are*. There's a romantic connection when someone first discovers something: they tie it to memories that happened during that moment of discovery. They liked your first band a lot, loved your first album especially, and can't really progress beyond that, because they lost their virginity to "Freak of the Week" in the back of their older brother's Camaro. And what I say to those people all the time is this: "Do you miss your hairstyle that you had when you were in high school? Because I liked you better in that hairstyle. I don't like this new hair you've got right now. I want you to have that horrible, teased-up, crazy hair you had when I first met you." That's how it makes you feel

when people say stuff like that—that is, the kind of people that wish they were still in high school, banging the head cheerleader.

That attitude weirds me out. I have to say, that's never been my modus operandi in life, and it's one reason I do have a problem staying in the same pants every year. I've constantly wanted to evolve, shed my skin, move on, and not look back. A lot of the artists I really admired did that as well: David Bowie, Prince, John Lennon, Neil Young. They chastised Bob Dylan when he went electric, but I have to say, I wouldn't have it any other way. When I finally realized I could change, it was a big leap for me. I thought I couldn't; I was really scared that I wasn't wanting to play wonky guitar solos any-more, but I kept overdoing it trying to prove my "rockness" to people. One thing I really always got indicted for was trying too hard—the image, the over-the-top stage show, everything. That was fun and shit, but I did feel sometimes like how I imagined John Cougar felt when he turned back into Mellencamp: he probably hit a certain age and thought, "My name is *'Cougar'*? That's so lame." I thought about this many times. See, Butch isn't my real name. Sometimes I hear my name in conversation and start freaking out: I'll look at the floor and think to myself, "That's not my real name. I'm a fake. I'm a phony." I feel more together now than I ever have in my life, whereas I used to definitely hide behind a facade and an image. " 'Mellencamp' doesn't sound very 'rock'—how are we going to sell that?" But now I get it. I know now why "the Coug" changed it back.

I was in a very lonely place. I'd kind of abandoned my band, and was now this guy who stood *behind* people, producing their records and writing songs for them rather than performing onstage. That was a big wake-up call, a slap to my ego: "Well, you know what, maybe I'm not going to make it big—maybe I'll always be just a mid-level artist." "Mid-level artist" is what they always call people of my ilk: it's both a compliment and an insult. We mid-level artists can sell a few records, sell out the midsize venues we play, keep our integrity, and

have our fan following all day long, and that's rewarding and gratify-
ing, sure. But it's also like, "Okay, maybe I'm not going to be this
massive Lady Gaga star on MTV after all." I was never the artist who
was on the right side of the fence, or the left, either; I was just always
on the wrong side, regardless of which one I'd chosen at the time. I
guess I'm not commercial and sweet enough to be Jason Mraz, and I'm
not awkward and cerebral enough to be Thom Yorke; instead, I pull
from both poles and come out somewhere, yes, in the middle. It's bet-
ter to be a mid-level artist than a one-hit wonder, for sure, although I
guess I'm both. I mean, I was in a one-hit-wonder band, survived, and
became a mid-level artist. I like it here. Record-label wise, I think I
always just tried to work with someone who really appreciated where
my particular brand of that middle ground was coming from. I wanted
them to know that they were taking a gamble of sorts: having a Butch
Walker solo album might not be, you know, the gangbuster unit-
shifter of the year . . .

Hey, I'm the one who shoots myself in the foot with a clever gun
all the time. It's not the label. It's not anybody else. For my solo albums,
I always did deals where I could definitely have a budget to make my
record the way I want, with no one telling me how to do it. That's
when I first started getting that kind of control, where I would say,
"Here's my record," and no one would tell me, "Oh, it's not done yet.
I don't hear a single. You need to do this, and do that, and this and
that, too, and work with this A-list producer of the moment." I'm sure
there's some contingent in the industry that might argue against that
approach: "Maybe if you would've listened to the direction we gave,
maybe you would have sold millions of records." I am modest enough
to know that's not true. There's no way I'm going to sell millions of
records. The music that I do probably doesn't fit into that queue that
people can be slotted into for the pop masses to be inundated with. I
don't know why; it just doesn't.

I definitely know what I'm getting myself into. Sometimes, even

to my face, I hear certain industry people say something to the effect of "Butch always gives away his best songs to other people." To which I respond, "What do you mean, my *best songs?*" That kind of person obviously thinks the best songs are songs that sell the most or get on the radio: they don't have the taste in music to actually hear and appreciate something that's a little bit less . . . *hit.* As I said before, there's a huge difference sometimes between a hit song and a good song. They can be both, sure, but the thing is, I know the difference, and you clearly do not if you're telling me that I give away my best songs. When people ask me, "Why would you give away your best songs?" I say, "Well, can you really hear me taking it seriously singing some of those songs I write for other people? If you knew anything about me as a person, you'd know that those songs do not fit my life at all." Even if I wrote 90 percent of a song for someone else, which is the case sometimes, it never would work for me as an artist.

I learned a valuable lesson when I went in to work with Avril on "My Happy Ending." I'd mentioned that I had written those verses as a stoic sort of piano ballad in a lower key; they are just not a typical cookie-cutter pop lyric. And when I sang that version to Avril during that session, it was a million words a minute, full of words she didn't even understand. When I got to the chorus, I just saw her cock her head to the side with this weird look in her eye, looking very confused. Seeing that gesture, I had an epiphany: I saw ten million little girls behind her cocking their heads with a quizzical look at the same time. At that moment I realized, "That's it! It's too damn smart. It can't be too clever." By *no means* is this an insult to people, but those who listen to pop radio really don't want to think. They're listening to the radio in their cubicle; they're listening to it in their car, because they need it as an *escape.* But there's also an ingenuity required to create that escape. When Avril blurted out, "On the chorus, instead why don't I sing, 'He was everything, everything that I wanted'?"—at first I was doubtful: in my mind, I heard myself saying, "Oh God, *I* would

never do that. That's too *simple,* too . . ." I then paused, took in what she said, and totally agreed with her: "Exactly! That's it!" And then, next thing I know, *Boom.* Lots of records sold. Avril had totally made the right choice, and my instincts were totally wrong. I needed to separate myself to make the right choice, because it was a song for Avril, not Butch or, er . . . Brad.

Actually, the blend of Avril's perspective with mine is what makes "My Happy Ending" work as a good pop song. That gives it its own little tension: it's not just a brain-dead pop track. I've had a ton of my indie snob friends come up and tell me, "That's actually a good song." And that's when I think, "You know what? *Exactly.*" The art in it is in learning how to marry the two. And that's what Epic Records, which I'd signed to for a solo deal after leaving Arista, wanted from me. I think they were wondering when they were going to get that record, that song, that *hit* out of me. It was like a game of Russian roulette for them: were they going to get a more "me" Butch record, or that big simplistic pop song with big huge hooks? Naturally, I gave Epic, you know, not the latter.

At the time, I was really listening to a lot of Elton John, and Bob Dylan—stuff like that. I really thought I needed to just make a singer-songwriter record, which is a nicer way of saying "major-label suicide." I got married right before making Avril's album. Nora and I had already been through a rocky spot during the Marvelous 3 era; by the time I started making *Letters,* our relationship was easy, comfy, good, and baggage-free, so when I got my first big paycheck, we went to a little island in the Bahamas and got married in front of absolutely no one. We were like, "Let's just do it." But instead of reflecting on my relationship with Nora for *Letters,* I drew from my past girlfriends and affairs, as well as the breakups of both my previous marriage and Marvelous 3. In a song like "Maybe It's Just Me," the lyrics pertain to being partners in a band, having to let go of a fifteen-year relationship together, knowing it will make us happier and, in the end, help us

remain better friends. Those emotions just so happened to parlay into a kind of romantic breakup song. I didn't want to hide behind noise; I wanted people to hear that I had lyrics with something to say.

I basically had been off the scene for so long, and now I was back with a new record that was definitely more heartfelt and personal; this time it wasn't my snarky tongue-in-cheek default mode but something hopefully more raw and intimate to confuse my fans with. I had to relax a little bit and let go of the idea that I needed to hang on to this segment of fans—I needed to stop being afraid that I was going to lose my rock audience. I've always had this mixed-up fan base: some people are into my singer-songwriter stuff, others are into my power pop, a few are emo, the occasional indie snob downloads my stuff on the sly—and then there are total rock heads, the lifers who have been with me since SouthGang. I haven't played music like SouthGang's for nearly two decades, and they're still there to this day at my shows, waiting for me to play "Tainted Angel." *Letters* was never going to please that bunch—it sounded like an ELO record maybe, or *Captain Fantastic and the Brown Dirt Cowboy,* but definitely not *Pyromania.* With *Letters,* I realized, "Well, I'm going to just have to admit the fact that I will probably need to rebuild my fan base." And that's exactly what I did. I went out in a van and started over from scratch—just me playing acoustic guitar, plus Kenny Cresswell playing percussion and acting as road manager. There was no road crew, nothing; Kenny and I took turns at the wheel, actually. After ten years in a van, I was back in the driver's seat.

On the *Letters* tour, I was playing much smaller places than I'd played in a while, 100 and 200 capacity rooms—coffeehouses, even. When we hit the New York stop, I played the Village Underground to 150 people; today when I play New York, things are way better and I can play bigger halls and sell them out on a good day. I built it back up again, brick by brick, fan by fan. I loved it: it grounded me and got me back to making a connection with my *real* fans. Those people really listened, they did, and they must have heard some outcry. I felt

so much darkness in that period from the shock of my just letting go of everything. For once I let go of the past, I let go of my old band-mates, I let go of everything, and it was the first time I felt I could breathe. "Well, this is a weird place to be," I thought to myself, driving to the next town at five A.M. with Kenny passed out beside me in the passenger seat (or maybe it was the other way around).

The fringe benefits were drying up—I wasn't getting the free shoes in the mail from Puma anymore, or the instrument sponsorships I had when I had a hit on a major label—but I was free, and you could hear that fact every night onstage. As a result, to this day, I think the majority of my real fans joined my little traveling party because of that record. I lost all the casual fans who only liked Marvelous 3 because we had a single on the radio. The shows on that tour were better than any shows I've ever played with any band. The crowds were better than any crowd I've ever played to, as well. Everyone sang along to every word; I'd never experienced that before.

It was easy to sing along to songs off *Letters,* like "Best Thing You Never Had" and "Mixtape," both of which became popular concert songs for me. The latter came into existence because my sister gave me a mix tape when I got on the plane to move to L.A. for the first time so many years ago; what inspired me anew was that I found my sister's mix tape again and thought that'd be a cool song title. I made "Mix-tape" into a story about a guy and a girl—in particular, how the girl would never talk to the guy, because she was in love with someone else. It was, you know, one of those "I think we should just be friends" scenarios; I was absolutely channeling my inner Lloyd Dobler on that one. The weird thing is, when I put that record out, that's when emo exploded, and I knew nothing about it. I had no plans to be lumped into the same category as any of those bands; I was way older and had none of the same influences. But it just so happens that emo dates back to Elton John or Jeff Buckley, and those other singer-songwriters who wrote hopeless romantic love songs. Like, well, me . . .

"Mixtape" was weird. It is definitely my second "banana" after "Freak of the Week," but it never charted. Still, it ended up being one of my biggest near hits, at least in terms of influence. Avril loved it, and all these other people wanted to work with me because they liked that song. I remember a funny thing from the time around when I put that record out. I was producing this band called Midtown; Midtown's singer was Gabe Saporta, who is now famous for being in Cobra Starship and writing the *Snakes on a Plane* theme. Cobra Starship makes probably the most shtick-laden party music ever, but it's so great and fun; even better, Gabe knows that. But the Midtown album I was doing with him was this really serious, important-sounding rock record—all very intense, with every song about the end of the world. It was *so* intense and pretentious it was almost ridiculous; I was like, "Gabe, get over yourself." And Gabe was such a chore sometimes to deal with. I loved him, but he would always run his mouth and make me so mad I ended up hitting that guy in the stomach as hard as I could on a daily basis. In particular, if he wanted to wind me up, he would come in singing "Mixtape" all snotty and mockingly. That became the song everyone would associate me with, to the point where I don't really play that or "Freak of the Week" live anymore. "Mixtape" was another banana, and I just couldn't stand the taste of banana anymore.

Yup, "Mixtape" made me a 1.5-hit wonder. It did marginally well—it wasn't a radio hit by any stretch, but it appeared in all kinds of movie and TV soundtracks, and just got used for everything. Over time, "Mixtape" became a semi-staple youth relationship mini-anthem, and I was proud of that. I remember when Avril asked me to go on tour and be her opening act, she was all into that song. Funny enough, I have a version of Katy Perry singing "Mixtape."

A couple of years before anybody knew who Katy Perry was, she came up to me at the Hotel Café, which is an intimate venue in Los Angeles. She used to hang out there, believe it or not, in the singer-songwriter crowd—not in the dance clubs, as her whole persona

would indicate now. Anyways, when I met her, Katy told me, "I love your stuff—I've got to work with you, and you need to work with me!" At the time, she was signed to Columbia, having been discovered by this real seedy A&R guy there. I had already done two albums for Epic, which was a sub-label of Columbia, and was working on my third for them, *The Rise and Fall of Butch Walker and the Let's-Go-Out-Tonites,* so Katy and I were kinda label-mates.

Donnie Ienner, who was chairman of all the Sony Music labels (including Epic), supposedly loved "Mixtape" and would completely berate his staff for not breaking the song at radio. "That song is a hit!" Donnie always used to yell. "We need to cut that song with somebody else *now!*" Of course that's when I got the call from the A&R guy, who was like, "You know, I've got this artist Katy Perry, and I want to cut that 'Mixtape' song with her." I was already working with her anyway: I produced two songs, "One of the Boys" and "Thinking of You," that would eventually come out on her first solo album and sell really well. But not before we would do "Mixtape." I have a version of her singing it solo, and then a version of her and me doing a duet. Neither got released, because Donnie Ienner mysteriously vanished from the company, and Katy was dropped soon after. A gentleman I'll call Chuckles the Clown became the label head around this time, and while I loved Chuckles's used-car-salesman style on the one hand, he was completely ridiculous in his own way as well. Soon after Chuckles's reign began, we were in a meeting together, and the subject of female artists came up, in particular how cluttered that pool was with all the various Michelle Branch and Avril types. At one point, while he was buttering my ass and offering me my own label and production deal, Chuckles said, "Yeah, we got this artist Katy Perry, but she's never going to do anything. We're going to drop her." He had no idea that I had just worked on Katy's record, nor did he fathom her potential for stardom hugeness. "That would be a mistake," I told him. Sure enough, as soon as she'd been dropped by Columbia, Jason Flom signed Katy to Vir-

gin/Capitol, and this time she survived the transition when Flom got the inevitable boot and Rob Stevenson took over (running a record company just ain't winning any awards for job stability in the "new economy" these days). Both Jason and Rob knew that Katy's record was a hit waiting to happen, and indeed, "Thinking of You" became a Top 10 single, if not the monstrous smash that "I Kissed a Girl" was.

I knew the minute I met Katy Perry she was definitely a star: sure, she's physically attractive, but more than anything, she's *compelling,* with total charisma. That was clear well before anyone was concerned about her kissing a girl. Before she got her new record deal, I'd always run into her out in Hollywood. She'd be at all the shows that everyone was supposed to be at, and we'd sometimes have a drink and shoot the shit. She'd be at these concerts by herself, which I liked, because I was usually there by myself, too. I never see people out by themselves; everybody's got to have their security blanket wrapped around them, it seems. But Katy was always alone, raising hell, screaming and jumping up and down with excitement. She was really paying attention at these shows. I remember when we were standing next to each other at a show for a band called the Sounds, and the lead singer was really taking over the room; seeing that, she said, "I want to be that!" From what little I knew about her, Katy had lots of ambition.

My ambition, meanwhile, drove me to make another solo album. The writing of *Letters,* my second solo record, which came out in 2004, was inspired by a box of old letters that I found while rummaging through my old things. Those were letters I'd gotten over the years from fans, which inspired all these stories I turned into songs. The literal context of the album came from "Joan," which has become one of my most favorite "fan" songs: "I went to the closet to get dressed for work/When I spotted a box I had not seen before/With all kinds of letters that never got sent/To a guy in Colorado, since 1994/ And I know it's wrong/But I sat and opened, in no certain order/A letter or two . . ."

Nora's mom, Jeannie, was also on my mind: she'd become termi-
nally ill with cancer the entire time I was beginning my solo venture.
I loved Nora's mom. We had developed a great relationship over the
five years Nora and I had been together; I wrote a song, "If (Jeannie's
Song)," inspired by her on *Left of Self-Centered*. Nora had already lost
her dad to cancer, and they had been very close, so losing her mom
too was an especially painful blow. Her entire family is very close, so
we were all together the night before Jeannie passed away: she couldn't
speak and was already in a half-conscious state. We all kind of took
turns at her bedside, saying good-bye: each of us went over and had a
private final conversation with her. When it was my turn, I went over
and whispered in her ear that I was going to ask Nora to marry me the
next day. In response, I could hear Jeannie kind of whimper, which
was amazing, as she couldn't talk or open her eyes; at least I got a reac-
tion out of her, which seemed to be a nod of approval. The following
morning, which happened to be Christmas Eve, Nora's mom passed
away. And that day I got the wedding ring that had been given to
Jeannie by Nora's dad; I got it from Nora's brother, who wanted me
to present it to her. I gave Nora the ring on Christmas morning. She
said, "Yes."

Jeannie's passing and the events that followed inspired one of my
best songs, too. While I was happy in my new marriage, *Letters* still
documented my going through a catharsis. I had to figure out how to
be an adult again—how to grow up, move forward, and move on;
that's why there's a little bit of sadness captured on that record. *Letters*
definitely represented a new coming of age in my life. I listened to it
again recently, and I'm really proud of it; there are lots of great moments
there. "Thank-You Note" is the last song on the album, which I wrote
as a tribute to Jeannie right after she died: it's my little diary of watch-
ing what her daughter was going through as she filled out all these
thank-you cards to people who attended the funeral. It was an after-
thought: when I delivered *Letters* to my manager and label, I was

freaked out, because I didn't think anybody was going to like it—and it was so personal, if they didn't like it, clearly it was *me* that was the problem. But when my manager, Jonathan Daniel, heard "Thank-You Note," he told me, "This is the best thing you've ever done."

I first connected with Jonathan Daniel around the time of my first solo album. I already had the record done and a deal in place with Arista—and no manager. After the last Marvelous 3 album, my manager Nancy and I severed our ties. It was a pretty amicable parting: I really just felt I needed to break with my past and do something new, and I had choices. All of these managers were calling, because, hey, who doesn't want to be your manager when you just signed a new record deal?

I remember getting pressured particularly hard by this one manager who claimed he managed the "greatness" known as Nickelback. Well, this guy did and he didn't—a young kid really did most of the day-to-day work and had actually discovered the holy grail of Calgarian nü–butt rock; the guy who was courting me, however, was the main older dude at the company and would just take credit for whatever the young kid did in his office. He was really aggressive: when I played the South by Southwest conference, he flew there to try to sign me. And he was wearing leather pants. Let me say again, he was wearing *leather pants:* that sealed the fact that I would never work with him, right there. Mr. Leather Pants kept dangling in front of me that he was able to get me on tour opening for . . . you guessed it . . . *Nickelback*. I told him, "Don't you get it? I make *fun* of those kinds of bands. Why would I care about that? Have you even *heard* my new record?" Then I met Jonathan Daniel.

Jonathan really understood my vision, and what I wanted to do in life. When we met, he was managing a band called American Hi-Fi, whom I was friendly with from playing the same festivals together back in the Marvelous 3 days. As a matter of fact, I met Jonathan when I hung out with American Hi-Fi for the first time, when we all played

one of those festivals in Atlanta. Marvelous 3 had played a secret show at the Cotton Club the night before, a "fans only" thing, and Jonathan and the American Hi-Fi guys showed up. I don't really remember meeting Jonathan that night, to be honest with you, and there are probably a lot of reasons for that. He's very quiet, and I was probably very . . . loud. I could be a bit much to deal with back in the day.

Later, however, we got together via the guy who had done the groundwork for my Marvelous 3 deal with Elektra Records, a guy named John Hecker. Hecker had a company called Hi-Fi Recordings, which was an imprint he ran through Elektra Records. Spacehog was Hi-Fi's flagship act: I loved Spacehog, and I loved John. He was this really loud, rude, extremely metrosexual rich kid from New York; he'd grown up very upper-crust on New York's Upper East Side, of course, and inherited tons of art from his art-collecting parents. John had the coolest office I'd ever seen—the perfect lair for slaying a band: vintage Playboy pinball machine, bar in the corner, skylights, right on Broadway in SoHo, with originals of those famous Weimaraner dog portraits by William Wegman hanging on the white walls like a gallery. It was such a rock-and-roll environment—just perfect. I never, ever saw John's wife, but he had a slew of pretty girls working at the office. I saw them and was like, "This is awesome! I'm in."

He had the gift of gab to the sky, Hecker. He came to see Marvelous 3 at the Continental in the East Village, right around the time when shit was just starting to happen for us. We were starting to get deal offers; by then, a couple of them were already on the table. Hecker was crafty. After our show, he had a napkin that he'd taken from the bar, on which he'd written "Anything You Want" with a dotted line underneath for me to sign! It was so ridiculously '70s: Hecker's mentor was Seymour Stein, the notoriously colorful cofounder of Sire Records, which was perfect. He talked like Seymour, he idolized Seymour, and he did business like Seymour; he just didn't have the power of Seymour, but he had moxie, and pimped out the whole Elektra

Records situation. I alternately loved and hated him throughout our entire tumultuous relationship together. But one of the great things Hecker did do was introduce me to Jonathan Daniel.

When I was going solo for the first time, John Hecker of course had to get involved in my record deal somehow. He was very upfront about it; he wanted to be with me for life. I kind of told him I wasn't sure if I wanted to continue doing business with him, but, regardless, we were still friends, and he proved he really cared about me underneath all his flash. I had my deal at Arista in place, but he said, "You need a manager. Talk to this guy, Jonathan Daniel. He's right next door to me." And so I just walked to the office next door, and Jonathan and I had a nice little sit-down. Jonathan was already familiar with my work from back in the day. He didn't reveal his own secret past from the Sunset Strip metal scene, however: we didn't even talk about that stuff until later—he certainly didn't say, "Yeah, I was in Electric Angels and Candy and all these other bands." I had to discover that on my own. But it was great. All I knew was this guy spoke very wisely and had a very Zen demeanor. He was really just starting out as a manager; American Hi-Fi was just taking off as his first big client. He would later be known as the architect of the emo invasion, the mastermind behind the comeback of roots-rock group Train, and a pioneer in developing the marriage of music and Internet—but our initial meeting was way before Jonathan worked with Fall Out Boy, Panic! at the Disco, Train, or Gym Class Heroes. All that stuff really would come later.

Indeed, Jonathan wasn't that ballin' at the time; in a way, I took a big chance on him. In particular, I was impressed by his honesty. "I'm not going to have the political pull that maybe some guy like Joe Nickelback has," he told me outright. "Look, I don't really care about being with this guy who manages Nickelback," I responded. "I don't really listen to that band. I kinda feel gross listening to that kind of music. They think it's all about radio; I don't give a shit about radio. I want to be an artist." Jonathan got where I was coming from; of

course, now Jonathan does have that pull. He's got all of it, and that's the beauty of all of this: that power came about via natural selection—it happened organically. I remember Jonathan saying, "I know what you are and I know what you need to be. I know you don't know it yet, but I know it. I'd like to help you do that—I'd love to manage you." Of course, I was still very full of piss and vinegar and didn't take shit from anybody. "Well, I don't want to do any contracts," I said. "I'm not going to sign a management contract." To which he responded, "I don't do contracts. If you don't want to work with me, why would I want to work with you? Why would I want to keep you? That would be weird." After that, I was thinking, "I like this guy." There was a mutual trust, a mutual understanding right away. And he was tolerant of my ways of a beaten-down dog—something that would take years of training to overcome.

That's the beauty of all this. The other guy in leather pants yakked my freaking head off about everything he's done, giving me his whole résumé and all of his accolades within five seconds of meeting me, like most managers do. (Note to "industry types": stop talking about yourself and everything you have done and listen to your artist. Nothing shows insecurity flaws like a braggart.) But Jonathan, he never bragged. He didn't mention, for example, that his brother was one of the key developers of the Web browser Netscape. Jonathan was also one of the principals involved in Big Champagne, the Internet research company that changed everything in the music industry. All of the radio stations ended up using Big Champagne so they could find out what the hell to play: they were actually finding out what the real kids wanted to hear, and that's when everything changed completely.

I was tired of the Darth Vaders, and Jonathan was more like Yoda. The other beautiful thing is, he didn't even start out as my "producer manager." There are a lot of companies that do nothing but manage producers and songwriters, but not the artist side. I actually had a "producer manager" for a while, and he did nothing for me except tell me,

"You know, you need to produce more records. Your artist career is never going to do anything." Dude was really that brazen. And it was a conflict of interest, because Jonathan wanted me to be an artist, which I felt was a testament to the fact that he wasn't in it for the money, or he would have been strong-arming me to do more producer gigs (which was the only place I could make real money). But sure enough, I left my producer manager, and Jonathan's overseen everything ever since, which is the only way it can work. Jonathan's atypical. To quote the greatly misunderstood Kim Fowley, Svengali of the Runaways, being a manager means "being a football coach for the criminally insane." Basically, managers usually are just coaches for a big football team of musicians who need to be steered down the right side of the playing field or they're going to get tackled. That's pretty much the cheesiest analogy I can give, but it's totally on point. A lot of artists are only artists—they don't grow up with business sense or do the right things. People know they can manipulate artists, and managers are supposed to protect them from that. But a lot of managers have only their pocketbooks at heart: they're trying to do things for their clients that aren't necessarily smart career-wise, but are what's right for getting the big money on the quick. Jonathan, however, was very fair with me—he told me he didn't want me to do things based on money.

I thought that was amazing and weird for a manager to say. For him, it wasn't about going out and getting a bidding war going, or making deals bigger just so that he could make more percentage money. I see this happen all the time. The thing people forget is that most artists are single-shot rifles: we typically get one shot at this, and that's it. Managers, on the other hand, are AK-47s—they get a whole bunch of shots at the target. They can just keep firing off record deals and finding new talent, redoing and recycling, getting record deal after record deal for artist after artist. There's got to be a lot of understanding between the artist and the manager on what needs to be done, otherwise it will be this huge conflict, because they get a per-

centage of gross revenues. Smart managers like Jonathan understand that if you're growing as an artist, everyone's going to make money.

I'm a mid-level artist, somewhere between flop and big-time. Except for the fact that record sales in general have gone down dramatically since I put out *Left of Self-Centered* back in 2002, I sell about the same amount for every record I release. 10,000? 80,000? I have no idea. My live show attendances, however, have done nothing but increase every tour, and that indicates the audiences are getting the music from somewhere. I don't care if they're getting it for free, and that's probably how they're getting it; they're coming to the shows and singing along to every word, so they must be into it. They're just not all buying records anymore.

I think I sold the most records when I was touring with Avril—it was some kind of osmosis effect, I believe. A lot of people asked me, "Why did you want to go on tour with a *pop star*?" To which I'd always respond, "Well, because you would if your band got offered the chance." I mean, if Slayer called and said, "Do you want to go out and support us?" I'd politely decline, because I wouldn't live to see the end of my first set. But how hard can it be playing to a stadium full of thirteen-year-old girls every night? All I've got to do is just sing well, make sure my pants are tight, and see how it goes. Sure enough, for a lot of those girls it was their first concert ever, and their parents were there with them: I was literally the first live band many of them had ever seen, as I played first before Avril went on. It was great. I had lines down the hall at my merch table after my set: I've never sold that much merchandise and/or records in my entire life. This was an amazing musical experiment that paid off pretty well. Thanks, pop audience.

Touring with Avril, I had a lot of fun, considering I was old enough to be her dad. The only thing I had to really compromise a little bit was making sure I didn't cuss like a sailor, as I normally do onstage. I

also kept the stark piano ballads to a minimum, and just banged through thirty minutes of all my up-tempo jams. And you know what, it was awesome—what happened was exactly what I hoped would happen. Those girls grew up; now they're eighteen or nineteen, smoking cigarettes, drinking beer, and coming to see *my* shows.

Before Avril got onstage, I was playing for half an hour, with half of the sound system's available output and no fancy light show, to 15,000 or 20,000 people a night. Shows that size are a logistical nightmare; there were certainly some *Spinal Tap* moments scattered throughout the experience. Sometimes we literally got janitor closets for dressing rooms; usually my name would be misspelled as well— Brush Watkins was a classic, or Bush Walker, or Bug Williams. I'd see that and think, "Really? Awesome. I've *made it*." There were a lot of humbling moments like those on the Avril tour. It was a little weird that I was there, as there was such a generation gap between all those kids and me. I would say certain things on the microphone and they wouldn't get it; then I would play a little bit of a Kelly Clarkson song and *they would lose their little minds.* The scene at the signing booths was really weird, too: it would be mothers, who were around my age, and their daughters. Some of the moms even told me, "I partied with you when you were in SouthGang back in 1989!" I'd hear that and just look at the daughter and think, "Is she *mine*?" Weird stuff like that happened all the time, and I realized that's why I do all this. I mean, it's pretty funny that I can be taken seriously by a teenager *and* I might have actually slept with her mother twenty years ago.

Ah, the past . . . Moments like those reminded me of a different time in the music industry. By 2004, when I'd put out *Letters,* the definition of what exactly constituted a hit was clearly shifting. Definitely, people were starting to put more merit on getting songs on TV and less on radio. I was paid a lot of money to record the theme song to that Richard Branson show *Rebel Billionaire,* which was a cover of "Live and Let Die" by Paul McCartney and Wings.

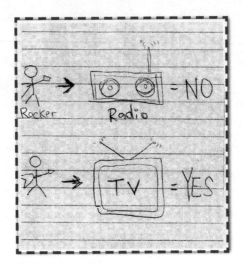

It wasn't even my song, but I cut it in just one day and I got a lot of money. Radio didn't matter as much, especially terrestrial radio; I never really fit in on the airwaves, anyway. I wasn't "good boy" enough for pop, and I wasn't "bad boy" enough for modern rock radio. TV was becoming the best place to get your music heard by a wide audience, but I also just never placed a lot of merit on TV for writing a record; so many songs these days sound like they were written primarily to accompany a climactic scene in *Grey's Anatomy*. Now it's too hard to get on TV. It's so competitive and cluttered: everybody wants to get their artist or song in a show or commercial. It used to be sacrilege—the ultimate sellout—to allow your song to be used in a car ad; now, even indie-rock *artistes* like of Montreal gladly let Volkswagen not only put their song in a commercial, but *change the lyrics*. More power to you, Kevin—pay that rent, boy!

Around the time I made *Rise and Fall . . .* , I met a person who would become one of my best friends in the whole world: Alecia Moore, who is better known by her stage name, Pink. We were first introduced when I was staying at the Chateau Marmont, the storied Hollywood hotel that became my second home; even when I was liv-

ing and running a studio in Atlanta, I ended up in L.A. half the year anyway. I'd actually wanted to work with Alecia for a long time, because I just thought she was an incredible singer. I knew she would be an amazing performer in the studio, but I didn't know what kind of person she would be. Obviously, I'd heard many stories: she had this reputation of being a partying, hell-raising wildcat—someone who takes no shit but gives a lot of it. Truthfully, I didn't know what to expect. I knew she'd had a dramatic success at a very young age, and not everybody handles that situation well. I would find out, however, that Alecia is one of those people who handled it superbly.

I found this out when we met about my possibly writing with her for a new Pink record, which would eventually be titled *I'm Not Dead* when it came out in 2006. There was considerable pressure around this collaboration: *I'm Not Dead* would be Pink's follow-up to her 2003 album *Try This,* which, even though it ended up selling six million copies worldwide, was considered a commercial failure after her previous effort, *Missundaztood,* was such a smash success. She had been working with some other people for her new album and had heard good things about me, but wanted to meet me first; I liked that, because I am a firm believer in meeting with someone before you work with them. I'd had experiences recording where I didn't know the person before, and halfway through recording I wanted to kill them.

I knew, too, she had been responsible for the industry resurrection of songwriter Linda Perry. Before Perry wrote smashes for Pink, like "Get the Party Started," she was considered, like me, a '90s alt-rock one-hit wonder (for the 4 Non Blondes' single "What's Up"); after Alecia chose her as her primary cowriter for *Missundaztood,* however, Perry ended up working with Kelly Clarkson and Christina Aguilera, and is the person responsible for foisting James Blunt onto pop culture. However, when Alecia and I met, she was on bad terms with Perry.

Our first meeting was at the Chateau Marmont's restaurant. She was there with a bodyguard and managers, because she was going

through a stalker situation at the time, but I'd have never guessed that from how relaxed she was. When I entered the room, I saw she was already seated in my favorite corner, which I took as a very good sign. As I sat down and introduced myself, she kind of squinted at me, then asked if I like to drink. "Oh yeah," I said. "I love drinking, and I'm good at it." "Do you like red wine?" she continued. "It's my favorite," I responded. "I consider myself to be a wine snob." "So do you like Châteauneuf-du-Pape?" And I was like, "I love French wines, and that's one of my favorites."

Two bottles and a bunch of laughs later, we'd become very fast friends. It was just us at that point: Alecia had shooed away the managers and all that, and we'd taken our drinks down to the pool area. As we were walking, she was holding a glass in each hand when she missed the step going down to the pool: she fell down the stairs, skinned her knees, and landed facedown—and somehow she didn't spill a drop of our drinks. Instead of having a diva fit, she was just cracking up and laughing hysterically on the ground with a horse giggle that was so cute. I loved that she saw the humor in the moment—and kept her wine from spilling a drop. "You've got good priorities," I told her.

So anyway, after that she came to my room and played me some stuff that she had been working on with other people, like Billy Mann, whom I love; he'd cowritten the biggest hit on *Try This,* "God Is a DJ." She played me two new songs she did with Billy, "Dear Mr. President" (which made me cry) and "Stupid Girls" (which made me laugh). It was so important for a hilarious, awesome song like "Stupid Girls" to come out and lacerate the celebrity Paris Hilton bullshit culture of the moment, and Alecia was just the person to do it. Soon enough, I'd be in the middle of that mess myself . . .

I realized after listening to those songs that Alecia was not just a pop puppet. "Dear Mr. President," when I heard it, gave me the chills: I teared up a little bit, because I realized my religious, social, and

political beliefs definitely lined up with hers to the fullest extent. Hearing that song, I thought, "Man, this is amazing and bold, and it's important to release this." I started to feel kind of inadequate and told her so: "What do you need me for? Why am I here? You've got already a great start with your songs. You don't need me." However, by the end of the night, she went into this worn-out old backpack that was haphazardly taped together, and pulled out all these notebooks. I was worried that they were full of really bad rhymes and horrible adolescent poetry, like a Linkin Park lyric—"I hate my life today/Nothing is going to be okay"—or something. The notebooks looked like they had been around for ten years: they were covered in stickers and scribbles from when she was in junior high. These were Alecia's songwriting books, full of lyrics. As she was doing this, I thought, "Wow, this is not normal. I'm not used to a pop star actually *writing* and having *books* of lyrics." As she flipped through them, she said, "I don't really know you, but I can tell that you're the person I want to share this with." She handed me one particular notebook and said, "Take this: I want you to see if you can come up with anything for this one song idea I have that's in the back of the book." I found it really odd, and very trusting, for her to just give me, a stranger, this book of private information and confessions. Little did I know how moved I would be by what I'd read in its ink-riddled pages.

I was going on vacation the next day for a week, after which we made plans for me to come back to work with her. I took Alecia's notebook with me and sat down to read it on the beach. It's funny—I later wrote a song that Alecia would eventually sing with me, called "Song Without a Chorus," which I wrote on the beach about writing a song on the beach. It goes, "Well, there's sand in my book from writing on the beach/Trying to find a song for you that the ocean can only reach/And this beach is getting wider than my train of thought is long/And each little grain of sand is some other asshole poet's song." That was me, actually writing my own scribblings while reading her

book. Flipping through the pages, I started getting chills as I absorbed her words. Quickly I came up with a chorus, and soon was able to take her musings and retrofit them into a song that would become "Long Way to Happy" off of *I'm Not Dead.*

Back in my room at the Chateau, I played the music for her while singing over the top of it. As I played, I could see she was getting goose bumps: that was the first thing we ever did together, and it was obvious we had a powerful connection. This was at a time when the relationship she was in was kind of in sink-or-swim mode. This was right before she proposed to her future husband, motocross champ Carey Hart (she actually held up a sign saying WILL YOU MARRY ME? on Carey's pit board as he competed in a race). For a lot of the time we collaborated, I was on the receiving end of a confessional.

It was all very real, but we had the best time. I ended up writing two songs for *I'm Not Dead,* and we've been writing together ever since. We wrote a lot of songs in that hotel room, where I'd installed a piano and a little mobile recording unit: we cut some vocals and other stuff there that actually ended up on the record, and then we wrote another song that never got released, called "I Hate That I Don't Love You Anymore," which was pretty intense. In that hotel room is also where I played her "Song Without a Chorus," which she really took a liking to. "I've got to sing that song with you!" she told me when I finished. I eventually did record that song back home in my Atlanta studio. Alecia came through Atlanta on a promo tour for *I'm Not Dead* and I had her come by the studio and sing on the song real quick. It was the last song that I had cut for *The Rise and Fall of Butch Walker and the Let's-Go-Out Tonites.* Alecia and I remained in close contact because of our weird, strong emotional connection. After she popped the question to Carey, the next thing you knew we were at Alicia and Carey's wedding in Costa Rica, which was beautiful and fun. We also met some other great people; she's got friends from all kinds of crazy walks of life—punkers, jocks, athletes, red-

necks—who hang out with her. It's not just anybody; it's a tight group, which reminded me of the way that I am with my family and friends.

My collaboration with Alecia is the most ideal kind of songwriting partnership I've ever had; Lindsay Lohan, erm, not so much. Yeah, I know what you are thinking: why Lindsay Lohan? It was absolutely a social experiment (more like animal cruelty). I wanted to work on that record strictly out of thinking, "I've got to see what this train wreck is like." That was the only reason to do it—well, that, coupled with being hounded on the phone by Tommy Mottola every day to do it. I'm not sure how well Lindsay knew my work before we "worked together." I remember she cornered me at the Chateau one night (way after I had worked on her record) and said, "Did you write *that* song, and did you write about me?" She was referring to Pink's "Stupid Girls," of course. I told her, "Well, you'll be glad to know I didn't" (but thank you, Billy Mann, for helping Alecia cowrite such a brilliant, much-needed song at the time). I easily could have, though, from my experience with her.

I thought that maybe trying to coax a hit song out of a wild and crazy tabloid starlet could be interesting and fun and funny. What the hell was I thinking? Sure enough, it was a disaster. For that project, I was in the studio with Kara DioGuardi—yeah, the ex–*American Idol* chick talked me into doing it. Kara was producing Lindsay's record, and cowriting all the songs, too (and singing most of the vocals, as she did for most of the actors-turned-singers at the time). Well, Lindsay didn't really write anything. Kara somehow convinced me I needed to get in on a couple of songs. I said, "Sure, I'll try it." Why not? You know, I'll try anything once, so I flew to New York City for The Great Lindsay Lohan Experiment™. Ironically, I used to joke about her with my friends and call her "LoHo," and then, when I finally

showed up to the studio, it was also called "LoHo Studios"! Yet another lap in the Sea of Irony . . .

So I went into LoHo to make tracks for LoHo. At first, I was alone there with my engineer, Rusty, knocking out some new tracks and polishing up a couple of older songs that I had already written previously. I also spent some time writing lyrics with Kara face-to-face, as well as building the track up into a full-fledged demo so Lindsay could come in and sing to it. Kara always sings the vocal first—that's why every one of those songs that she has ever written for someone else sounds like her singing, because it pretty much is. I can always smell Kara's handiwork on the radio. I know exactly what songs she wrote, because I know how she sings; I can tell her every inflection. Kara produces the vocals with the artist, and she's good at it; she's especially good at making those singers sound just like her. The singer basically ends up mimicking her style and phrasing anyway; anything that they can't mimic, they replace with Kara's original vocal (sorry, this isn't Popgate—you don't have to be a genius to even assume this). She is a great singer, so even her scratch demos sound like a finished record. Kara's a much better vocalist than most of these chicks she usually works with who get record deals, save a few like Avril or Pink. You can always tell the ones who are just obviously Auto-Tuned and Pro Tooled and constructed to death. The truly dodgy ones, however, are those who got record deals simply because they're famous already.

In fact, the first day we were supposed to work together, Lindsay didn't even show up. I just sat there, waiting around, thinking to myself, "You know this is strike three already, and I haven't even had strike one and two." I'm not the kind of guy who takes that kind of shit. I'm not a "knob jockey" getting paid by the hour; I'm not an engineer just waiting around for the talent to show up. Screw that— you show up when I ask you to, and if you don't, then I'm not going to work with you, because you're cutting into my socializing and shopping time (I kid—well, about the shopping). Instead of calling to

say she was sorry, Lindsay called me on my cell phone at the end of that day and said, "Hey, what are you doing? You want to go to a party with me and Paris Hilton?" "I'm sitting in the studio waiting on you to come down here and sing," I shot back. Clearly, none of this mattered to her. At this point, she didn't really know what I was about at all; she didn't know anything about me and acted like she probably didn't ever want to. It was pretty much Kara's gig anyway: she doesn't play an instrument, so she needs somebody to write the backing track for her to write lyrics and melodies over. "You finish it," I told Kara. "I don't want to be here. I'm not going to do this." The final nail, however, proved to be the zit on Lindsay's forehead.

I was pissed as hell after being disrespected by Lindsay, but Kara talked me into staying, which I didn't want to do. "Just stay one extra day," she begged. "I can get her to come in." Lindsay did in fact come down to the studio the next day. Around four or so in the afternoon, she strolled in with the most ridiculous cliché entourage of poseur hangers-on I've ever seen. There's the de rigueur, totally stressed, uptight, and freaking-out assistant, not much older than Lindsay, maybe twenty years old—way too young to own a BlackBerry. Then there's the token BFF, who, of course, is a snotty L.A. club-scene leech: clearly, Lindsay latched onto her to stay cool and feel relevant, while Ms. Club Scene latched onto Lindsay for all of the accoutrements that come along with a jet-setting movie star. Next there's the GBF, a.k.a. the gay boy friend, who is borderline mentally challenged. All he is is an overopinionated celeb hag who just hangs out with whoever's hot that week; he literally jumps from one celeb to the next while they're hot and drops 'em when they're not—I've seen this one, in particular, do it at every club and red-carpet event I've had to stomach in Hollywood. LoHo's younger sister was there, too; she was real little then. I was scared for her, frankly, seeing her in the clutches of that freak show.

What I found so typical and annoying was that Lindsay's entou-

rage all had bigger attitudes than she did. I remember, as I was playing back the track to one of the songs we were going to have her sing to, suddenly the GBF chimed in—like all of a sudden he had an *opinion* that was useful (not). "I don't think the guitar part is good," he spewed. I couldn't stop thinking, "Who the hell is this guy and why is he in this studio?" Still, I just bit my lip and sucked it up. I knew he knew nothing about music, and yet there he was, talking like I wasn't there, like I didn't write the guitar part we were listening to.

By this point, my blood was boiling. Nothing creative was being achieved; instead, Lindsay's assistant was yelling into her phone, frantically messaging on her BlackBerry, and generally panicking about everything and trying to look important. Lindsay's little sister was just running around big-eyed, dumbfounded that she was in this situation. Finally, Lindsay stepped up behind the mic, and I let out a sigh of relief, which only lasted until she actually got around to singing, at which point my terror exploded anew. I remember her very first note; it was supposed to be this really high note in the chorus, and she went right for it, only to literally fall flat. The note just came out so flat and horrible and cracked, but instead of opting for embarrassment, Lindsay freaked out. She started screaming melodramatically that her voice was gone: "Oh no, I blew my voice out. Oh my God!" At this, her assistant started crying. The GBF was crying, too, the BFF was crying, they're all crying; me, on the other hand—I'm just like, "What the hell am I doing here?" I now understood how I had failed the karma exam: this was exactly what I'd asked for. I wanted a train wreck, and now I was getting the *Titanic*. It's not so funny when you're actually living it and not just reading about it on PerezHilton.com.

After a few minutes of this panic, the assistant is on the phone, screaming at someone to make a doctor come "like, right away and fix this shit!" I knew Lindsay didn't need a doctor: one look at her and it was clear she'd been partying all night—*that's* why she had no voice. It was clear, to get this done, we'd have to piece everything together

from different takes and Auto-Tune everything to death. I shot Kara a look like "See you later" and went outside. As I walked out the door, I tripped over the paparazzi standing outside, completely blocking the entrance; I literally fell over them onto the sidewalk. In seconds, I was on the phone with my manager, going, "Get me on a plane right now—this is bullshit." I signed up for, and got, what I deserved, but it was not fun or funny anymore: it was like the *Apocalypse Now* of recording, and getting more twisted by the second. Literally before I could get off the phone (still not making this up), I noticed two doctors in white coats walk quickly past me into the studio.

After a few more minutes of haranguing my manager, I followed the doctors back inside, where I saw they weren't treating Lindsay for her voice. Instead, one of them was putting a cortisone injection into a zit on Lindsay's forehead. I sidled up to the medical dude pushing the hypodermic needle into Lindsay's skull and asked what was wrong with her voice. "Her voice is fine," he told me, looking puzzled.

That would prove to be the last time I delved into the great unknown of pop just for sheer entertainment purposes. I wasted forty-eight hours of my life, which I will never get back. I received proof of how oblivious and unremorseful Movie Stars with Record Deals were when I ran into her again months later at the Chateau, where I was staying and she was living. One night I was coming down the stairs from my room; she was walking up to hers with a couple of girl-friends. Seeing me, she was suddenly all "Hi, Butch! How *are* you?" She wouldn't stop—she was almost flirting with me; it was weird. The next thing I knew, she was calling my room at six A.M., wanting to hang out: "Hey! What are you doing?" She was obviously about to go to bed, while I was in bed about to get up. That happened a few times, and that was that. This was the end of my music/movie celebrity journey. No one got too hurt, and no vocal cords were severely damaged. All in all—and I say this, to which you will laugh—she is a sweet girl.

From the blog of Butch Walker

Pro Tools, Auto-Tune, Celebrities, and the Death of Rock and Roll (on MTV)

February 10, 2010

High scores in the video game of life . . .

Do you know what me and most people record modern pop music on these days? Not tape machines, like the days of yore, but computers. Computers loaded with a software called Pro Tools. This software can make your music do things that you cannot humanly compete with. With tape, you get what you put in. When you play it back, it doesn't lie to you. When you mess with a track recorded in Pro Tools for even an hour, you can make a song sound like a completely different artist. I can safely say, if I recorded a solemn, sparse version of a song with acoustic guitar and vocal, I could easily turn it into a Daft Punk track with a Public Enemy sample, a Led Zeppelin drum break, and a string section from an Andrea Bocelli record. You can make this work for you or work against you. Some people have had much success with this device, and if handled with care, sometimes catchy, hook-laden, and memorable results are produced.

The person that holds the high score on Pro Tools: TBD.

There is a software "widget" or plug-in that runs inside of the Pro Tools software that manipulates anyone from Lindsay Lohan to Jennifer Lopez (John Lajoie exempt) to be able to sing their notes in tune, therefore giving the illusion of "singing." This is called Auto-Tune. When overabused,

it has the effect of a Barbie doll fucking a robot and having children. It is normally used these days over a bed of music that sounds like a casino full of slot machines going off at 3 A.M. Usually, a technique coupled with the effect of Auto-Tune, to overstimulate your senses and completely dishevel your attention span, and as an end result, making your mind think, "This shit is awesome."

The person with the high score on Auto-Tune: TBD.

There's a popular and ever-growing technique on awards shows, where the live performance segments have more and more OTT (Over The Top) injected into them in order to one-up the next performer, or simply to just overcompensate for lack of raw talent. This popular technique started to surface at the MTV awards in Miami, when a very successful mogul and gifted dollar-bill counter (but marginal entertainer) by the name of P Puff Puffy Diddy performed what was believed to have been a "song" with about 40,000 dancers, circus freaks, midgets, bandmates, and a gratuitous DJ (rumored to be his brother). This technique proved to have killed rock music dead in its tracks, as the night's only three rock performances (by the three biggest rock artists of the year) were consolidated into ONE three-minute medley. If you blinked or leaned over to ask Eminem for your pills back, then you missed it . . . surely. Five bucks to anyone who can even remember the names of the three bands.

The person with the high score on OTT: Beyoncé.

More high scores next week. . .

★ ★ ★

The whole Lindsay experience proved inspiring in its own weird way, though. I ended up making a record with the guys who had been touring with me on *Letters* after the American Hi-Fi guys went off to do their own thing; I got to have a real bond with a band again and feel comfortable with it. We'd just come off this year of successful sold-out tours, a record that (by my mid-level-artist standards) sold great and received the best reviews of my career. It was the first time I'd ever had that kind of reception, as the critics had panned everything I'd ever done, from SouthGang to the Marvelous 3 to the first Butch Walker solo record. We laid down the tracks in my studio: I had a bunch of songs to choose from, which I'd written over the course of this feel-good year. A lot of it was about those insane moments of Lohan-ism, retesting L.A. again after I had been away from it for so long. I got a kick out of Los Angeles, because I managed to love it and hate it at the same time. I had a lot to say about it, and that showed up in all the new material—songs like "Paid to Get Excited" and "Too Famous to Get Fully Dressed," all of which ended up on *The Rise and Fall of Butch Walker and the Let's-Go-Out-Tonites.* "Bethamphetamine (Pretty Pretty)" was really the *one* from that album. Just being able to call it like it was on that record was pretty exciting and confessional to me: it was sincere but people don't take it as sincerity. It was very much about my universe, that album: songs like "When Canyons Ruled the City" and "Rich People Die Unhappy" stemmed from the stories I remembered from when I was living in L.A. in that one-bedroom apartment, with six metal dudes, back in the day. I'd look up at the Hollywood sign and all those houses around it and think that everyone in those houses must be famous, living these enchanted lives or whatever. I'm very proud of that record, because all those songs really are my reflection of the way I felt when I first moved to L.A.—from delusions of grandeur to the actual harsh reality.

Of course, around that time I bought one of those houses in the Hollywood Hills: I was wondering if I was becoming the clichés I was skewering in the songs. I was aware that art was imitating life, and maybe I was becoming the butt of the joke; I didn't know if I was really happy. Despite my successes, life was very bittersweet, which is why there's such a dark element of that record. It was an ironic (instead of iconic) celebration of everything I loved and hated about L.A., which often were the same thing. The title was obviously a light-hearted stab at David Bowie's *The Rise and Fall of Ziggy Stardust and the Spiders from Mars,* the humor disguising a very gloomy element to the record. *Ziggy Stardust* was an album about an artist who was crushed by the music industry. Ultimately, I think mine was, too: it chronicled over time what happens when you get some success, money, and fame, contrasted against the superficiality of the city I was living in. Even if you get swept up in its hooks, the darkness is going to hit you at some point, like an inevitable hangover. It's tough when that happens, in a good way. Besides, people love you when you're sad: they love co-opting your misery, which is tough to pull off when you're not miserable. I was just reflecting the environment that I was in.

By the end of the whole *Rise and Fall* experience, I'd burned out. We toured a lot on that record, which was a totally epic, decadent, and expensive experience: I took out backup singers and did the whole T. Rex glam-rock thing to the hilt, and it was great. We even had some fancy translucent platform risers that lit up with blinding lights whenever we would jump on them to pose. Every once in a while I like to lose myself a little bit, and that was that record and tour. But then I came back to reality and realized I needed something a little bit more substantial to chew on. I needed time off. I needed a new place to call home—in particular, I needed to get the hell out of Hollywood and go to the sand, because Hollywood was destroying my marriage and me. There's a tractor beam there that fixes on your soul, and it's hard to escape once it sucks you in.

There's always this constant need to have to justify yourself to people—you hang around douchebags like that long enough, and you are going to *become that douchebag.* I just couldn't get with Hollywood's competitive nature; at the same time, I was starting to feel uncomfortable if I wasn't out every night at a hot party, the new hot bar, a red-carpet event, whatever. I did that, and all it did was bring me misery, grief, and friction at home. There was a lot of emptiness there. I was faced with a conundrum: I had to run kicking and screaming out of Hollywood to survive and keep my family together, but still be close enough to come in to work and do stuff. Therefore, I followed the path of my idols Tom Petty and Bob Dylan and moved up to . . . Malibu.

GOING BACK, AND GOING HOME
Following the Smoke to Sycamore Meadows

He was bitter as the smell of a magazine review
But he had all the cars
And the pools, and the view.
—*Butch Walker, "Rich People Die Unhappy"*

Here comes the hardest thing we've ever known . . .
—*Butch Walker, "Here Comes the . . ."*

I was in love with Malibu—driving on the Pacific Coast Highway on a motorcycle, looking at the sun shimmering like glass on the ocean, I couldn't help it. I loved both the fantasy and reality of the place: the fantasy was a Beach Boys song, that zone where the California surf and sun merge into one. Malibu was the place where my heroes had all recorded classic albums—Bob Dylan, Neil Young, Tom Petty, Shwayze (kidding). But what I loved most about Malibu was that it was so *dead;* there's nothing to do, which is probably why so much music comes out of there. There are no bars. Everything closes at nine o'clock. That was exactly what I

needed; in other words, it was the exact opposite of Hollywood, which was rotting my brain, my morals, my music, my marriage—everything.

It was decided: I was going to move to Malibu and have some of that classic rock-and-roll fairy dust rub off on me. But before that, I had to complete my Hollywood gauntlet. I had to make a record with Tommy Lee and be involved, however tangentially, with a reality TV show. Yes, reality TV forced me out of Hollywood. Read on . . .

My short, unfortunate stint with reality television coincided, not coincidentally, with my residence in Hollywood. It was the emptiest I've ever been inside: I was going out every night and actually worrying about whether I was at the right nightclub or party. In other words, I was clearly losing the plot, even as I struck the occasional studio gold.

I became involved in producing a Tommy Lee album: I thought, at this point in my life, that was an interesting and fun idea. It was cool that I was hanging with my childhood idols from Mötley Crüe. We couldn't be any more different, in a lot of ways, but to do a record with that guy was on my short list of things to do before I died (or he). While I probably didn't have much in common with Tommy's career—he's older than me and has gone through so much—I wanted to experience his magical, crazy, creative world known as "Tommy-Land," firsthand. With all due respect to the people who were involved with doing that record, it couldn't have been a more disastrous pain-in-my-ass experience, just because of the horrible, multiple managers involved and difficult people to work with; not all of them, but some of them. Where I differed from all those people was I didn't really place this huge, monstrous, U2-size validity on a "TV band" album. To my mind, it just seemed like something interesting and fun to do; notches on the bedpost don't get any better than that.

The whole thing came about because Tommy knew of my stuff,

and he had a solo album coming out, as well as a TV show, *Tommy Lee Goes to College*. The single from Tommy's solo record was going to be the theme song for the show, of course, and I was the man to bring it home. Tommy had e-mailed me a rough idea of a song, with some ramblings of him singing filler melodies—but no chorus. In fact, there were no lyrics, but the track sounded good, and the chords were fine to write something to. I wrote all the lyrics to the song that would become "Good Times" on a napkin from the Chateau Marmont, making a decent-size chorus for it. I got together with Tommy over at his producer Scott Humphrey's house and sang it for them, and it was a hit.

The instant Tommy walks in the room, you love him and he loves you, because he loves everything. He's that guy, with a magnetic personality and a big penis. Between the two, everything is going right; lots of women love him and lots of dudes want to be him. I'm not saying I wanted to be him, because I was happy with who I was, but when I was young, he was definitely one of my idols. In my hair metal moment during my twenties, the irony is, people compared me to him all the time (sans anatomic). I was this tall, skinny, dark-haired dude with tattoos, and everywhere I went, I heard, "Hey, Tommy Lee!"

It turned out that when I talked to Tommy, I discovered he's a lot more complex than people give him credit for. He's a real music fan, who actually has great taste in music and keeps up with all kinds of new stuff. He's very open-minded and full of life, and I really respect that—he's got the blessing and the curse (mostly blessing) that growing up and feeling old is overrated. Musically, at that point, Tommy was really feeling stagnant with Mötley Crüe; he felt they weren't going anywhere forward musically, while he was wanting to do all these DJ gigs playing techno and whatever. And he just loved pop, too—he would play me all these super-pop records. The funny thing is, the same day I was meeting him for the first time, one of the guys who walked in was another one of Tommy's unlikely buddies: Andrew

McMahon from Something Corporate and Jack's Mannequin. I was just like, "What? Why is *this* guy here, and why is he high-fiving Tommy? This is great. This is perfect. This sums everything up about me not being crazy for being attracted to the Tao of Mr. Happy."

The funny thing is, "Good Times," the song Tommy and I wrote together, actually became a Top 20 hit. We made money on it—good times, yeah! It was just lighthearted fun, making that; I didn't think about it too much. When I played it for Tommy and Scott, they both flipped for it, and then I just took the backseat and let them run with it. I wasn't coming in to produce or anything, but I sang the chorus, which made it on the record; that was a pretty fun moment, laying that down. I just sat there in the studio, going, "Wow! This is . . . What's happening?" It was one of those weird moments where I'm like, "I'm in the studio with the guy who put his penis in Pamela Anderson." Well, that doesn't really narrow it down . . .

Dealing with Tommy's manager was a pain in the ass, though. I didn't like the fact that I had to deal with some shadiness, but nothing ever scarred our relationship, even reality television. One day while we were working, Tommy said to me, "Hey, they want to do this TV show with me. You should get in on it, bro!" Soon enough, I got a call from Mark Burnett, the big reality TV producer (*Survivor, The Apprentice, The Voice*). He wanted to talk about getting me involved with a show he was producing, called *Rock Star,* a kind of harder-rockin' version of *American Idol,* or so they hoped. The first season of *Rock Star* featured the band INXS absurdly trying to find a replacement for its deceased iconic front man Michael Hutchence, which I considered to be a personal sacrilege; still, I agreed to hear Burnett out. I could barely understand what Burnett was saying, though: he was talking to someone who doesn't watch TV at all. I've never seen a single episode of *Survivor,* or *American Idol,* or anything like that. You'd be surprised how many of those *American Idol* records I've been asked to do and completely skipped over. Supposedly, these were huge, platinum-

selling records, but I was like, "Huh! I've never heard of them."

Because "Good Times" turned out to be a hit, I think Burnett thought I might actually have known what I was doing. They had drafted Tommy in for the series' second season; the premise of that next iteration of the show—and, eventually, the band—known as *Rock Star: Supernova* (I still throw up in my mouth a little bit at that name) involved finding the lead singer for a super-group made up of veterans of legendary bands: Tommy from Mötley Crüe, of course; ex–Guns N' Roses guitarist Gilby Clarke; and Jason Newsted, who had famously quit Metallica. At first, Mark wanted me to be in the band and do the whole thing. Tommy was a better fit: he's easy to get to ham it up on camera, and at the time he wanted a musical gig that didn't involve Mötley Crüe. I knew Gilby, too—a great guy who really lived it: as a matter of fact, I ride motorcycles on the weekends with Gilby all the time. I didn't know Newsted at all, but I'd discover he was definitely the most intense guy I've ever met in my entire life. Comedically intense. Ridiculously overintense. About *everything*. Jason had his smirking "metal game face" on all the time. If I asked him something like, "Hey, do you want to play bass on this part real quick?" he'd become overcome with angst and put his hands on his face, rubbing his eyes and seeming tortured. I was just like, "Dude, come on! This is a *reality TV show record*."

Burnett was pissed that I didn't want to be in the group. "Dude, I'm not famous," I told him. "My presence is not going to help you get viewers." But he still wanted me to spearhead the whole thing and write all the songs for the album. I did, however, agree to be a guest judge on the first week of the show, which was enough to send me screaming for the (Hollywood) hills. I think Burnett thought I might work as a kind of chicken-fried Simon Cowell or something. I was sitting there thinking, "Okay, what's going to happen? I've never done this." Dave Navarro was the host, and he was perfect. He's a real comedy act—the guy with his shirt off all the time: "Look at my body, I'm

witty and cute." Despite his looks, Dave also has a great personality. He's funny as shit and a really nice guy, and so much better at this kind of thing than me. Where he has *zero* shame in his game, I, on the other tattooed hand, felt ridiculous up there, especially because everything I offered up (any criticism, anything constructive I said) just became so edited into meaninglessness. It reminded me of that skit from *Mr. Show* called "Pallies": they might as well have just superimposed on me a fake hand giving a thumbs-up, going, "That's great!" They just wanted it to be so *positive* all the time. I was just like, "God, guys, you must stop this. This is *not* reality." After that, I decided I'd never do anything like that again. Well, until I did . . .

I did learn a lot from Tommy on that project, though, especially about the power of positive thinking. Tommy has big dreams and big aspirations, and that's how his fame has gotten to where it is. For example, he was dead serious when he wanted to know how much it would cost for them to shoot the artwork for the *Rock Star: Supernova* album—*in outer space*. It was a natural, as the name of the band had the words "star" and "supernova" in it. Tommy was like, "Seriously, how much will it fucking cost? How cool would that be, dude?" All the while, I'm just sitting and thinking, "Good God—this is just a reality TV show band." But God loves Tommy for having those big dreams. Some days he would just be hammered, and I couldn't even really get good drum tracks out of him; some days he just killed it like the insane drummer he is. One thing was consistent, though: being single at the time, every day he had a new, insanely hot girl under his arm. Tommy's entourage was immense: there was his tour manager, assistant, Jägermeister roadies, and all these other people on payroll. And oh yeah, he had his personal helicopter pilot, too.

One Friday, we were getting ready to do some recording when Tommy stopped the session and came into the control room. "Oh dude, Nine Inch Nails, Peaches, and Bauhaus are all playing at Irvine Meadows tonight!" he exclaimed. "We should totally go!" To which

I responded, "Well, we can't do it. There's no way." Irvine Meadows is two hours away from Los Angeles, and it was already four o'clock, which meant it would be almost impossible to get there on time through the hellish weekend-warrior gridlock. We would've had to leave in the morning to really get there feasibly on a Friday, when heavy traffic starts at noon (does everyone in L.A. only have to work until noon on Fridays???). Tommy, however, proved unfazed by these obstacles: "Oh dude, it's no big deal—my buddy has a helicopter."

"My buddy has a helicopter." Now I knew how the other half rolls. I'd never been in a helicopter, ever, but this Tommy adventure sounded like fun: I love Peaches, I love Bauhaus, and I love Nine Inch Nails, and the Tao of Mr. Happy x-factor sealed the deal. Thirty minutes later, we met up at Tommy's house at the foot of the Hollywood Hills. A few hundred yards away, I see a couple of police helicopters circling. I'm thinking, "Well, it's Friday, maybe they've got somebody on the chase." Police helicopters chasing someone down the highway is actually a fairly normal activity in Hollywood. At the same time, these cop choppers were *really close*. Then I saw Tommy come running out, looking jumpy: "Come on, dude, we've gotta go! Hurry! We've got to get up the hill *now*!" I was like, "Oh okay." I'd already learned that anything goes in TommyLand, but I still wasn't prepared for what happened next.

We jumped into Tommy's customized Escalade and headed up the hillside. "We've got to get to Slash's house," Tommy kept saying. Hearing this, I'm thinking, "Slash? From Guns N' Roses? We're going to Slash's house? I thought we're going to see Nine Inch Nails?" As we drove up the hill, we kept getting closer and closer to these helicopters. Sure enough, when we got to Slash's house, there were cop cars galore parked outside, with the SWAT choppers swarming overhead, too. In the middle of all this mayhem (pun), a big helicopter was plopped in Slash's driveway, its propeller span barely, *barely* small enough not to take out everything around it. I didn't know this at the

time, but it's completely illegal to land a helicopter in private airspace, in a residential area—so, naturally, Tommy used Slash's house to do exactly that. Slash wouldn't mind, or even know: he was in rehab again, so it was a perfect plan, or at least it seemed so at first.

Because Slash was detoxing elsewhere, Tommy thought nobody would be home, which, of course, makes it *totally cool, bro* to land a helicopter on his lawn. However, it wasn't totally cool with the cops, who were interrogating Tommy's pilot homey ruthlessly. Still, never underestimate the power of the Tao of Tommy. He got out of the car, ran up there, and within minutes, the police started clearing out; Tommy was even taking pictures with the cops, signing autographs, and so on. Helicopter dude took some serious chances, potentially endangering homes and lives, but hey, if Tommy puts his arm around you and someone captures the moment with an iPhone, then smiles all around . . . Helicopter? *No problem, bro!*

As the cops drove off, we piled into the helicopter, lifting into the sky right out of Slash's driveway. Maybe this scene is normal for Tommy, but me, I was just tripping out on the whole thing. We were zooming through all the buildings, hovering just above the fray, and most important, dodging all the traffic; in twenty minutes, we were getting our drink on backstage at Irvine Meadows. They actually cleared out a space in the parking lot for us to land in, and sent a car to get us. Moments later, we were watching Peaches do her thing onstage, and I was really excited to see her, because I was always a big fan of hers. She played first, but we got there in plenty of time. The whole experience was awesome. My friend Samantha was the drummer for Peaches, so she introduced us, and Peaches and I hit it off right away: she and I just got wasted and went to the soundboard to watch Nine Inch Nails, and it was a blast. I was having the time of my life.

When it was time to go, Tommy and I grabbed a ton of drinks and got back in the helicopter; I was actually working my own private bottle of red wine. The plan was this: park the helicopter back at

Slash's, then take the pilot to Rökbar (a bar Tommy was a partner in—note the telltale umlaut) and get him drunk to thank him for hooking us up. The only glitch was that, by midnight, it was really dark out. Pitch black. As we got close to downtown L.A., pilot dude asked, "Hey, do you guys want to get a closer look at the buildings?" So he started weaving and bobbing through skyscrapers, getting within, like, twenty feet of them—close enough where I could look into the windows and read the papers piled on people's desks. All this was crazy, fun, and wildly dangerous. Luckily I was drunk enough that I wasn't that nervous.

By midnight, we'd ended up back over the Hollywood Hills, but everything around Slash's house was completely black. All the lights were turned off in the entire neighborhood, as no one in the Holly-wood Hills stays up late on the weekends; they're in bed by nine o'clock, tops. I started to get worried when pilot guy said, "All right, you guys are going to have to help me look for Slash's house, because I can't see anything." There was no landing strip, nothing like that: yup, we were trying to land a helicopter in the dark in a residential area. Nope, never did that before. Homeboy, meanwhile, is flying close over the tops of houses and trees, causing dust and trash cans to swarm all over the neighborhood like a tornado hit it. Finally, we saw a recognizable landmark: the gate with the big "S" for Slash in the driveway. As we landed in the pitch black, crap was flying every-where. Everybody got out, jumped in the Escalade, headed to Rök-bar, and didn't return to Slash's until six A.M., at which point the pilot was totally wasted.

When we reached the helicopter, the propeller blades had been completely covered in toilet paper—it looked like a mummy. Appar-ently, what had happened was Slash's wife had been home the whole time—she'd actually been the one who'd called the cops in the first place, and to get revenge, she'd completely covered the heli in toilet paper. Literally a week later, I was listening to the news on the radio

in my car and heard: "A helicopter joyride for Tommy Lee and friend resulted in the pilot being arrested . . ." I was just thinking, "Oh my God, I'm so glad I'm just 'and friend.'" Never before has being faceless and anonymous been so great. I don't know if the pilot ever went to jail, though. I'm guessing Tommy probably smoothed it over, as he does everything; he's the great rock-and-roll diplomat. Working with him really is like a box of chocolates: you just never know what you're going to get. But it all made for a fun little excursion, give or take a few violations of airspace law.

Yeah, that's right, dude/bro—I went on a helicopter ride with TOMMY LEE (high five!). Ah, that moment when you, and especially your wife, fear that you're becoming a parody of yourself . . . That's when it's time to run kicking and screaming out of Hollywood. I just had to get away from the Hollywood calamity—in particular, the community of plastic, overcompetitive, overcompensating, music industry A-list songwriter-producer types, of which I was now, paradoxically, a member. Suddenly I was making money—*decent* money— for the first time in my life. The future wasn't the worry it had been before, but I felt bizarre inside. I'll be the first to admit the hypocrisy: if I say on Twitter that everything on the radio sucks, I'll always get the haters tweeting back something like, "Yeah, but you're part of the problem because it's you writing those songs for the people, asshole!" I know—I get it. As I rose up the rungs of the producer/songwriter- for-hire ladder, the people I met in that world seemed so far away from what I'd imagined myself to be. I pictured them on treadmills, working out viciously in the morning with their trainer in their personal home gym, furiously dictating a new hit single into a headset mic, their every utterance and hummed melody duly recorded by a nubile maiden or a cabana boy, depending on one's proclivity. This gave them the nitro-adrenaline necessary to go into the studio and

rock through fourteen appointments that very same day, each one a cowriting "sesh" with a different kid who has stars in his or her eyes (and whose manager demands a sizable cut of the publishing).

Ah, the phenomenon of the "cowrite." All the little pop tarts and American idols coming up in the game enacted a coup on the professional songwriter: because they represented the closest thing to a guaranteed hit in the download era, they now had the leverage to demand songwriting credit on every song they performed on, as well as the money that goes with it—regardless of their ability to, you know, actually write a song. The biggest money to be made now—no, make that *the only money* to be made in a dying industry—is through songwriting and publishing. It's not through record sales, because there are none; that means that producer points and royalties are pretty much reduced to nothing, too, depending on the genre (that's code for "most country-music fans don't own computers").

Publishing is a gamble, just like going to Vegas. There's this big bank, see, also known as the "publishing company": its initial trick in the music business is/was finding songs, then getting them placed in films, television, and on the radio, after which they can collect royalties on the airplay. If the songs end up selling and doing well, that's how they make their money back. They're basically a talent-scout agency for songs, combined with the financial structure of a lending institution. Throughout the whole span of my career, the publishing company always approaches and says, "We want 50 percent of your publishing on everything you write for the next x amount of songs or years, and we'll give you x amount of dollars upfront as a cash advance." "Cash advance" is really a pleasant-sounding code for "loan recoupable from royalties." Those royalties are tracked by companies like ASCAP, BMI, SESAC, or whoever: when they are finally collected, they all go back to the publishing company, 50 percent to them and the other 50 toward recoupment of the advance that they gave you.

Nine times out of ten, publishing companies do not recoup that

advance. Artists never go in the black, so it's good to just get a big advance upfront and walk. It's easy to have this mentality of "Well, if I do really well, then they're going to recoup and I'll eventually make some more extra money, right?" *Wrong.* But it's still a pretty good deal, because the publishing company has taken all the risk; if your songs tank, you still were given an advance. It's a bad deal, though, if you blow up huge and then realize, "Oh shit! I gave 50 percent of my publishing away for forever and a day to this company that does nothing in terms of placing my songs anymore. They just expect me to do all the work." Some publishers are better than others in terms of actually living up to their end of the bargain and getting your songs placed; that's the *only thing* they're supposed to do, and mostly they just dick it up. I have been lucky with my recent publishers, but it took several bad deals throughout my life to get to a good one.

When SouthGang got signed, we did a joint deal with Virgin Publishing at the same time. What's funny is that deal amounted to nothing except Virgin owning my publishing for the next seven years; the advance money all went to managers, lawyers, and taxes. We never made a dime on it—what was left over was, like, beer money for the weekend. No one ever thinks of it that way when big sums—$400,000 or whatever it might be—get thrown at you. I got a big publishing deal back in the Marvelous 3 days, but they didn't really do anything to shop my songs—and *we had a hit.* Even though we had a hit song, the deal never recouped. They gave me a lot of money—I received enormous publishing advances on each record I put out at that time—and the loans never got paid back. They pretty much didn't exercise their option to renew my contract after Marvelous 3 broke up, because they didn't have any faith in me. They were like, "That dude's *done.*" Little did they know, when I did the deal with Arista, there would be this great licensing guy there who placed "My Way"—this goddamn song of mine that I hate more than any of my other songs—into *everything.* I made more money off that, because I was free and clear of my

previous publishing deal. I was getting 100 percent of the royalties, because the rights had reverted back to me.

It still pays to be a writer, and it pays well if your songs that you've written do well. In the Internet age, they aren't doing those big deals anymore, because there's no money in it like there used to be. They're getting more aggressive in the placements, because they have to, but it doesn't fully compensate. Still, the real money definitely remains in writing, even if there's less of it. If I produce a record, I get a fee, because it's a service, but you don't get paid for doing a writing session with somebody. You're just taking a gamble with your sweet time on whether or not that song is going to get used. But if a song I wrote on eventually gets the shit played out of it on the radio, those royalties are going straight back to me. That was the case in Marvelous 3, too, because I was the sole songwriter in the group. So many bands have these arguments when they are setting out on their mission. It's usually a moot point, because one hardly ever makes any damn publishing money: nobody ever recoups, nobody ever sells records, and 97 percent of all releases fail substantially. On the other hand, bands like R.E.M. and U2 split everything equally, which is kind of why they're still together; if you don't split everything equally, and then you do end up succeeding, then that's when the animosity kicks in. In that situation, what happens is the non-songwriting part of the band ends up driving Pinto wagons and living in crack houses while the main songwriters get the Corvette and the big house on the hill. Well, that is extreme, but it has happened. Overall, it pisses people off.

I remember back when SouthGang got signed, we were going to split everything four ways. We didn't want to be one of those bands like, say, the Eagles, that broke up over publishing splits and money; even the Beatles struggled with these issues. So we just said, "Let's not do that." But in Marvelous 3, I usually insisted on sole songwriting credit, and in hindsight, it's the worst argument I ever won. The worst law I ever laid down was that it was *my* band, I had already written the

songs, and I was going to continue being the sole writer. "Well, look," I remember telling the fellas at a group meeting, "I've put a lot of hard work into this while everybody else was off doing whatever else besides writing songs." At the time, it didn't seem like there should be any argument at all, but it will always be an argument until the end of time on what's fair. And I can't really honestly say one way is fairer than the other: it's based on personal ethics, and how close you are with your band. Those were my brothers in Marvelous 3, and I still feel horrible about how it all went down. I think the only person who felt weird about it was me; they were great about everything—even after we broke up, there was zero animosity, zero hard feelings, which never happens. We did not make thousands. We made hundreds. We split everything else *but* publishing equally: merchandise, touring revenue—all the other things we never made a dime off of, we split four ways. Slug and Jayce got one-third of zero, but I got a big chunk of cash, which happened to come from publishing. I remember saying stuff like, "I'm going to make sure that everybody gets taken care of," but I got those publishing checks that they didn't, which created a system of have and have-nots regardless. But honestly, the publishing money that came from songs that I've written for or with other people way outweighed any I've done for myself or for my bands.

I had heard stories about this guy, whom we will call "Larry," who was basically another big writer-producer's backing-track guru. That big writer-producer and studio Svengali, who's cranked out absolute smashes for the likes of everyone on pop radio in the last fifteen years—Backstreet Boys, Britney, 'N Sync, everyone—isn't really a muso as much as a melody genius; he needs somebody to help create the actual music and grooves, and that's where his little "beat boy" Larry comes in. He always had his secret-weapon dude to basically come up with the music track, a guy who would regurgitate riffs from hits already happening at radio and then change one little thing to avoid getting sued; that was "Larry." Literally, people who I've worked

with who worked with these guys told me Larry will just take an old song, cut it up in Pro Tools, and redo it, changing the smallest number of parts necessary to consider it a "new" song. That is his formula. It's not about creativity or originality; it's just based on being a literal music machine—as in Xerox machine.

That's not to say that the shit doesn't sound good, because it does: it always sounds like the radio circa *right now,* which is why he's so big. If only the dude himself was so articulate in person. I remember when one girl I worked with a while ago came up to me and said, "Hey! I want you to meet my new friend 'Larry,' who I'm going to be working with on my record!" In the pop world, it's common for several producers to work on an album, so I never got competitive about that. At the same time, there is an underlying given that you're going to be a little leery about anyone else who's working with the same artist you're working with. You're always going to be like, "What's *their* story?" It was just never in my heart and soul to become nasty and conniving and flat-out steal, like these assholes do. Another artist I worked with who is a great judge of character told me that when she worked with this big aforementioned writer-producer, that there was this other guy, Larry, who came up with the music tracks and everything. And while the tracks sounded nice and they're cool and all, I just remember her saying, "God, I didn't like that guy." Everybody I know who's a good person has nothing but horrible things to say about "Larry." And yet again, I always have to judge for myself, because I don't want to just accept stereotypes—after all, I've been stereotyped myself so many times before. Some dudes, however, take the shit to the next level.

There was this whole scam that came out about how this song the dude and Larry did on this girl's record was the same as another one they'd previously sold to another artist; at the time, I remember she was telling me what a dishonest piece of shit this guy was. She was mad: you could put her song against the song that Larry had written and pro-

204 | *Butch Walker*

duced a year earlier for this other group, and it was exactly the same. You can mash up all the Nickelback hits together, because they are all the same song; they can't sue themselves, so it works for them. But when a producer does that to another artist, selling the same song twice, that's shitty; that's *lame.* They made my friend look bad, and every time that guy was involved, something like this would happen. I remember going to YouTube to compare the songs and thinking, "Damn, it *is* the same track as this other group's song!" It had different lyrics, but the same formula, the same arrangement, the whole thing. My friend didn't discover this until her record was already out, and she was *pissed.* I remember her telling me that she confronted Larry about it at an awards party or something. She was like, "Fuck you! I'm not working with you ever again. This is bullshit—you don't do this to me."

And then it happened to me—I got "Larry'd," too. I'd been working with a girl on a track called "I Can't Say the Name of the Song": I was the first person to work with her on her new record. Being the first person to work with an artist on a high-profile pop project like that can be a good and bad thing. We'd come up with the song eight months before; when we went in the studio, she didn't have any songs yet, nothing. I told her I had this idea for a song that started with the cheerleading vibe of "Mickey" by Toni Basil, a classic '80s hit that had the hip, funny New Wave sound she was diggin' on. In fact, I took a sample from "Mickey" and got clearance for it. I have no problem with sampling: it's cool as long as it's paid for, agreed upon, and totally legal. That sample kicked off what turned into a great track that was clearly a hit. I started the song off with the whole "hey, hey" chant thing from "Mickey": it was a call to arms, signifying that she was ready to take on this whole new, vibrant, cheerleader-type persona. The middle bridge featured a whole breakdown of her doing a cheerleader rap thing. Yep, the song was an across-the-board jam. And when the label heard what we'd come up with on that song, they were like, "We've got our single!" *Awesome,* or so I thought . . .

Cut to eight months later: she's working with Larry on another track for the album. Of course, with her he did what he always does— he's a good manipulator, so he just fills the artist's head full of so much shit. He just tells them what they want to hear, really. For example— I had heard this from a friend at the session—she'd get behind the mic for a vocal take, and before she started singing, she might say something casually like, "Oh, I've broken a nail." Larry, of course, jumps up and yells, "Stop the fucking session!" He starts parading around and yelling at the studio assistant to go get him "a goddamn nail file right now!" All this stuff, of course, makes someone like her think, "Wow, he really cares about my feelings!" The studio environment is very emotional and intimate, and you become fast friends there; what I'm guessing happened next was she and Larry got drunk and she played him "I Can't Say the Name of the Song." That would prove to be the worst damn thing that would happen to me in a while.

In this guy's case, nothing happens innocently: it's all going to be underhanded. As such, he dealt me the lowest of low blows. After she played Larry "I Can't Say the Name of the Song," he basically told her, "Well, that's not a hit. I can do that better." Next thing I know, I'm getting requests from her about changing stuff in the song. It was weird: the way she was talking didn't sound like her. It was pretty clear to me somebody was telling her what to say. All the while this was going on, Larry was covertly trying to get her change everything in *my* song. He would do that with everybody, telling artists that anything they had done with other producers wasn't going to be a hit unless *he* redid it.

Yeah, he's *that* guy. He got this weird antisocial tic, where when he walks into the room, the first thing that he says to a total stranger is, "Hi, I wrote 'Every Hit Song on the Radio in the Last Three Years for Every Artist.'" Sadly, that kind of opening line works wonders in Hollywood, which is why I was itching to get out. To be honest, his work with my pal was the first thing he did that broke him to the current status that he is at now: he's "everybody's guy" when someone

needs a surefire hit. Despite the fact that Larry eats at the music-industry equivalent of the popular kids' table in the lunchroom, a lot of people besides me also want to kill him. But the reason why *I* do is because he did me dirty with that girl. I never heard any of the stuff that she had done with him, and he'd never let any of that leak out anyway. His process wasn't totally leakproof, however: I found that out one day when I checked in with her then-manager. I was excited about "I Can't Say the Name of the Song" being the first single, but then manager dude was suddenly skittish: "Oh no, we have a new first single now." Hearing that quickly provoked a suspicious, *Zoolander*-style raised eyebrow: "*Oh really?* Whose song?" "It's a Larry song," he responded. I could have figured as much—*of course* it was Larry. The manager tried to change the subject; he was obviously uncomfortable talking about it. The single was going to radio in two weeks, so every-body was going to be hearing it everywhere soon enough, but the fact that I wasn't allowed to hear it before then seemed sort of fishy. Add-ing to the audacity of it all was the fact that I was at her house the night before, and nobody mentioned it—neither she nor Larry. It was a New Year's Eve party, and naturally he was there, kissing much ass.

That behavior seems pretty much business as usual, from my expe-rience. Previously, before any of this went down, I remember him coming to her surprise birthday party that we threw her, and just being a total brown-noser. I just didn't like his vibe: I remember later on that evening we all went to a club, and he was jumping on the couch and screaming, pouring his drink on himself and trying to overcompensate. Seeing that, I was mortified. I wanted to scream something along the lines of "Dude, you're *forty years old*—what the hell is wrong with you?" He was just trying to act out this "wild" party-guy persona, and it was just gross to me. I remember turning to her husband at the time, and saying, "Who is this dickhead? Why is he here? Why does she like him?" It had nothing to do with me being territorial; this guy is just a *jackass*.

At her New Year's Eve party at her house, he was acting the same way—except now, as we sat out by the pool, he was kind of kissing *my* ass. I already knew about how his whole deal with my other friend went: she told me she gave him a real smackdown. I already heard about him ripping people off, too, but I didn't know that he had done it to me yet. I was definitely leery of him after all of a sudden he's asking her to recut the beats in "I Can't Say the Name of the Song"—my song. When I heard that, I had a very specific response: "No, I'm not giving you producer credit, none of that."

I found out some other producer-writers eventually quit working with him, because this had happened several times already, with lawsuits popping up left and right. Unsigned bands would complain that their demos were getting completely ripped off by him for other songs. I didn't think much about it; it was all fine and good until I was the victim of the same thing. That's just not the way I was going to go down. While he was ripping me off behind my back, at this party he's talking to my face about what a fan he is of my work, *blah, blah, blah*. I remember him asking me, "So, when you write songs for people, do you even bother with *lyrics* or *melody*? Or do you have somebody come in to help you with that? Because I can't do anything with lyrics and melody; I need to bring in outside help." *How interesting.* Hearing this, I was offended and appalled. I wondered, "If you can't do that, then what the hell do you do?" It's the difference between being a songwriter and just a beat-maker: obviously, you're just a beat-maker if you don't even bother with the lyrics and melody. Melody and lyrical situation is what makes a pop song *pop*. Anybody with GarageBand can make a track sound like the radio, but it takes a certain skill to be a memorable lyric and melody writer, which for years was called *songwriting*.

After experiencing all kinds of weirdness from my friend and Larry, I thought to myself, "Man, I'd sure like to hear what that awesome single they wrote together sounds like." I needed to find out what the deal really was; after all, I had a sneaking suspicion what

their song was going to sound like. I was friends with all of her band, so when one of her band members called me one day to shoot the shit, I asked him about the new single, as I knew they had to be rehearsing it for her upcoming tour. "Oh yeah," he said guilelessly, totally unaware as to why I was curious. "It sounds like that 'Hey, Mickey!' song from the '80s."

Ahhh . . . At this point, I felt entitled to hear it, because I knew some foul play was involved. I eventually heard the song through nefarious means—and sure enough, the first five seconds of the song featured my "hey, hey" hook from "I Can't Say the Name of the Song"; it was an exact rip-off of my song, all the way down to the fact that they did a spoken-word rap in the breakdown of the bridge, just with different lyrics. The only thing that was really different was the chorus, which, it turned out, Larry had lifted from a song by *another* group. The group actually filed a lawsuit over the matter, and they ended up settling out of court. Really, there was no way that was the artist's idea—she does not have the group's records in her record collection, she was too young to have ever heard that song and wasn't even born when the original came out—but some middle-aged music-encyclopedia dude like Larry, well . . . That was a pretty awesome day when that news came down the pike. I still find it so ironic that the one part of the song that didn't get pilfered from me, they eventually got sued for when the song reached No. 1 in the charts.

All my publishers, people at the record labels, everybody—they were all hitting me up when they heard the news, because they all knew Larry had screwed me. Everyone was writing to me, saying, "Yeah, payback's a bitch," with links to the stories. People should know this stuff, because the industry is never going to tell them. The music business was never built on high moral rectitude anyway, but the opposite. Therefore, some of those very same people who wrote me laughing about the lawsuit still work with Larry to this day, even though they know he rips people off.

There was no way *I* was going to take Larry to court: he knew how expensive that would be for me, and that he'd made the song just different enough to complicate the legal situation. But the fact that someone was so creepy that they'd steal an idea from me just because they thought they could do better, while the night before they're telling me to my face what a fan they are of my work . . . Well, it was clear just how much Larry was a fan of my work. In the height of my redneck pride, I sent Larry a text; I just wanted to see what kind of reaction it would get. I kept the message very vague: "Hey, nice first single." Of course, seeing that, he completely flipped out: he called the girl, called the label, called everybody trying to find out how I'd heard it. To me, that was guilty behavior. If he wasn't guilty, he wouldn't have reacted that way.

That little vague text set off a mad, panicked pandemonium. Her manager was calling my manager, calling the band and asking how the song got to me. When confronted about it, I told all of them the truth: "Yeah, you don't get it. Larry ripped me off because he knew 'I Can't Say the Name of the Song' was going to be the first single, and he wanted that honor for himself. Piss off." Of course, when I finally confronted him about it, Larry blamed it all on her; he said that right to my face.

When I played Larry's song over the phone for my manager, he clearly noticed the similarity, as did everyone else. "This is bullshit!" he exclaimed. I told him the best way he could help me was to convey a simple message. Jonathan had spoken to Larry many times, so I told him that he needed to call Larry and tell him he better always watch his back, because if I ever see him out in public, I'm going to severely beat his face in. I didn't care about going to jail, which would be a lot cheaper than trying to settle a lawsuit; it would be way less than the court fees alone. And I knew that if I broke his nose in half, I would feel good about it; I also wanted him to know that I will not be messed with. The girl, meanwhile, genuinely felt so bad—it took her

nearly three weeks to get up the nerve to call me. When she finally did, she just busted out crying. "I didn't steal your song!" she said tearfully. "You know what? I'm over it now," I responded. Whatever. I'd settle things my way.

The funny thing was, I got sent an invitation to a Christmas party thrown by the management company that represents Larry; of course he was one of the sponsors of the party. I was psyched—when I got that invite, naturally I thought, "Okay, I'm going to go to that party, find Larry, and beat his ass." So I go to the party, and by about midnight, it had been going on for a while. That was when I spied Larry out of the corner of my eye, clearly all coked out and wasted and dressed all "homeboy" in an Adidas tracksuit (keep in mind that this guy is the most white-boy-looking thing on the planet). He's talking to the bouncers all jittery; it seemed like he was maybe a little nervous to see me there. So he walks over with this shitty grin on his face, like he's getting ready to say something cute that he's previously scripted to throw me off guard. I didn't give him the pleasure, of course: I just grabbed him by the back of the neck and said, "I'm not going to sue you—I'm just going to beat your ass. Whatever you owe me, I'm just going to take it out on your stupid face. We're going outside." He flipped out and recoiled, and the whole thing devolved into a yelling match. Every time I said something, all he would say was, "I wrote every hit song on the radio— you didn't! I have five songs in the Top 10 *right now!*" I'm like, "What are you, four years old?" It escalated to such a point that a good buddy of mine, the producing/engineering veteran Jack Joseph Puig, of all people, ended up pulling me off him. It grew into enough of a ruckus that the bouncers came over and threw me out onto the street.

That was pretty much the only chance I got to settle that score. I look back on it now and think I just should've finished it right then and there. I grew up a scrappy kid with a lot of pride, and when

you steal a million dollars out of my pocket, out of my son's future security, I'm going to kill you. It's not just, "Ha! You really got me this time! But I'll get you on the next one!" It's not a game to me like that, but in Hollywood, it is a game. That world is just a game, and I just don't play it. I don't want to. After that, I was really jaded and pissed: *that's* when I said, "Screw this, I'm out. I don't need to be in this scene, in this gross and tacky world." In hindsight, this all happened before everything in my perspective and world radically changed. After what I would go through next, I just felt sorry for the guy: he just sits around all day telling everybody about how even though he has a $5 million house, he "had to buy the one next door because the neighbors were complaining about the noise." That part is kind of sad, but I don't think that will ever change in the industry. You just can't let that side of it get to you, especially when you carry a lot of pride on your shoulders like I do—or I did, rather. Until the fire.

I'd hit the bottom of the barrel of the Hollywood experience—and that barrel is filled with sharks and those other little tiny fish that bite chunks of your flesh and then shit it out and sell it as something new. To dig myself out of that, I had to create a new home for myself, in a much more hospitable environment for true creativity. I packed up our house in the Hollywood Hills and moved up the coast, to Malibu. I'd found the perfect house there: it was owned by Flea of the Red Hot Chili Peppers, so I had hoped it was clearly blessed with the fearless rock-and-roll mojo I needed right about then. Seeing it, I knew that this place was my manifest destiny; it even had a full-on professional recording studio built into it. I had to keep pinching myself at my fortune: I had a big house up in the canyon overlooking the ocean, with my own recording studio in it. Compared to my Malibu digs in Sycamore Meadows, my little Hollywood house seemed too small—a

literal double-wide trailer in the trailer park of the entertainment industry.

Naturally, when I got this Malibu house, I had to fill it up with two of everything. I got every motorcycle I ever wanted, every guitar, every car: a Range Rover, a Mercedes, an imported Land Rover Defender 4×4, a BMW café racer, a custom-made chopper or two. I didn't need all of that, but I got it anyway. I bought so many clothes that I never wore. I just became obsessed with having everything I wanted but never had growing up. I just collected and collected and collected. I think I was trying to distract myself from the fact that I was entering into a massive creative block (or a midlife crisis, maybe).

I went up there thinking that I could write—that I could get out of the destructions and distractions of Hollywood and be inspired. Instead, I went completely brain-dead. I hadn't yet admitted to myself that I still hadn't really recovered from the comedown of my last record: it was eating me up. I had post-tour depression, going from touring a mega-dome to maintaining a canyon home for what, exactly? I wasn't really sure. Here I was, I'd removed myself, just like I wanted, to Malibu, and the beach, but . . . *Nothing.* I didn't know if I wanted to be away from all that, yet I cut myself completely off at the same time. I was scared. Once again, I found myself in an enormous paradigm shift in my life. What was I going to do with myself for the future? Where had I been up to that point? What kind of person was I, and what person was I going to try to be?

My self-identity was definitely fractured: I was making money off of other people's records, but I didn't know where *I* fit in. I was making the most cash I'd ever made in my life, and didn't have any context for it. I didn't grow up with a lot of money. My family wasn't poor, but we weren't rich, either, and we lived lean; everything we had was considered a luxury. Also, there was the fact that I'd worked my whole life to get every little thing I had. Nobody bought this stuff for me. This was not trust-fund money buying the motorcycles. This was not

inheritance cash funding my vintage guitar habit. This was me earn-
ing it after all the adversity I'd gone through for fifteen years up to
that point. I was proud of that achievement, but, as I sat in my big
studio in my big wooden house on top of my big hill overlooking my
big ocean view, I never felt so . . . *blank.*

Our house on Sycamore Meadows sat on three acres of rose gar-
dens; it was like living in the countryside of France or something. I'd
see deer running through my yard, and just loved taking that all in.
But then I'd go and sit in my studio and get depressed all over again.
I had forty vintage guitars hanging on the walls, a million dollars'
worth of recording equipment that I'd collected over the years, every-
thing sitting right there at my fingertips—and when I'd sit down and
try to write a song, nothing came out. I couldn't write anything and
started to freak out: "Wow, here it is: complacency." What if I never
write a song again? What if no one wants to work with me? Will I be
able to afford this lifestyle next year?

More important, more horrible, I wondered, "Is this where it all
stops? Like the name of that really good Strokes album, is this it? Was
this the end of the ride? What if I'm *done?* Have I become like the guys
who were my idols when they were younger but just got fat and mis-
erable and terrible at their art when they got older? Is that going to be
me?" I was approaching forty, and it was like, "What the hell is hap-
pening?" I projected that neurosis onto my relationship at home with
my family, and as a result, things were going a bit south. I thought
Malibu would provide a utopian solution to any marital discord. Nora
wanted to move to Malibu, too. She hated Hollywood with a passion,
and I totally don't blame her. She just wasn't *that* girl, but I think she
would've seen me becoming *that* guy if we'd stayed there. Not that I
was much better in Malibu, facing in front of me this massive writer's
block built of luxuries and amenities. I was convinced I was doomed
to write shitty music from that moment on, if I didn't give it all up and
move back into a one-bedroom apartment with just a laptop and an

IKEA futon for furniture. Not surprisingly, the only nuggets that I figured were good enough to make my next record were about my relationship in potential peril.

The house on Sycamore Meadows wasn't our first choice of Malibu abodes. I actually looked at this place called Indigo Ranch, fifteen miles up into Coral Canyon, in the middle of nowhere. Indigo Ranch was where Neil Young had recorded all of his great records from the '70s, amidst its thirty acres of epic farmland overlooking the ocean. There was a studio there, set off in this rustic little 1940s-era hunting lodge. The Moody Blues had actually built the studio before artists like Neil Young and James Taylor took it over, and it was a heavy, cosmic, legendary place. It was actually built on Chumash Native American ceremony land, and had a very magical vibe. I was like, "This is it! This is meant to be my mystical studio where I truly discover myself!" I wanted it so bad, and was willing to wager every penny I had to lock down Indigo Ranch and get the hell out of Hollywood.

I remember being in negotiations with the sellers. The place had been on the market for five years, with no bites. The studio had long been out of business, too, so the price was definitely lower than it should've been. The price kept going down and down and down; when it was almost half of what the original asking price was, I made an offer. Nobody wanted a recording studio up there! They were all looking for some big, ridiculous, vibe-less Malibu McMansion—of course we didn't care about that. Indigo Ranch was perfect for us.

Soon after I put in my bid, I went up to the Indigo Ranch grounds and snuck in. I did a Native American prayer that my sister taught me; basically, if you do this prayer, you'll get what you ultimately want to happen. I felt really good afterwards, like something definitely happened—like a scene in some serendipitous, Tom Hanks–style roman-

tic movie, where you wish for something and then the wind blows as some sort of a sign.

The next day I got a call from the real estate people saying, "This rich Malibu woman who's been eyeballing the property for years came in from out of nowhere and offered double what you offered." This was our place; we had finally found it, and she took it out from under us. We were distraught. But check this out: that same day we lost the house, we discovered Nora was pregnant. I think the prayer brought us our son, James, instead of the house, actually. Indigo Ranch eventually burned to the ground, and we would have been screwed sideways if we were living there. So what happened happened, but for a reason. But fire wasn't done with me yet.

I clearly needed something to wake me out of my stupor, and the universe was going to provide it for me if I didn't discover it myself. I was just sitting there in Malibu, surrounded by everything I ever wanted in life, totally uninspired. In what seemed like no time, my son had turned six months old. A dear friend told me that having a kid would be a wellspring of inspiration. "You are going to write so many songs," he said. No, I wrote a bunch of *kid* songs, all talking about how cute my son is and stuff. I had hundreds of those, but I was pretty sure they weren't going to make my next album. My son's birth was amazing— instantly life-changing. They all say it's the best thing that ever happens to you, and it is. It's definitely the scariest, most frightening thing that ever happened to me. It's great, but that first six months of having a kid was also tense: it was rough at home, and there was a lot of fighting. It's not easy, keeping a connection between the parents and not making it all about the kid. Some songs, like "Vessels," came out of that moment. For the most part, though, I was still facing that creative brick wall.

Around this time, James and Nora decided to come to New York City with me on a trip to see me play a couple of acoustic shows there

over Thanksgiving weekend. The weird thing is, normally, Nora would never come across the country to see me play, especially with a six-month-old in tow. For some reason, though, we thought it was important to be together during that rough patch. We were trying to make things work, make things happen, and strengthen our family; being together as much as possible just seemed like the best way to do that. We've never made a better decision.

My shows in New York were awesome and went super-well. After the first one, I stayed out late and partied with my friends at the club where we played, as is traditional. At around four in the morning, I went back to join Nora and James in the hotel room, promptly passing out in my whiskey-enhanced state. I woke up an hour later to my phone ringing; all these calls were coming in about how the Santa Ana winds had been kicking fires around Malibu. A month before that, in October, the Santa Anas had started a fire in Malibu that took out maybe ten homes. Some of those were a good four or five miles from our house, which was scary. We even evacuated then, because our house on Sycamore Meadows was up a canyon on a cul-de-sac, at the very end of a dirt road, with only one way out. If the fire had gotten any closer then, we would've been screwed—we were literally wedged into a hill. So we evacuated and stayed in a hotel room for a couple of nights. That fire didn't get to our house, but it did torch Suzanne Somers's house just up the road.

The whole thing was so weird, and kept getting stranger by the minute. All my Malibu surfer buddies kept calling: "Dude, the mountain behind your house is on fire!" One of the first calls I got that morning was from our friend Johnny. Johnny is an animal rights activist who works for PETA and loves dogs, so he'd watch our pets whenever we'd go out of town. At the time of the fire, he was staying at our house with our two beloved dogs that we'd had for ten years; they loved to play with his dog, so it was usually a perfect arrangement. That day, however, he called at five thirty in the morning to

tell me people had been calling the house saying that we need to get out of there.

Initially, I was pretty blasé about what Johnny was saying. I'd been told that even if a fire comes within one mile of your house in Malibu, chances are the Santa Anas will change direction and send it somewhere else. Besides, we had already cried wolf a month before that, after we had to evacuate; I couldn't mentally allow myself to think something like that could happen. This time, though, Johnny said he knew something wasn't right just by looking at the sky: it was really dark outside, almost pitch-black, and typically by that time in the morning the sun would have risen already. I remember, while he was on the phone with me, he was saying stuff like, "Oh my god, it's like hell! It's like hell!" Johnny is a little bit of a dramatic person anyway, so I didn't know how seriously to take him, but he sounded pretty shook. "You and the dogs need to get out of the house," I said. "Take my car—yours is too small to fit all three dogs in. And before you leave, can you run into the studio and grab the hard drive that's sitting on top of the mixing desk?" I had all my master tapes from throughout my entire career stuffed in the closet, but that one hard drive had all the stuff I'd been working on for the last year, for other people as well as my own stuff.

I didn't think much about what I'd asked Johnny to do. It's easy to grab a hard drive, and I figured if the fire turned out to be really serious, he'd be able to go back and grab Nora's dad's burial flags and military medals, our family photos, my priceless guitars, artwork, and all of our other mementos. But I wasn't even thinking about that. I remained pretty calm, which was clear when my mom called, after seeing the fire on the news. "It's nothing to worry about," I reassured her. "The flames can come within a mile of the house, and nothing is going to happen. Don't worry about it. We'll be fine."

Nora was still sleeping, so I took James for a walk. I put my son in the stroller and we made our way to Union Square, where I was

hoping to find some coffee and get my groggy, hungover brain working. We went into the nearest Starbucks: as we waited to order my espresso, I saw the morning news broadcast on a television behind the counter. There was a story about the fires in Malibu—and when they cut to the scene, the footage showed the fire closing in on the area right where we lived. My heart fell. Immediately, I called my friend Ryan, almost as an afterthought. Ryan lived in Malibu, and the fires had almost torched his place a month before, so I figured he'd understand the favor I was asking now. "Hey, Ryan," I said. "Will you go to our house and just grab Nora's dad's flag and a couple of my guitars in case something happens?" I regretted not asking Johnny to do that, but I didn't realize what he was actually going through at that time. I thought that there was nothing happening yet in terms of the fire getting close to Sycamore Meadows. I was wrong.

Ryan didn't say anything at first; later, I realized he was probably in shock. I was still standing in line at Starbucks when he finally spoke up. "Dude, I went up to your house," he said, out of breath. "The cops had your street barricaded off. I barreled over the barricade in my truck and rode up there anyway and I . . ." He stopped for a moment to cough. "I tried to get as close as I could to the house." I suddenly perked up, no longer needing the benefit of caffeine. "What are you talking about?" I asked him, still stuck in a cloud of massive disbelief and denial. "Butch, it's gone," Ryan responded, his voice trembling. "Your house is gone. It's all gone. The second floor was already gone when I got there."

Hearing that, I started crying. I couldn't believe it. It's not every day you find yourself in Starbucks with your son asleep in a stroller, facing the fact that you've just lost everything you had. A month before, I had unloaded a semi-truck of studio gear in the driveway; a month before that, we'd unpacked everything we'd shipped from our place in Atlanta. And now all that, plus a 5,600-square-foot house,

was gone, burned to the ground. I was paralyzed: for a good while, all I could do was sit there in disbelief.

Returning to the hotel room proved to be a pretty emotional moment. I woke Nora up, which wasn't easy; she's not one to get out of bed easily in the morning, and was grumpy being disturbed so early. "Honey," I said between tears, trying to shake her awake. "The house is gone. Everything is gone." She couldn't believe it. There was a lot of crying—to be honest, we didn't really know what to do. Nora started calling people, trying to find a place for us to stay when we got back, while I called Johnny to tell him I was sorry; I felt guilty I'd asked him to get my stuff. When I got through to him, he was pulled over on the side of the Pacific Coast Highway, still in Malibu. He hadn't gone anywhere, because he'd gone into shock and had to stop driving. "Johnny, the house is gone," I told him. He was like, "I know, I know, I know"—and then he started crying.

What he hadn't mentioned when we'd spoken earlier was that, the entire time he was on the phone with me, the house was on fire all around him. When he'd woken up, the whole back side of the house was already engulfed in flames. While I was telling him to go and get my stupid hard drive, the kitchen skylights were melting above his head, dripping all over the floor, and the windows were exploding from the heat. He was too in shock, he said, to let me know what was really happening. By the time he'd gotten the dogs in the truck, the whole second floor had already caved in; that's where he'd been sleeping. And when he'd finally arrived at the bottom of the driveway, the electric gate had gone kaput—it had opened about three-quarters of the way but ground to a halt when the power lines had snapped in the heat. Johnny drove through the gate anyway, scratching the hell out of the car, but he still had to run a gauntlet of obstacles to keep from being trapped: flaming trees had fallen over in the middle of the road, and he had to drive over them to get to safety. That was a lot of turmoil for anybody to have to deal with; we felt

terrible that Johnny had to go through that. Flea called next. He'd been there, watching the house burn to the ground. Flea was so gracious, so genuinely concerned for us. To him, he'd lost a property, which was a drag for him, surely, but he knew we had lost everything we owned, in that house.

Making things worse, we couldn't get back right away—we were stuck in New York. It was Thanksgiving weekend, and the airline wouldn't let us change our flight. We had to wait two more days to get home, which was a drag. As soon as we got back, Nora and I went up to the site. It's weird—the first thing you want to do is just go back. Not that you can save anything; you just want to go back and start dealing with it emotionally. It was a little rough going, but pretty quickly we realized how great all of our friends were. As we trudged up the ash-covered driveway, of course the first person to come roaring up to meet us was Alecia. She had a bag of clothes in her trunk for us, which is something I'll never forget; that says so much about the quality of her character. During that time, it was overwhelmingly heartwarming to see people come out of the woodwork to help. We'd come home with just our overnight suitcases to our name, which was all we had left. In no time we were flooded with clothes, baby stuff, everything we needed that we no longer had.

Until that moment with Alecia, I never expected I'd be so happy to see a bag of clothes. You know, it's not like we couldn't have gone out and bought new clothes or whatever. We had money; the fires didn't burn our bank account. But in a moment like that, you're just so overwhelmed and shocked, the last thing you're going to do is, you know, go to American Apparel and stock up on body-conscious V-necks. Eventually, once you start putting everything in perspective, going shopping doesn't seem so traumatic; instead, it makes your heart just open like crazy. In a new and lucid way, I started thinking about those people whose houses burn down who don't have anything—low-income families who have nothing, who can't afford to replace

anything because they don't have any insurance, who are out on the street because there's no one to help them out when something catastrophic happens. Living through a fire's aftermath, you never take what you have for granted ever again.

It seems ironic, but after all that, we ended up getting a room at the Chateau Marmont; we lived there for probably two months with a baby and two dogs. They were kind and generous after hearing about what had happened to our place. After a little remove, I started realizing what a blessing it was that we weren't there when the fires happened. It was an absolute blessing, because you know what? If Nora and James hadn't come to New York with me, I don't think they would have gotten out. I don't think Nora would have woken up, because she can sleep through anything. She didn't even wake up when I first told her our house had burned down, because she probably thought she was dreaming it! My mind always goes to that dark place where I wonder what would've happened if things had been different: I dwell on the thought that I wouldn't have a family anymore. Yes, it was indeed a blessing that we weren't there, and that Johnny was there and our dogs were safe. We were alive, which meant that everybody was fine in the end. That's all that mattered.

The media coverage was also ironic: all the headlines were like, "Flea lost his home." Fire insurance basically paid Flea back for the cost of the land, but not the house, so he was way out of pocket, too. But Flea was the first one who said that, while losing the house was an inconvenience for him, for us it was devastation. The reality was, Sycamore Meadows was our home; Flea had moved out of that house a year before that. This was the house that we were in negotiations to buy, where we were living as a family, where we were going to live forever. Because we didn't technically own the house on Sycamore Meadows, we didn't have homeowners' insurance; maybe 2 percent of our stuff was covered under renters' insurance. That was a huge financial hit: I'd tied up all of my money and investments and

gear into that house and studio, and it was all gone. It wasn't a fair deal for anyone.

Eventually we started to rebuild our lives from scratch. After we left the Chateau, we spent another month in a spare house that one of my surfer buddies had in Malibu; he told us we could have it as long as we needed it, and wouldn't accept any money. That was the spirit we felt from our friends: all of these people came together and had the pictures they had of us framed to replace the family pictures we'd lost. My friend Marnie worked for Diesel and made sure we had clothes; in fact, I'm wearing the Diesel jeans that Marnie gave me then as I type these words. That kind of support made me realize that we could make it, that things weren't so bad, that this wasn't the end of the world—actually, it was amazing and incredible. To have people like that in our lives changed everything. After that, I was forced to really rethink what was important. That's when the floodgates opened, and songs just started pouring out of me.

The first song I wrote after the fire—in fact, it was the first song I'd finished since well before we'd lost the house—was "Going Back/Going Home," which would end up on my 2008 album *Sycamore Meadows,* named after the street where we lived. After the fires, I'd really learned the difference between going back and going home. That's exactly what I said when I was getting off the plane from New York, with just three suitcases to our name: we were going home, but we didn't really have a home to go to, so I guess we were just going back. That realization left me wondering what was going to happen now that I had no material possessions, yet all these untapped emotions remained inside me. That's when I understood all these life lessons for real. Not only did I not need two of everything, I didn't need most of those things, period.

I did need something to write songs on, however. My creativity got

a big jump-start thanks to a cool thing Alecia did. She came over one day and said, "Well, I didn't see you on your birthday, so I got you a late birthday present"—and handed me the most amazing electric guitar. After the fire, I didn't have any electric guitars: nothing had survived from the collection I'd built up for decades. Yeah, it was painful to even think about replacing them, so when Alecia brought out this guitar case with a big bow on it, I was flabbergasted. She'd gone and picked out the most beautiful, tobacco sunburst Gibson Les Paul—the exact same model Ace Frehley played with KISS in 1974, bringing me totally full circle in my musical life. This was the most beautiful guitar I'd ever seen, but more than anything, Alecia's gesture just blew my mind. It was like, "Oh, that's going to be *my* guitar now!" I was starting over, and Alecia provided the first step. Sure, I've built up a nice collection of guitars since then, but that Les Paul is still the most cherished instrument that I possess today. Still, I wondered if I was ever going to be able to write anything ever again, but then everything just started to click.

Jonathan, my manager, was a saint through the whole experience, immediately flying to L.A. to be with me after everything happened. When I told him about knowing the difference between going back and going home, he was like, "You write a song called that, and it will be the best song on your new record, I guarantee you." He was right, as always. It's one of my favorite songs that I've ever written, just because it's so honest. There's a whole breakdown section where I spit out my whole life story in one minute, "Subterranean Homesick Blues" style:

Cut to a life, being born in '69
Low-class suburb, everything's fine.
Fondue parties, my mom and my dad
Drinks being drunk, and fights being had.
I lost my virginity to a girl in my band
She was four years older, she made me a man.

So addicted to sex, every chance that I got
With whoever I wanted, until I got caught.
So I took my penicillin, and I took my band
To a town made of glitter girls and cocaine friends.
Got handed the job by the age of eighteen
Saw more than most people that I know had ever seen.
Played every bar, drank 'til black-and-blue
Did the morning-show bullshit—and went to China, too.
Where they left us to die, without a ticket to flee
Inciting the riot, we were only twenty-three.
Packed it up, started over just as fast as we can
Selling tapes, making merch in the back of a van.
Living hand-to-mouth for the next five years
Took up drinking wine, gave up drinking beer.
Signed another big deal, with a devil in a dress
A "one-hit wonder" I think describes it best.
Decided to burn out, then to fade away
Went back to the van the very next day.
Picked it up, made a living without any help
Made amazing friends, if I say so myself.
If living like this at thirty-eight is a bore
Then c'mon God, please give me thirty-eight more . . .

Those words literally came out so quickly, like I threw it up. Maybe Jay-Z can do that shit off the cuff without even writing it down, but that's not my gift. I'm very hard on my lyrics, and I'm very tough on myself about what I'm saying in my songs, and never come up with things that quickly. But this was cathartic like never before: a lot of my songs are these tales lived out by fictional characters, but "Going Back/Going Home" was easy to write, because it was just the truth. It was my whole story; all I had to do was just put what happened in chronological order. When I wrote the song's opening

lines—"I'm not happy with myself these days/I took the best parts of the script and I made them all cliché"—that was how I saw myself before the fire happened. I wasn't happy with where I was at and where I was supposed to be. There's a difference between being wealthy and being healthy and wise: I had everything I was ever supposed to want, and I found out the hard way that that shit doesn't make you happy. It sounds obvious to say that now, but when you're in the middle of it, it's anything but.

The second line of "Going Back/Going Home" is "This red bandana is slowly going to fade, even though it's the only thing the fire didn't take." When we came back from New York, I remember pulling a red bandana out of my backpack and thinking, "Man, that is so funny—I just lost everything, but that stupid red piece of cloth has been with me since forever." I've worn bandanas since I was a kid; I've always had this thing for rags, and I don't know why that is. I think it's just some sort of childhood security blanket for me—crossed with maybe being branded with Chachi's image from *Happy Days* at an early age. At the same time, I felt it was also a metaphor for the fact that *I* was fading.

The craziest part of the whole story is, with the house literally exploding all around him, Johnny had actually rescued my hard drive! When I got back—not home, but *back*—Johnny came to our hotel room at the Chateau. He was carrying this stupid metal skull-and-crossbones briefcase that someone gave me, which was like something Marilyn Manson would carry his lunch or spider collection in; I never used it for anything except transporting hard drives, because it looked so ridiculous. Seeing it in his arms almost brought me to tears: it held every bit of work I'd done that year, from unfinished productions for Avril and Pink to crucial demos that eventually became songs on my next album, *Sycamore Meadows*.

That hard drive was all I had left as evidence of my creative life, and Johnny had risked his life to save it for me. Frankly, I wish he hadn't taken that risk, but in the end it meant so much that he did. The fire took all the masters of my previous records, and I didn't have any backups. That was a real bummer, knowing that I'd never be able to recall the original tracks to *Letters,* or *Rise and Fall . . . ,* or even the Marvelous 3 albums. I couldn't remaster them, for example, or even just freak out and listen to them on the original reel-to-reel tapes—but I had my skull-and-crossbones Marilyn Manson–looking lunchbox. I was crushed, but slowly I began to realize it didn't really matter. What was I going to do with those old master tapes anyway? I'm not a remix artist, and I don't sit around and pull those things up on the reel-to-reel for trophy's sake. I didn't really want those gold and platinum records that used to hang on the wall of my hallway. I actually made it a point. I was like, "Screw those records. I don't need trophies in my possession." It all just made me feel a little bit more humbled, I suppose.

Now the songs definitely were coming out. I wrote all these things that I didn't think I could write before, because I was scared they'd come across as too personal, too honest. Frankly, I was afraid to put myself out there like that. I'd always hidden behind songwriting as if I was writing a script for a movie: my lyrics usually described a fantasy world for someone else's reality, but not mine. Now, finally, I was able to tell it like it is. After the fires, I felt like I had nothing to lose.

MY HAPPY ENDING

*Drinking with Strangers, Playing Something Called
a Banjolin with Stevie Nicks and Taylor Swift, and
the Critics Finally Get It . . .*

If there's one thing my father said when he was younger
To a kid with a mullet that looked like his son
To want and to try is the difference why
Some people will walk and some run
—*Butch Walker, "Song for the Metalheads"*

Throughout my life, I keep finding myself drinking with strangers.
Ever since I was sixteen, which is when I started playing in bands,
I've spent most of my time in bars and nightclubs, typically with a
drink in my hand, talking to someone I've never met, sharing intima-
cies that I probably shouldn't, in a tone that might be a little slurred by
last call—which is usually when I have to get back in the tour bus and
drive to another bar. *Rinse; repeat.* That's just become my lifestyle; it's
a part of who I am. I mean, my name is engraved on the end of the
bar on a big gold plaque at a place called Smith's Old Bar at Atlanta,
Georgia: I guess they give awards for the consummation of this stuff.

I can't tell you how many interesting folks I've met drinking with

strangers, how many memorable moments happened in those tight, dark, sweaty, loud, (once) smoky spaces. I remember being with my Brit friend Ian and coming up with the name Marvelous 3 sitting right there in Smith's, at the bar with my name on it. I don't make a lot of friends sitting in a recording studio, that's for sure. I think that's yet another reason why I will never just be a producer; believe me, I know plenty of great ones who don't really like people and could use more social skills. I guess either you're born that way or you're not—I enjoy human interaction too much. I've met more people through just being random and being the guy who can talk to anyone and everyone in drinking establishments. To this day, I've made most of my closest comrades—almost every human connection I maintain, really—in a bar, or a club, or some ridiculous party where I clearly didn't belong. Almost all were people I'd never met before, but I wasn't scared to get to know them. I still do this up to this day: whenever I'm on tour, I'll go sit at the hotel bar by myself, make some new friends, and then invite them to whatever show I'm playing in that town. That approach sums up about three-quarters of the lifestyle of the road: the pre-show, the post-show, and everything in between. I feel that if you don't ever venture outside of your comfort zone, you will not have enough colors around you in the end.

Of course, there are some pitfalls to drinking with strangers, as I discovered while touring the Midwest with the Floyds back in the day. We were set to play in Iowa at a little bar named Murphy's, which was located in a resort on Lake Okoboji. (I know, it sounds like you just sneezed, right?) Murphy was this fella who looked just like an even more stoned-out version of the cartoon character Doonesbury: he was the nicest, most mellow dude, a champion wakeboarder in the summer who would pack it in and rent skis to tourists in Tahoe, California, all winter long. Yes, Murphy was a true leisure expert, and I admired his lifestyle of dual-season bohemia more than most.

Strangely, I had just torn my ankle tendons in a stage mishap the

night before our Murphy's gig: when I showed up to play the show in Murphy's fine town, I was on crutches in a leg brace. That kind of thing never slowed me down back then: usually, I'd be able to balance myself and my guitar onstage with a healthy diet of vodka and anti-inflammatory pills. Regardless of this setback, the show was amazing, and the kids were very festive. We usually finished great show nights the same way with what else but . . . Jayce and me bartending together. Have I mentioned I loved—and still love—drinking with people I don't know? Jayce was feeding me pint glasses of vodka and lemonade that were about three-quarters vodka, with maybe a splash of that lemon stuff. After about six of those, I kinda forgot about that big dose of codeine I took after we got offstage due to my throbbing foot. If you have ever given a high five and it looked like ten, then you know what kind of state I was getting myself into. All the while, this cute little hippie girl had been trying to get to know me all day at the venue. She was sweet, and even though I wasn't interested, I was nice enough to her (which I have learned over the years isn't always the best signal).

By three A.M., the bar had to close, so what seemed like the most rational thing for a group of about twenty of us to do? Why, take Murphy's boats out on the lake and go waterskiing, of course. *Perfect.* We got down to the dock, and I was walking like what resembles a cross between a crab and Linda Blair on a staircase in *The Exorcist.* I can't feel my hair when I pull it. Somewhere in my mind, this didn't seem like a great idea. *Water. Boats. Skis. Death.* I found I couldn't communicate these feelings, however: while I was no longer slurring, it was largely because I couldn't even open my mouth to talk. Of course, things got even darker. Somehow, due to my paralytic state, I was forced to get in this little boat with a drunken frat boy in the driver's seat; some weird, homeless-looking, toothless, David Lynchian crackhead; the hippie girl who wanted to have my children; and, get this, *her boyfriend.* Yes. She apparently had a boyfriend the whole time, whom I'd never met until that moment.

Of course, I was too messed up to even introduce myself to him.

As we puttered out onto the water, the crackhead was just staring at me, laughing and smiling like he'd just killed a puppy and enjoyed it. Next thing I knew, Señor Crackhead offered me a joint. Normally, I am not a taker of the pot, but when I am that hammered, I will try anything. I took a puff. Wow. It burned my lips, mouth, tongue, lungs . . . everything. Crackhead guy kept on laughing at me: I swear, just like in the movies, his cackle had that echo-laden reverb on it that makes you feel dizzy and confused. Well, turns out if it looks like a crackhead and smells like a crackhead It's gotta be crack in the joint that the crackhead is making you smoke. So this was all going well. My first and only experience smoking crack would be while blasted on codeine and vodka, trapped on a boat with strangers in the middle of nowhere. But wait, there's more . . .

The whole time I was getting my crack on, the hippie girl was up front with her boyfriend, having an argument. I was too splattered to notice until the girl came across the boat to tell me what was going on. Turned out, she was in love with me (already?) and had told her boyfriend she wanted to break up with him to be with me and . . . *WHAT THE HELL???* I'd just met her, wasn't even interested, and now she's on this twelve-foot-long divorce vessel, telling her very angry and big boyfriend that she is leaving him for me? I freaked out, yelling at Phi Skipper Kappa to take me the hell back to shore. I couldn't even walk or talk when her boyfriend came up and started yelling at me and calling me a home-wrecker. I couldn't defend myself; I was just too hammered. When we finally got to the dock, I rolled out of the boat and ran, sideways, with my foot in the cast, all the way to our hotel about three miles away. All I remember after that was walking into the hotel room, puking on the dog we'd taken on tour with us, and going to sleep in the tub.

Yes, kids, sometimes drinking with strangers can be bad. But times like these provided critical preparation for my studio career. Produc-

ing a band for the first time proves a pretty similar process to going out and boozing with people you don't know. You have to create this kind of immediate intimacy, so why not have a few drinks together and bond? Even if a band doesn't drink, it's the same process. Surprisingly, it happens: the irony is, most musicians end up eventually going sober—they either can't handle their alcohol, their nerves are fried, or age has simply taken its toll. Even if I was sober (which may happen by the time I finish proofreading this book), I'd probably still go to bars and act the same way. At this point, pretty much my entire life occurs at some kind of social gathering where liquor is flowing. I still very much enjoy drinking, as a social lubricant and otherwise—I don't think I'll ever regret the fact that it's been a key ingredient in my rock-and-roll experience. That's what music is about, isn't it?

Another perk: pretty much the minute you pick up a guitar and walk onstage, you don't ever find yourself paying for drinks ever again. That's how it gets you—it's the free swill with free will. You're not going to make any money, but you're going to drink for free with a lot of people for the rest of your life. So there—for better or worse, that's how I've made it up to now: by having free drinks with strangers. And now music is free on the Internet, so go figure. I remember when both used to be too expensive for me.

Right when music was at its most free, that's when I myself embraced the DIY power of our new Internet age like never before. I decided to self-release my next album, *Sycamore Meadows,* totally independently. Going the DIY route also made sense considering that this was my most personal, searching, confessional record ever (and I was already an oversharer—just ask any of my Twitter followers). Naming the record after the street where our house burned down was significant, but not in the way one might think. We'd only lived there a year, so it wasn't like it had earned this exalted status of the big historic welcome mat in my life, like the street I grew up on as a kid or something like that. But it just felt right to give it that title, because that's

that's where everything got left. That name conjures up this lush, green image, but by the time you get through the songs, you realize all that's left there is ash. It's a beautiful disaster, which sums up life, my songs, and probably everything I've ever done.

I was scared to put out a song like "Vessels," one of my favorite songs on *Sycamore Meadows*: it was about that moment when my family life and marriage were on the rocks. I didn't know if I wanted to put that out there, but in the end I knew it had to be as raw and honest as possible. "We don't get along anymore" is the chorus lyric: that says it all, pretty much cut and dried. I always thought "Vessels" was like a scene from a movie where a couple meets for the first time and falls madly in love. The words paint a picture of a time when you first meet *that* person, and everything is shiny, new, and untainted. There are no problems, and everything is great at first. There's lots of laughter, sex, and wild abandon; then, when things settle in and you get too comfortable with each other, the romance wears off and there's just a lot of fighting. I feared that happening with Nora and me, and getting it out in that song was a way of dealing with it and making sure it didn't happen. Probably the biggest so-called hit from the album, "Here Comes The . . . ," was definitely in that same confessional mode: it documented where I was at in my relationships before the fire happened. I started that song when Alecia and Carey were having problems; it was weird that one of my best friends was going through some of the same things I was, which made it even more intense when she told me she wanted to sing on it.

When Alecia and I were working together in the studio around that time, I was as much a therapist for her as I was a producer, and she served the same function for me. I was there listening to her, helping her deal with her emotions while we tried to write songs; there was a lot of crying and a lot of worry about what she was going to do. As we commiserated, I felt really bad for her: I'd been there before—I'd been through a divorce and knew what it was like. When I first played

Alecia "Here Comes The . . . ," one of the main reasons she wanted to sing on it was because she was feeling big-time what the lyrics were saying: "Here comes the heartache, the move-out date, excuses for my friends . . ." That's the hardest part, telling all your friends who are friends of both of you, "Well, we're not going to be together any-more, so you can be my friend or her friend, but you won't be friends with both of us in the same room."

I couldn't keep that bittersweet vibe from even the hokiest songs on *Sycamore Meadows*. "Ships in a Bottle" was really sort of a sad num-ber about seeing an old flame with someone else and how that affects you. "Passed Your Place, Saw Your Car, Thought of You" is another example: it's about someone I used to be with a long time ago who is no longer alive. She's been gone from my life for some time, but the memory of her sticks with me. No matter who you're with now, there's a memory that remains about people from your past, maybe about a certain way that they touched you or kissed you; I think that that's why that song is there. It's a hard one to write and put in there, too, especially when you're in another relationship. "Summer Scarves" was about an old girlfriend of mine in high school: we used to break into abandoned houses and have sex. Being young, we didn't have anywhere to go, so we had to improvise: we were just going crazy off teenage hormones and looking for some sort of weirdness to get us off. As a songwriter, you've got to face that stuff, and I wasn't scared to be honest on this record. That's the one thing I'll always take home with me, is that I was honest on *Sycamore Meadows*.

In that light, "A Song for the Metalheads" is very personal, because it deals with how I battled with living in the shadow of my former identity. I've battled the residue of my hair-sprayed moment since the demise of my first band. Before I wrote that song, I'd always been too scared to write about it, to say, "Look, I'm not in a heavy metal band anymore. I'm not going to play guitar solos that stretch twenty minutes. I'm probably going to play acoustic guitar all night, without any pyro

blowing up onstage"—although, admittedly, that would be kind of awesome! Really, what that song is about is, if you like me for who I am now, that's great. But if you like me for who I was fifteen years ago, that's great, too; just don't get bummed out and expect something different from me. I've changed. I've evolved. I've *grown up,* thank God.

I'm not being condescending if those people are still wearing their long hair and Dokken shirts and headbanging at forty years old because it never left their souls. More power to you. But I've had people come to my shows and yell at me because I'm not playing SouthGang songs. If you're going to pay twenty bucks to yell about me not playing music that hasn't been heard since 1988, then I don't understand why you're wasting your money—you must be really lonely. Sorry, dudes, but I had to move on. Metal definitely hasn't left my soul, but I don't desire to represent it aesthetically or sonically: I mean, some of the worst lyrics of all time are in all those songs. Hair metal was literally the worst lyric-writing moment in rock history—no "new Dylans" came out of those days on the Sunset Strip. I just didn't want to sit around and wank on an electric guitar anymore. That's why I just violently wrote that song and told it like it was. I'm not dissing metalheads, and I'm not dissing my roots, either. The lyrics pretty much sum up my feelings about it:

> *Press the tape recorder, let's get this all down real fast*
> *Before the insignificant thought goes by*
> *There's one more slow song left to write for the record*
> *To make all the metalheads cry*
>
> *Throw rocks for not rocking, and stand there just mocking*
> *With hands in their armpits that they'll later smell*
> *When you live in the past there's one thing that will last*
> *It's resentment that time won't sit still.*

All this talk of being stuck in time reminds me of the blessing and curse of my entire career in rock. It's weird: I've always felt like I'm five years too early, fifteen years too late. If I'd truly succeeded with any of my previous bands—if SouthGang or Marvelous 3 had become totally *huge*—it would have been horrible. I say that all the time. I said it the minute we broke SouthGang up. I told the other guys, "Don't you guys get it? This is our 'get out of jail free' card." You can look at this as a failure. But if we were trying to put out music *now,* people would just not take it seriously, because "it's the guy from Winger" or whatever. We got a chance to get out scot-free and walk away from this burning fire of dying '80s hair metal, and I've never looked back.

Back to burning fires. To that end, I made sure there were definitely some lighthearted moments on *Sycamore Meadows,* like the song "The Weight of Her." I didn't really want this record to be one big cliché— you know, "My house burned down: listen to how sad my record is." That would never be me. I still kept my tongue in cheek about a lot of things after the fire, and I felt like the record should reflect that. "The Weight of Her" was the very last song I wrote. It had a nice, easygoing, free-flowing wispiness to it, and it just so happened that it was the very first song on the record. The opener couldn't be this drab Nick Drake moment; I needed something to *kick things off.* By that point, my mojo had returned a little bit. It was a metaphorical journey for sure: the chorus is one big metaphor for not letting the weight of the world bring you down, but I said *her* world, because I just felt like the weight of *the* world was too cliché. The whole album is about relationships, so having a woman's world weigh on me was kind of a metaphor for the whole record. That set the tone for the record, so we could get into the heavier stuff.

Another song off *Sycamore Meadows,* "ATL," is also very important to me—one of my favorite songs that I've ever written. It really is just

a story about what happened to all the people that I grew up with from Cartersville, this small Georgia town where we cruised the McDonald's parking lot for fun, because that's all we had to do. "ATL" was really a broad statement about how much I really wanted and needed my family and friends after the fire. Even after losing everything, I realized Atlanta always was my backbone: it's my true home, and I needed to say that. After the Malibu fire, the first show I played was in Atlanta. "ATL" was the first song of the set, and it was great, a really heavy moment that brought my fans and me together. Those three letters are the first thing you see when you get off the plane in Atlanta, and they always say "home" to me.

Another tragedy occurred just as I began the whole *Sycamore Meadows* journey. On August 21, 2008, I got the news that Jerry Finn had died; he'd suffered a massive brain hemorrhage that July and never recovered. Making *ReadySexGo* with him was a great experience, and my working relationship with Jerry was what made it amazing. Jerry's passing was a very, very sad event, something that shook up the music community. Indeed, everybody who had worked with him was so affected—he'd just done so much for them. It was so tragic, because Jerry had just come off doing his best work producing two albums for Morrissey. He was such a sweet, great guy who was selfless and giving with his skills and knowledge. That was a tough loss; I still think of Jerry often.

Just as Jerry had become the go-to producer for the pop-punk elite, I had become Dr. Emo, thanks to the success of "Mixtape" and my work with Simple Plan and Avril. But my emo-ment really kicked into gear when I produced Midtown's third album, *Forget What You Know,* in 2004. Midtown was like the *Star Wars* of emo's original empire before it was big. After doing that record, I got all the calls to do that kind of stuff. I was actually one of the first people Fall Out

Boy met in the "music industry." Well before they had any main-stream fame, my manager was considering taking Fall Out Boy on as clients. They were playing a showcase gig at the Continental club—a truly grimy little punk dive in New York's East Village—so Jonathan, his partner Bob, and I all went to see them. They were actually open-ing for a ska band called Mustard Plug and got heckled and booed by the audience. Still, you could see that they had the right songs, the right hair, and in Pete Wentz, the mouthpiece for a whole generation of kids; he's been an innovator, a torch-carrier. I'm proud to say I've been a fan of Fall Out Boy since that very first show. To me, they're like Cheap Trick: a kind of a dolled-up version of something super-important by someone else, but awesome in their own right, bringing their own energy and poetry to the situation. Patrick Stump, he's becoming a force of nature: the more they let him get soulful and avoid the emo voice, the better. We had a lot of conversations about that in the early days. I remember one particular time we were work-ing together in the studio, he was singing his ass off warming up, and I was blown away. "Man, why don't you sing like that all the time?" I asked him. "Kids won't let me do it right now," he responded. "That can't happen yet." Each genre has its rules, I guess; punk rock cer-tainly did. In the Sex Pistols, it was not cool to be a good musician, even though Steve Jones was a badass guitar player. He liked Humble Pie and Peter Frampton and all those guys, and was a real blues-rock virtuoso, but in the Sex Pistols, he only played two chords. It took bands like the Clash to come along and show people that you could be musical and still be punk.

That same thing could happen with Fall Out Boy. Ironically, I passed on producing the first big Fall Out Boy album, *From Under the Cork Tree*—another classic Butch Walker career move. Yeah, baby! Jonathan tried to get me to do it and I told him, "Emo-ver." "I'm over that stuff—I can't do it," I said; I didn't want to do any more variations on "Freak of the Week." And, of course, Fall Out Boy did their album

with Neal Avron producing, and it was huge. But that's fine; it didn't matter. I ended up working on Fall Out Boy's next record, *Infinity on High,* producing one song and singing backgrounds on another. It was a pleasure, as I am a genuine fan of their songs.

So I think that's how that all happened. I was getting calls to do other records like that: I produced The Academy Is . . . , worked on an album for Saosin, and so on. I'm treading lightly in that genre right now, although fairly recently I produced a Dashboard Confessional record. It was as a result of working on Dashboard's record that I actually met one of my hugest, prepubescent heavy metal–era guitar heroes, Yngwie Malmsteen; it's funny how random moments sometimes cause your worlds to collide. For the uninitiated, in the '80s, Yngwie Malmsteen became basically known as the fastest guitar player alive—and yes, his name is pronounced "Ing-Vay."

While I was in Miami working with Dashboard, all we could talk about was Yngwie: he lived there, and the guys told me how they'd seen his legacy around town. He was instantly recognizable—a big fat dude wearing leather pants, a pirate shirt, long hair, big earrings, and big jewelry. Yngwie is still living the dream (or is it the delusion?). It has been two decades at least since a band would get signed because of their guitar player's shred skills, but that time has never left for Yngwie, who still considers himself a massive, important star. With him, time has stopped. He is still an anomaly in that he goes there, but like Yngwie's former female conquests of the '80s, that car is pretty beat up and has seen better days.

I knew going to Florida that I would cross paths with Yngwie, especially after one of the guys in Dashboard told me, "Yeah, we were practicing at this rehearsal place last year and you wouldn't believe it, but we saw Yngwie Malmsteen playing there one day!" He'd pulled up next to a kinda beat-up "Magnum P.I.," not-so-cool, red '84 Fer-

rari in the rehearsal space's parking lot. As he got out of the car, he heard this insane shredding erupting from inside. Suddenly, this giant walks out of the door, playing guitar with a wireless pack on: it is Yngwie—wearing sunglasses, attitude cool as a scoop of ice cream, just soloing away, not missing a note. As he played, he fixed my pal with a tough glare. "Is that your fucking car?" he growled. "Well, you fucking better move it." He said that and then went back inside, never missing a note. I guess Yngwie *really* doesn't want anyone parking next to Magnum.

My own run-in with Yngwie involved, naturally, reality television. While I was in Miami with Dashboard, I agreed to be on some show called *Wedding Day,* where they give a couple the wedding of their dreams and film the whole thing. Apparently, the groom was a big fan of mine, and his dream was to have me play a song of mine at their ceremony. I thought that would be a cool thing to do, so I split the studio for a couple of hours and went to the hotel where the wedding was taking place. Of course, Yngwie was on the show, too, presenting the groom with a certificate from Rock and Roll Fantasy Camp or something. This time, I decided, I was going to meet Yngwie for real, properly. He did his bit for the wedding before I arrived, though, and had already started to leave, so I ran through this huge hotel trying to catch him. I rushed out to the hotel's entrance, where I spied his trademark red Ferrari parked over in the valet area. Standing nearby was this big-chested European lady—older, but model quality—getting into a Mercedes with three kids, one of whom was holding two scalloped-neck Fender Strat guitars (with no cases): that was the giveaway that they were Yngwie's family. I asked the woman, "Is Yngwie here? I have to get a picture with him." "He'd love to—he just went to the bathroom," she said sweetly. "He will be out in a minute."

Sure enough, after sixty seconds passed, Yngwie came running out of the hotel. He flew right past us and ran toward the Ferrari like

he was being chased by paparazzi—except there were no paparazzi. It's amazing: he's such a legend in his own mind, he has to have his wife and kids leave in a separate car! As he was getting into the Ferrari's driver's seat, his wife yelled, "This young man wants a picture with you. He is a big fan." So, of course, he came over to pose for a picture with me, totally disgruntled. I start dropping all kinds of crazy fanboy details, like how much the album by his first band, Steeler, meant to me when I was a little shredder. His eyes lit up: "Oh my God, *Steeler*? You know about the old school?" Of course, after that, he was my best friend. For about two minutes. Then he left. After getting a ride with his wife, because his beater Ferrari wouldn't start.

When you meet someone like Yngwie, who's still living the dream, it's hard to stay cynical about the music business. It's never going to be old school again, that's for sure: the future is here, and the labels are still in denial about it. The labels ran from the Internet; their big heads and big wallets were all that mattered, and kids started realizing they didn't need labels to promote their bands. More and more of those kids know now that it's not a good idea to jump into these "360" deals the labels have come up with, where they take not just the profits from your record sales, but your merchandise and publishing, too. As such, *Sycamore Meadows* was a truly indie, self-released record: I went back to my DIY roots with Marvelous 3 and the Floyds on that one. So how was that different from being on a major label? I couldn't tell you, because I've never really been on a major label where they really did anything that effective or powerful. I was already an established mid-level artist—a self-running, self-made thing. I didn't really have any problems that a label needed to fix; I didn't have any hills that they needed to climb, because I'd already climbed them. The hills that the labels were trying to climb were unrealistic goals for an artist like me—there was no sense in trying to jam my songs down the

throat of pop radio, or getting a video of mine played on VH1 or something. It's probably just not going to happen. Ryan Adams doesn't get played on the radio, ever; you wouldn't know if he made videos anymore, because nobody plays them. So why be on a major label? All they care about is whether or not they're going to sell a bunch of their products, which are called CDs, which are these things that are pretty much sitting under your soda can right now.

The record business was already fucked when *Sycamore Meadows* came out: the labels had fallen asleep at the wheel, and digital downloads were the sleeping giant under the carpet that nobody saw. The execs were too lazy, too fat, and too happy. They were in deep denial: in their collective corporate minds, there was no way that they would ever *not* be responsible for a band's career. They were used to dictating what songs the artist plays, telling them how to dress, and, more important, taking 85 percent of the damn cheesecake. In other words, the major-label business remained highway robbery, and has been so since the 1950s. These days, if a major label has a song on the radio and it's a Top 5 hit and selling a million copies, it's to a very concentrated demographic that doesn't use computers. However, the kids who do know computers don't like that kind of music shoved down their throats, and their legions are growing.

My manager's the smartest man in the biz, and he's the first one who saw it coming. He told me ten years ago, "The record business is fucked. You just watch." As I mentioned before, Jonathan helped create something called Big Champagne, a tracking service that truly monitors the popularity of music on the Internet. He and his partners were selling this technology to radio stations so they could do proper research. Pre-Internet, radio research was based on taking a sample of a song, called a "call-out hook," where telemarketers called random people out of the phone book at random times throughout the day and played part of a song for them. Sometimes that voice on the phone might say, "That song sucks, I don't want to hear that"; the next thing

you know, that song got yanked off the radio playlist. What an inane, fouled system! It's not accurate. My manager knew that for years, and he knew that accuracy depended on answering one question: "How do we get right into the kids' computers?"

Big Champagne does just that, tracking exactly what they're downloading and listening to in every city. What they found out was that a lot of kids really didn't want to hear Nickelback or 3 Doors Down another hundred thousand times—or even at all. The labels couldn't fathom this info, because, in their minds, they were still the tastemakers, the kingmakers. For years, the labels decided what people would listen to, and what music would be on the radio; today, no more. When labels realized that they lost that power, and kids were downloading millions of albums for free on peer-to-peer sites and they couldn't shut those sites down, it was pretty much over. I even wrote a song about this phenomenon back in Marvelous 3 days, called "Radio Tokyo." "Radio Tokyo" was about a dream I had about some sort of underground radio station taking over the airwaves and playing what people really wanted to hear. I guess it wasn't a radio station—it was a computer, but I didn't know that back in 1999.

Even Metallica, the biggest metal band of all time, tried to shut down the computers. That was the biggest hypocritical statement on the planet: when Metallica started back in the '80s, they talked incessantly about how they would trade cassettes with other people to turn them on to new bands. It's one way they spread this new sound they helped create. So, Lars, what's the difference between an MP3 and a cassette tape? Do you think James Hetfield said, "Well, there's an Exciter song and a Celtic Frost song on this tape that I haven't heard before. Oh, I feel so guilty! I should go to the record store and buy it instead of taking this cassette from my bro." If you were a broke kid, probably like the members of Metallica were at one point (many, many art collections ago) and like almost every kid in America is today, you didn't buy music if you didn't have to. I used to tape off the radio all

the time. I remember that was a big controversy back in the day: the powers that be were terrified home-taping was going to be the downfall of the music industry because of the fact that you could actually tape records off the radio with the built-in cassette player on your stereo or boom box. Last I checked, home-taping didn't kill music, and so far, MP3s haven't, either. So what the hell is the problem?

The problem is greed; it's about *money*. It's the exact problem we have right now, not just in music but as a society overall: everyone is too concerned with how much more money they can have than somebody else. It's not the fan's responsibility to figure out how the music industry makes money, but it's the artist's problem if they're not. And so, when artists are already only getting 15 percent of their own record and they're giving 85 percent of it to a label, of course the knee-jerk reaction for an artist is, "Oh my God, please, kids, don't download my shit for free. I'm already getting screwed enough by my label! Now, I'm not going to make *anything*." However, the people who make 85 percent off of music are going to be 85 percent more pissed about downloading. Look, it was no coincidence that when the CD came along, it cost nearly the same to manufacture as it did cassettes—except labels charged twice as much. And when they switched format from cassette to CD, labels kept the deals for the artist structured exactly the same—very unfavorable, with the same splits—so the labels were doubling their profits.

With the CD explosion in the '80s, it was no coincidence that every major-label office expanded. Everything boomed: they were on fire, and it wasn't because there were more records sold than ever before. So, of course, they got happy and bloated—and slow to change. I remember I had one of the first Diamond Rio MP3 players, which held, like, twenty songs—and I had to kind of keep it under wraps. I couldn't even really talk about it, because it was really taboo to be a signed artist—or even worse, working for a record label—and have an MP3 player, because *you were supporting piracy*. Of course, the biggest

device ever to revolutionize music, the iPod, is basically what the Diamond Rio became; iTunes is the only thing keeping the music industry alive in terms of selling products. It's still an unfair deal for artists: what iTunes charges is only a few dollars different from what a CD costs, except for the fact that there's no manufacturing cost. Even as the *Titanic* sinks, the labels refuse to pay the house band.

That was our whole issue with Marvelous 3: we didn't sell any records, because Elektra Records wanted to sell our album for full price, while, at the same time, other labels were practically giving records away just to move units and attain high chart positions. You had Buckcherry and Orgy and Eve 6 and all these other bands out at the time, brand-new artists just like us, with songs on the radio, but they were selling their records for $6.99—basically two for one. If a kid can buy a bag of weed and a Buckcherry CD with his allowance, he's going to buy the Buckcherry CD and skip the more expensive Marvelous 3 CD. That's the thing—these big, rich suits lost the plot. They forgot how hard it was for a kid to take his ten-spot and go to a record store and go, "What can I buy with this?"

It's a double-edged sword. I mean, it's not like the download revolution hasn't affected me. But it hasn't affected me in a bad way: you can still make great records without overspending. I never wanted to overspend on records, anyway. I was lucky to ever see any money left over from the recording budget to split among the band. That was always the goal, but it never happened, because of the spending habits of the label and the producers, the sushi budgets and the mixing and remixing and re-remixing the album until the A&R guy, who'd never played an instrument in his life, was satisfied. All of a sudden, the label that wasn't there for the whole record now wanted to over-A&R the shit out of it. Every day they were like, "Well, now we're going to get a remix by this other guy to get things *just right*." And each time the record was remixed, $10,000 a day was flushed down the toilet and out of my pocket in points and recoupable fees. The labels don't give

a damn what they're doing with your money, because they're not hurting; it's no skin off *their* noses. They just want to go to their power lunches and say, "Boy, that last mix I had done really fixed this Marvelous 3 record. I had to remix it fifteen times to make it *finally* sound good!" I had that very conversation with Sylvia Rhone, the head of Elektra, while recording Marvelous 3's second album. I told her, "You don't care about going over budget? Well, you're rich, and my band members need to put food on the table." It's so stupid. No wonder the music industry is broke, with this mind-set.

On the other hand, we live in an incredibly exciting time for music (see how we turned this into a positive?). I wrote in one of my blog posts that, while the record business is screwed, it was in the best way possible. Everything now is in the hands of the artists, the kids, and the fans. Hallelujah, how long have we been waiting for this moment? Thirty years? Forty? It's a revolution, and it's working. There are kids turning down major-label offers because they're smart enough now to say, "I'm making good money on tour, I'm making records with my laptop that sound good—I don't need those people telling me what to do." Those kids might sell just five thousand CDs in stores, but twenty thousand T-shirts on a tour. It's funny: major-label deals are so old, and kids do not want to do anything that's old. When they get offered these corny, exploitative, 360 deals, they're like, "That's so old-fashioned. That's what my *dad* would've done."

I first found out what MySpace was when I did the Midtown record. Kids found out I produced and worked on that Midtown album, and all of a sudden I had a hundred thousand friends on MySpace. It kept growing and growing, too. The emo kids were definitely the early adopters, in terms of harnessing social networking to get music out there. Rob Hitt, the drummer for Midtown, now works with my management on their Internet strategy. Rob was the first one who

told me, and everybody else, that this new thing called Twitter was going to take over. He pulled me aside one day and said, "Don't worry—I saved twitter.com/butchwalker for you." I was like, "Oh, Twitter. That's cute. I'll never use it." Of course, now I post on Twitter maybe five times a day. Gluttonous lemming . . .

I learned a lot about how to deal with this new technological era from people like Rob. I want somebody to be able to read my tweets if they so desire; I want somebody to be able to download my record. I want to have that exposure, because if someone listens and connects to my music and likes it, they'll come to see me play and I'll hopefully, in a perfect world, be able to tour forever with a fan base. The record companies never did anything to help promote shows, but you can sell out four nights at an L.A. venue in twenty-four hours just by posting it on Twitter. In fact, recently I've played my biggest shows to date. I sold out Webster Hall in New York City on my last tour, which I'd never done before on a major label or with a hit song on the radio. I'd never even played Webster Hall.

Right now, the money to be made in music is off live shows. The actual thought of making money off record sales is obsolete unless you sell a million copies anyway; you'll never recoup, the way the deals are structured. That's always been the case, so if I've learned anything, it's that downloading does not hurt the mid-level artists; it *helps* the mid-level artists. I remember a friend of mine from a band I had recently produced was in a tizzy about kids pirating music. This kid was very computer-savvy, so I guarantee you, he was potentially hypocritical and downloaded tons of music himself, but he was starting to sell some records and was feeling scared. I told him, "Dude, I don't know how to break this to you, but you're not ever going to see a dime of royalty money unless your records go platinum." "You are just jaded," he responded. "You're just bitter because your records haven't sold. I'm really happy with my label and they're great to me—they take good care of me." I was like, "Meet me back here at seven thirty P.M.

a year from now at this very same bar, and I want you to tell me how much you love your label." Of course, a year later, his band had been dropped.

Irony of ironies, I am one of the producers that those major labels consider acceptable for their artists to work with. As an artist, half the year I make records that will hopefully move my soul (not units) and I don't care about how much they sell. As for the other half, well, sometimes my worlds collide in the best way. In 2009, I found myself writing and producing for Weezer, which brought all the strands of my life together. I'd coexisted in the metal era with Rivers Cuomo's hair band Zoom; in the alt-rock era, Weezer blew my mind with their "blue album," giving me the courage and inspiration to start Marvelous 3. Meanwhile, Weezer pretty much invented emo with *Pinkerton,* essentially giving me a whole other career bump with that one.

Cut to 2011: I'm living in a really cool, humble, but great little house out in Malibu on a great street. I've got great neighbors from all walks of life. One of my neighbors is a really sweet crackhead girl who lives with her daddy; on the other side of me is one of the Beastie Boys. It's all over the place like that, and I love it. I feel like I'm most comfortable anyway being the chameleon. Life is good. I've got my studio down the road a bit in Venice—a cool spot once owned by Bob Dylan—and I drive there every day on the Pacific Coast Highway, listening to music, which I don't get the chance to do much, because I'm helping raise a little boy. That takes up all my time, and rightfully so.

Amidst all this, I get a call from the Weezer camp: they want to know if I'd be interested in writing a song with Rivers. The only catch is, he wants to write at his house. When they gave me his address, I realized it was right down the street from me—I actually *walked* over (a pleasant exoticism when living in the L.A. area). When I arrived, Rivers asked me, "Did you walk?" And I said, "Yeah, I'm

your neighbor." That day we wrote a song, "If You're Wondering If I Want You To . . . (I Want You To)." I ended up producing it, too; a few months later, it was a No. 1 hit at modern rock radio. Rivers's "people" asked me to come in again, help redo some of the tracks, and then write some new ones from scratch. Our collaboration worked out pretty well: I ended up with two songs on Weezer's *Raditude* album, but it wasn't like I was special. At that time, Rivers was working with every songwriter in Hollywood—well, he didn't work with Desmond Child, but that would've been awesome (actually, as we were going to press, it came out that Weezer, in fact, ended up working with Desmond on their recent *Hurley* album!). Still, it was so gratifying remembering how I'd listened to Weezer constantly while driving around Oklahoma with my little band playing to a hundred frat kids a night; that paved the way to where I am today. Working with artists like Rivers and Weezer is one of the fulfillments that make it worth it to keep on going.

It was also just cool to be a part of someone's inner machine and seeing how they work to maintain their legacy. Rivers enjoys tweaking the system: he's a master player, and he knows exactly what he is doing. I remember sitting across the table from him, and his saying, "What do you think of 'The moon was shining on the lake at night' as the opening line for the song?" I thought to myself, "I would never write that lyric, not for myself or even the poppiest of pop artists." The kicker is, he's a Harvard grad. That's the punch line: he told me, "I can get away with that line, because my image will always undercut the corniness." And he's right. He makes pop art, and it's a blast. Pitchfork was the first to say that *Raditude* sounded very Jonas Brothers, and I agreed. When Rivers first told me what he had in mind, I was like, "Let's make a new 'My Name Is Jonas'—not 'My Name Is Nick Jonas.'" But with *Raditude,* he was on a mission to make the biggest pop event he could, and more power to him. There was a method to Rivers's madness: he'd never cowritten with anyone before—the

dude is a genius songwriter on his own, obviously—but this was the last record Weezer was doing for the biggest major label there is, Interscope, and Rivers wanted to go out with a bang.

Or a pop. Hey, I've done my time writing pure pop. When I got asked to write the new international campaign theme song for Coca-Cola, what sealed the deal for me was that Prince had done something similar for Pepsi back in the day: "You got the right one, baby, uh-huh." It's like six stupid notes, and it's genius. Those six notes were the foundation for Pepsi's huge campaign in the '90s: they got Ray Charles to sing it, and I thought that was kind of cool. Plus, Prince made millions off that move. So when Coke came calling, what did I do? I called Cee-Lo Green, who's somewhat like today's Prince—if Cee-Lo's on it, it's going to be good, no matter what. When I called Cee-Lo, he said, "Oh Butch—I'm in, baby!" I sent him the hook, the chorus, and the rest of the track, and he came up with some really positive, very spiritual verses. Next I called Brendon from Panic! at the Disco, Patrick from Fall Out Boy, and Travie McCoy from Gym Class Heroes; Cee-Lo got Janelle Monae on it, too, and it was *on*. I gave them the track and they all loved it—besides, it was Patrick Stump's dream to work with someone like Cee-Lo. And it was different for me, because I was able to get outside my box, too. I'd never written for urban artists, for one; just to write something strictly for a soda can and not have to be too married to it or shoot myself in the foot with a clever gun lyrically was refreshing—but hardly easy. I had to make something that was simple, hummable, and sounded immediately like an instant classic; sure, it was for a soft-drink company, but I found that to be a fun challenge. I recorded the track in a day in my little home studio, everybody sent me files of their parts, and *boom*—instant soda pop.

The beauty of it all is, there are still pop stars. In the future, I think pop music will thrive only in major-label hands. You can't take a Britney

Spears or whatever and sign her to XL Records and expect them to even know what to do with her, or want to do anything with her. I just feel like there's always going to be a need in pop and country music for a major label to promote to people who don't have the *Internets*. It's funny—the public is going to perceive me as the pop guy, because the only records I've done that they know about are pop records. That's the irony, and you know what, pop records will always sell. Just as I was finishing writing this book, I had an encounter with a real pop star of the moment, Taylor Swift. I never asked her, but I have a feeling she managed to make it to the top without getting a Flying V–piercing-a-heart tattoo on the Sunset Strip.

Anyways, Taylor and I connected because, on a lark, I'd put together a fun little cover of her hit "You Belong with Me," where the primary instrument was, of all things, a banjolin (yes, it's exactly what it sounds like). I recorded it quickly and slapped it up on YouTube. Despite the fact that the video featured me urinating a hundred times, it quickly got something like 300,000 views—one of which was by Taylor, who loved it. She loved it so much, in fact, she asked me to back her up as she performed my version at the 2010 Grammys. Adding excellence to injury, we were to be joined by Stevie Nicks, who sang harmony on "You Belong with Me" and duetted with Taylor on "Rhiannon." I'm sure most viewers didn't even realize I was up there, and if they did see me in the corner of their TV set, they probably were thinking, "Who is that gangly, tattooed dork with the funny hat, playing that weird instrument with those actual famous people?" It was an amazing experience, one that pretty much sums up the surreal place where my life has landed. That whole thing reminded me of the power music has to move someone to tears, to make them mad, happy, to make them laugh, to make them sad. Not many things can leave that lasting impression, not video games or wrestling matches, or other things that have come and gone over the years. When I heard Elvis coming out of my mom's record player at the age of four, it

moved me in a way I'd never felt before, and I've been chasing that feeling ever since. Hey, it ain't where you're from —it's where you've been.

Sometimes I get cornered by people trying to "make it" in the music industry; typically, they ask me variations on the same set of questions. "How can I write a good song?" "How can I start a rock band?" "How can I become a solo artist?" "How can I become a cowriter?" "How can I get a fireproof house in Malibu?" "What is Pink's phone number?" First off, I don't know the secret to how to write a good song—and as I've said before a million times, sometimes there's a difference between a good song and a hit song. Writing a good song is really about what's good to you and not what you think other people think is good. Ultimately, there's no way for me to answer these questions without sounding cliché, but I always say don't try to be like me—be yourself. It sounds lame, but that's the real secret to success. The minute I stopped trying to be like other people and started being myself, I actually started getting somewhere.

The other cliché that's proven true is, if you want success, you just can't stop. You can't give up when your house burns down. You can't give up when people tell you, "Don't move out to California, because you'll never make it—everybody else is way better than you." You can't give up when the first beer bottle (or forty) gets thrown at you; that's going to happen. You can't give up no matter how many bad gigs you're going to play, because you're going to play a bunch of them. You can't give up when a songwriter steals a song you wrote and ends up getting a hit out of it. You can't give up no matter how much your soon-to-be ex wants you to. And when you get older and successful and wealthy, and you're in a place where you feel like everything is great and you've achieved everything you set out to do, you can't give up. And you can't give up when a critic gives you a bad review.

Of course, sometimes you get a good review—even me. After years I'd spent as a mid-level, one-hit-wonder artist, things finally seem to be swinging my way. We played Lollapalooza and didn't get booed by hipsters; I think they might have liked us, actually. We did a sold-out tour without a song on the radio. I got to (in a very inadvertent way) play on the Grammys for the first time. And *Rolling Stone* actually liked my new record. I'll never forget the last line of the review: "Butch Walker is a total hack. And he's also one of the best songwriters in America." Finally, in a sort of backhanded way, I had been vindicated for my valiant efforts. As silly as that little line was, I felt like, from just one young dude's opinion, I could finally sleep better that night. I'll drink to that . . .

Let's cut through all the bullshit for a minute. Everything you just read was fun and all, but . . . I need to let you know something. I sat at a gas station tonight and heard "99 Luftballons" by Nena come on the radio while I was pumping gas (not fist), and started getting a euphoric feeling. It was when the keyboard pad kicked in during the breakdown of the bridge, and Nena is singing softly: that keyboard sound takes me back to my youth instantly—it hit me hard. I had a couple of glasses of wine in me, but what really did it was just thinking about hearing that song for the first time twenty-five, maybe thirty years ago. I was jumping up and down on the bed. I remembered girls who I was in love with at the local swimming pool. I remembered being in the back of my sister's boyfriend's pickup truck and having my first beer buzz. The bottom line is that music puts a time stamp in your brain from the minute you connect with a song. And it stays with you forever. This I know. I have a debt to Nena for putting out that song. All I know is that when I heard that dreamy keyboard line at the gas station tonight, I almost lost time. I forgot everything around me. I started thinking about how sad it will be when this feeling won't be in my life. I started thinking about my ailing father, and how I will hear a million songs that will always remind

me of him. How we sat on creek ledges and fished for bass, and those were the best days of my life. How I won't be here when my son is my age. And how . . . Damn. This is the hardest thing to say, but I will be fifty in less than a decade. Your youth is the most important thing you will ever have. It's when you will connect to music like a primal urge, and the memories attached to the songs will never leave you. Please hold on to everything. Keep every note, mix tape, concert ticket stub, and memory you have of music from your youth. It'll be the one thing that might keep you young, even if you aren't anymore. Let the music play . . .

ACKNOWLEDGMENTS

would like to thank a few people for this narcissistic oppor-
tunity to ramble on for some two-hundred-odd pages, and
for actually convincing me that it was a *good* idea: my best
friend and mentor, Jonathan Daniel; Lynn Grady and every-
one at HarperCollins; my life and blood, Nora and Jamie
Blue Walker, Butch and Melissa, Dana and Leah Walker;
Jayce Fincher; Mitch "Slug" McLee; Jesse Harte; Chrystina
Llorree; The Black Widows; Jason Childress; my cowriter
Matt Diehl; and not to ever forget . . . my fans, the best in
the world. I am humbled.